IN
SEARCH
OF
EVE

IN
SEARCH
OF
EVE

*Transsexual
Rites of
Passage*

ANNE BOLIN

Bergin & Garvey Publishers, Inc.
MASSACHUSETTS

First published in 1988 by
Bergin & Garvey Publishers, Inc.
670 Amherst Road
South Hadley, Massachusetts 01075

89 987654321

Printed in the United States of America

Library of Congress Cataloging-in-Publication Data
Bolin, Anne.
 In search of Eve.

 Bibliography: p. 195
 Includes index.
 1. Transsexuals. 2. Sex change. 3. Sex role.
I. Title II. Title: Transsexual rites of passage.
HQ77.9.B65 1987 305.3 87-13702
ISBN 0-89789-082-5 (alk. paper)
ISBN 0-89789-115-5 (pbk.: alk. paper)

For my family

Acknowledgments

I am deeply indebted to the transsexuals and transvestites who so graciously invited me into their lives. In sharing with me their rites of passage they embellished mine, not just in the academic arena but experientially. The words "thank you" do not adequately express my gratitude towards these sensitive and articulate people who came to be my friends.

The anthropology faculty at the University of Colorado at Boulder were most helpful. Special thanks must be given to Paul Shankman who provided immeasurable assistance in reaching the final version of this manuscript. His careful and meticulous editing, guidance, and perceptive comments were invaluable and thoroughly appreciated. Dorothea Kashube also furnished a number of original suggestions for improving the manuscript in addition to being a source of inspiration. Omer Stewart encouraged my interest in American phenomena and was always available with ideas and feedback. My gratitude extends to A.J. Kelso for getting me started in anthropology and for providing a great deal of intellectual stimulation in the interim as well as a lot of sound advice.

I offer my appreciation to the anthropologists at the University of Colorado at Denver for an invigorating environment in which to write and work. Duane Quiatt was especially helpful and reinforcing. I am grateful to him for his careful reading of the manuscript, his thoughtful suggestions, constructive recommendations, and just being there. Lorna Moore was also an asset in contributing expertise and insight. Thanks must be given to my family for their total endorsement and to my spouse, Greg Babcock, for his extraordinary nurturance and love. Finally, Beth Flanagan's expert preparation of the manuscript is gratefully acknowledged.

Contents

TABLES

FIGURES

Preface

This book concerns sixteen male transsexuals in the process of becoming women. The research spanned two years using participant-observation as the primary method, supplemented by life histories, questionnaires, and masculinity-femininity indices. In addition, attendance at weekly meetings of the Berdache Society, a transsexual support group, and immersion in transsexuals' everyday lives was included in the research strategy.

The transsexuals' metamorphosis was a patterned development that had the characteristics of a rite of passage. Their rite of passage was dramatized by important stages and events that punctuated their progress towards the sex-change surgery. The medical profession, transsexual intra-group interaction, stigma, and transsexuals' perceptions of women were the salient factors shaping their passage to womanhood.

Transsexuals were followed as they separated themselves from their former male lives after finding the label transsexual, as they began a therapeutic relationship with their medical caretakers including female hormone therapy, as they prepared for and actually adopted the female role, and as they were finally incorporated into society as women after

the surgical conversion. The approach taken here did not assume that transsexuals began their rite of passage with fully crystallized feminine identities, but rather regarded these identities as gradually emerging in conjunction with changes in social identity and physical appearance.

Several findings of this study refute commonly held notions about transsexuals. Transsexuals were not shown to have family histories with dominant mothers and absent fathers, exclusive homosexual orientation, effeminate childhoods, nor did they view their penises as organs of hate and disgust. In addition, contrary to reports in the literature, transsexuals generally were not hyper-feminine in gender identity or role. These findings may contribute to the study of gender dysphoria and to a growing body of work on secular ritual and symbol in contemporary America.

IN
SEARCH
OF
EVE

ONE

Introduction

The knock on the door had to be Sasha, picking me up for a visit to the hospital where a mutual friend, Allyssa, had just undergone surgery. Sasha, who is in her late forties but looks ten years younger, was casually dressed in blue jeans, a blouse, and heels. Her brown hair was styled in a shoulder length, curly hairdo. This, together with her petite five-foot, four-inch frame, contributed to an aura of youthfulness, as did her seemingly boundless energy. Our mutual friend was ostensibly in the hospital to have a hysterectomy, as she had informed her employers.

As we drove, we covered a number of topics, from feminism to a man Sasha recently met. She told me of the wonderful evening she had with a man with whom she had spent the night. She found the sexual adventure complete in all respects but one: she could not have intercourse, as she told him, because of her "female problems." Allyssa was, in fact, in the hospital because of these same "female problems," although the surgery will effect a permanent "cure."

We were terribly excited as we entered Allyssa's room. Allyssa was happy to see us although her enthusiasm was somewhat dampened by

1

the ravages of major surgery. She lifted the covers and showed us the temporary metal wire below her naval which held in place the upper end of her new vagina. Allyssa was recuperating from a sex-change operation. Her "female problems," like Sasha's and many others, are unique. These people are women who have male genitals. Allyssa and Sasha have been living in the female gender for some time now. Their bodies have been feminized as a result of female hormones and they pass undetected in society as "natural" women. They fall asleep as women, wake up as women, and are women in all respects but one. Their only chance for normalcy lies in the transsexual surgery in which they become genital women, ridding themselves of the penis, a symbol of their male history and a deterrent to their complete incorporation into the private and intimate sectors of human life where bodies are important.

In fact, the surgical technique is so sophisticated that the "neo-vagina" is virtually unrecognizable as a creation of artistry rather than of nature. Labial folds, a clitoris, and vaginal depth equivalent to the natural vagina culminate the transsexual's somatic metamorphosis. At this point, not only does the transsexual appear as a woman, but her "neo-vagina" functions as a woman's. Because the vaginal cavity, the labia, and the clitoris are constructed using the sensitive tissue from her male genitalia (the vaginal cavity is lined with this tissue), she is capable of sexual pleasure and, in many cases, orgasm.[1]

Allyssa and Sasha are two of a number of male-to-female (genetic males desiring to become females) transsexuals who are part of a larger transsexual network, the Berdache Society, a local support group for transsexuals and transvestites.[2] They are part of a much broader population of transsexuals in the United States. Estimates of that population range from 3,000 to 6,000 in this country and may be "ten times that number world wide" (Pauly 1981: 45). This number is, however, a conservative estimate and many transsexuals are not included in these figures for several reasons. Unless the person's atypical gender identity is developed to the point that surgery is requested, he or she will not be incorporated in the transsexual statistics which include only those who have either had the surgery or who have been designated by the medical or mental health sector as transsexual (Pauly 1969: 57).[3] Therefore, those in the process of becoming transsexuals are excluded. Although much of the information about transsexuals is collected by gender clinics that provide programs for psychological evaluation, therapy, hormonal management, and even surgery, many

transsexuals who are under the care of medical and mental health professionals in private practice are lost forever to scientific scrutiny, unless the caretaker is undertaking his or her own investigation.

Studies of the prevalence of transsexualism reveal a significant discrepancy in the male and female ratios of those requesting surgery. Males apparently request the surgery to a far greater extent than females, although ". . . transsexual proponents have claimed that the incidence of female-to-constructed-male transsexualism is rising . . ." (Raymond 1979: xxi).[4] To date the literature reflects the male-female discrepancy in the sex ratio in this population and consequently a much greater body of information is available on male-to-female transsexuals.[5] This literature, primarily in the medical and mental health fields (with contributions from a few sociologists), indicates a steady rise in requests for surgery. Improvements in the surgical techniques and increased opportunity for surgery through the establishment of gender clinics may account for the increase. The actual ease with which surgery can be obtained has nevertheless declined in response to increased rigor in the evaluation of those requesting surgery.

Medical and mental health interest in transsexualism is organized through the Harry Benjamin International Gender Dysphoria Association. Its membership consists of professionals of all kinds who are associated with gender dysphoric clients, in other words, transsexuals, ". . . any and all persons requesting hormonal and sex reassignment" (Berger et al. 1980: 3). Until recently, though, the medical and mental health sectors were not concerned with transsexualism. It first came to the attention of the scientific community in 1953 through the work of Hamburger, Stürup, and Dahl-Iversen who were responsible for making public the surgical conversion of George Jorgensen into the now-famous Christine (Benjamin 1966: 14; 1969: 3). In that same year, Harry Benjamin published the first article on transsexualism and, at a symposium during the meetings of the Association for the Advancement of Psychotherapy, first coined the term *transsexual*.[6]

During this early period of transsexual research, perhaps due to the notoriety of Christine Jorgensen, the psychoanalytic community resisted the idea of surgery as a solution to the problem of gender dysphoria. In the ensuing years, little research was done since ". . . in the minds of many in the medical profession, the subject was barely on the fringe of medical science and therefore taboo" (Benjamin 1969: 5).

In 1966, Benjamin published *The Transsexual Phenomenon*, ush-

ering in a new stage in research and gaining acclaim as the parent of
the field. This work was followed by numerous others including Green
and Money's edited collection of articles entitled *Transsexualism and
Sex Reassignment* (1969), Stoller's *Sex and Gender* (1968), and Wal-
inder's *Transsexualism: A Study of Forty-Three Cases* (1967). Prior to
1965, Pauly could only find 100 references on the subject of trans-
sexualism, but in a MEDLARS search of the 1967–1978 literature
he retrieved 412 articles on transsexualism. Pauly estimates that cur-
rently there are about fifty publications on transsexualism per year
(1981: 45).

In the brief history of the field of gender dysphoria, the literature
has been dominated by medical and psychological interests that have
yielded valuable insight into questions of therapeutic, hormonal, and
surgical management of transsexuals as well as research on post-surgical
adjustment and the ever-present questions of etiology. Thus, a large
body of literature that can be classified as clinical (e.g., medical,
psychiatric, and psychological) has emerged, contributing greatly to
the understanding of transsexualism from those perspectives.

Of late, however, researchers have been trying to fathom transsex-
ualism beyond the individual and family milieu perspective of the
clinical approach and are considering the individual within a broader
context, specifically within the context of society and culture. These
researchers are coping with such broad questions as the meaning of
the transsexuals' transformations, the qualitative aspects of their ex-
perience, and what their experience reveals about American cultural
norms. Kando (1973), Feinbloom (1976), Kessler and McKenna
(1978), and Raymond (1979) are among the researchers who place the
transsexual within the context of culture, although the specific ques-
tions are as diverse as the researchers. This new sociocultural literature
augments medical and clinical knowledge of transsexualism, focusing
on a complementary set of concerns. Anthropology contributes to the
sociocultural literature via the cross-cultural record, where gender role
anomalies have been reported and analyzed as early as the beginning
of this century. For a more detailed review of the literature see the
Appendix.

The Research Strategy: Methods and Perspective

The question I address is: How are genetic men transformed into
psychic, social, and somatic women in a culture that regards gender

as genetic and hence non-negotiable? The present work follows the sociocultural approach to transsexualism, although it stems less from the influence of the authors cited above than from experience in and a research methodolgy derived from the discipline of anthropology. I had originally planned a study that spanned two fields, the clinical and the anthropological. My research question was clinical in scope; I was interested in the etiology of transsexualism. The methodology was interdisciplinary in that the case study method, used by clinical researchers as well as by anthropologists, was incorporated (see Langness 1965). In addition, participant-observation, the traditional method of the anthropologist was also to be employed because it facilitates getting to know people intimately. I felt participant-observation would give me access to life-history information that transsexuals might be reluctant to give to medical/mental-health caretakers because of their professional relationship to this population.

My interest in understanding the etiology of transsexualism was formulated prior to my ever having met a real, live male-to-female transsexual. In the two years since I initiated the research my interests changed as a result of field work, although my research methods did not. As the research progressed, my original premise, that an anthropologist might elicit different information from transsexuals than a medical-mental health professional, as a result of a different role relationship, proved correct. I saw, too, that instead of studying the phenomenon from the clinical and, hence, medico-psychological or etic (scientific outsiders) perspective as a basis of understanding transsexualism, I could include medical and mental health professionals as part of transsexuals' interaction field. Gender dysphoria professionals were an important group in the ethnography of transsexuals written from an emic (insiders) perspective (e.g., how transsexuals perceive their relationship to medical and mental health professionals).[7] After the information was gathered, I needed to make some sense of the data again from an etic perspective, as an anthropologist stepping back and reassessing the relationships of transsexuals to their professional overseers.

It was immersion in the field experience that led to the final approach taken in the present work. The transsexuals' gracious acceptance of me into their support group and their lives allowed me total involvement in their day-to-day experiences, their relationships with each other, the medical and mental health sectors, and society at large.

As I became involved in transsexuals' lives, etiology became only a

minor issue, revealing the relationship of transsexuals to their medical-mental health caretakers. The ethnography began to take form as it became evident that the transsexuals I knew organized their lives around one factor, pursuing womanhood and surgery. The central question then became "how do transsexuals, in spite of male genotype, phenotype, and history, become women?" From my research it became clear that they pursued a common and conventionalized strategy.

Although subscribing to guidelines set by medical policy that outline the formal steps transsexuals must take before surgery, transsexuals through interaction with one another, give content and semanticity to their journey into the female gender. The medical model for becoming a woman is enhanced by transsexuals' own conceptions of the "good, right, and proper way" to broach womanhood. Out of their affiliation with the Berdache Society, norms, rules, myths, and sanctions developed. Medical policy provides transsexuals with a prescribed schedule of events for their passage into womanhood, but transsexuals themselves have added much content, taking medical prescriptions and elaborating and refining them.

The pursuit of womanhood is conventionalized and regularized even further by the meaning transsexuals impute to their experience. Progress toward adopting the female role is imbued with gender denotation expressed ritually and symbolically. Transsexuals are participating in a metaphorical as well as a literal transition to womanhood, in which their male gender is given a death blow symbolically and actually as they don the female role, and are reborn phoenix-like into a new gender through passing, female hormones, and the surgery. The metaphorical becomes real in the transsexual's self-awareness when she feels herself to be a "real" woman upon whom nature has played a cruel joke. Described in these terms, the metamorphosis has all the characteristics of a rite of passage in which identities and statuses are transformed within ritual parameters. The manner in which transsexuals become women is "prescribed, rigid and has a sense of rightness" about it (see Bossard and Boll 1950: 14 on rites of passage).

The rites-of-passage model was originally coined by Van Gennep in 1909 (Eng. trans. 1960) to explain how people cope with change in their lives. This model was later refined by Chapple and Coon (1942). Van Gennep hypothesized that all people experience life crises—situations in which the individual confronts the vicissitudes of biology and culture as a consequence of merely existing. The cultural

solution to changes in status or situation was viewed by Van Gennep as a rite of passage in which transitions between statuses or positions were ceremonialized and ritualized. Ritualization and formalization of rites of passage was seen as a cultural mechanism for easing people into new positions and dissipating the stress and anxiety arising from such changes (Van Gennep 1960: 5).

In the original and subsequent schemes, the rites of passage were divided into three phases: separation, transition, and incorporation or preliminal, liminal, and postliminal rites (Van Gennep 1960: 1–3). Although Chapple and Coon and a few other anthropologists such as Turner (1962, 1974) have expanded and refined this model, not many anthropologists have employed it in complex societies because of the bias that rituals always involve the supernatural and only "primitive" people have a world view that incorporates the supernatural to such a great extent. The handful of anthropologists and others who have taken this scheme and applied it to complex contemporary societies have claimed that secularized societies also have rites of passage (Burnett 1975; Bossard and Boll 1950). These authors note that even in secularized societies change is problematic and solutions may be culturally expressed in secularized rituals.

It seems that transsexuals are people participating in an unusual rite of passage, specifically a rite of transition, as a bona fide category in and of itself with its own phases of separation, transition, and incorporation. I consider it a rite of transition because their progress to womanhood centers around the phase of transition in which they leave the male role and are in the process of acquiring a female role. The phase of separation for transsexuals is not necessarily discrete or prior to transition but is a series of events in which transsexuals symbolically and actually are removed from their previous world as males. The transition phase is a period in which transsexuals are instructed in and learn their new role as women, and prepare to enter society as legitimate claimants to their new status. Incorporation is characterized by the surgical conversion where the neo-vagina is created from male genitalia. They are then more completely integrated into society as women, fulfilling the cultural requirement that women are people with vaginas, and thereby gain access to the most intimate sectors of women's life.

The medical and mental health communities refer to transsexuals who are actively pursuing surgery as being "in transition." Transsexuals

adopt this term also in conjunction with medical-mental health usage. Transition is designed as a specific life phase in the transsexual's career following the recognition of the self as a transsexual. Transsexuals are in transition when they establish a therapeutic relationship, begin taking female hormones, and begin passing as women in anticipation of living and working as females prior to surgery.

In addition to the rites-of-passage model, the theory of symbolic interaction, particularly as it is represented in the numerous works of Erving Goffman, is used. A convenient theoretical overlap exists between symbolic interaction and the rites-of-passage model. For example, Goffman has assumed that ritual and symbol are intrinsic aspects of the conventionalization of human interaction and communication pattern found in contemporary everyday society (1969: 4). In essence Goffman has described the same phenomena and has similar interests to Van Gennep and Chapple and Coon. All were writing about the rituals of social relations. They shared a concern for the meaning that is associated with ritual experiences, although Goffman focused on individuals, and Van Gennep and Chapple and Coon on culture. Goffman's concepts are particularly valuable in understanding the transsexual's right of passage not only as a transition of gender, but as a journey out of stigma (1963).

Incorporating both approaches, the transsexual is viewed here as participating in a rite of transition with all the facets of a ritualistic and symbolic transformation of status. Structure, content, and meaning arise from transsexual interaction patterns and relations with medical and mental health caretakers. Transsexual transition is a process of becoming a female, hormonally and socially. Not only does a social identity transformation occur, encompassing the individual's role, performance, and others' perceptions of that performance, but a personal identity (the individual's self-concept) metamorphosis also occurs as a mechanism of the feedback of the individual and society as the transsexual incrementally becomes female.

Transsexuals are involved in a unique transition in which an "ascribed" or inherited status is disavowed and a new status is coveted. They violate one of the most basic tenets of society, that gender is invariant and cannot be "achieved" or "acquired" (after Linton, see Andreski 1972: 168–69). Their transformation is a multifaceted one in which the unachievable is achieved. By participating in this gender violation, these renegades of the male role paradoxically support the

societal tenet that there are only two genders, and one cannot be in between. Their passage is one into normalcy, where after the surgery, they can disappear into their culture as natural women. The rite of transition is therefore a temporary sojourn of transformation; once they have passed and endured it, transsexuals can assume the status of those born female.

Definitions[8]

A major part of understanding transsexuals as males who feel like females and who dress like women is understanding what they are not. They are not transvestites. The Berdache Society included a population of heterosexual transvestites and these people contributed much valuable information by serving as a vehicle of comparison and contrast with transsexuals. Moreover, transsexuals and transvestites are often confused with another group of people: homosexual cross-dressers ("drag queens" in the gay argot). Because transsexuals, heterosexual transvestites, and drag queens all share the behavior of cross-dressing (wearing the clothes of females), there is a superficial similarity amongst an otherwise diverse group of people. Nevertheless, clarification is necessary to avoid any misconceptions in terminology.

DRAG QUEENS:[9] Drag queen, or the less pejorative term, female impersonator, refers to a cross-dressing role institutionalized in the gay community. Drag queens are a subgroup within the broader gay population, who are at once part of the gay community, yet separate. The boundaries between drag queens and the gay community-at-large are rather fluid as individuals may drift in and out of this subgroup. Drag queens are, however, a distinct group with specific lifestyle attributes. They usually work professionally in their capacity as female impersonators, presenting themselves onstage typically in the image of glamorous movie and recording stars. They are part of a broader group of effeminate men in the gay community known among gays as "queens" or "nellie" men. The most extreme form of being a queen is to be a drag queen. The gay community is somewhat schizophrenic in its attitude toward these men who impersonate women. On one hand there is subcultural support for impersonation as an ability that requires expertise, falling within the larger idiom of "camp" in the gay com-

munity. Camp is "analogous to soul in the black subculture" (Newton 1972: 105). ". . . [T]he essence of camp is in its love of the unnatural: of artifice and exaggeration . . . [I]t converts the serious into the frivolous" (Sontag 1970: 277–78). Dressing as a female is part of a general mode of camp expression. On the other hand, female impersonators are subjected to a great deal of discrimination by the gay community. They embody the stereotype of the homosexual as an effeminate man who dresses in women's clothes. The gay community has the same attitude toward drag queens that heterosexuals take toward homosexuals, ". . . stratif[ying] . . . [t]heir . . . 'own' according to the degree to which their stigma is apparent and obtrusive" (Goffman 1963: 107).

Although gay female impersonators share cross-dressing with transsexuals, they are above all else gay men. Drag queens do not conceive of themselves as females. Drag queens only impersonate women, and do not have a gender identity conflict as do transsexuals. Unlike transsexuals, female impersonators are part of a subculture organized around an unconventional choice of sex object (see Newton 1972). The transsexual research population, in contrast, has formed an association only temporarily held together by the individual's cross-dressing and quest for surgery. Transsexuals eventually cease affiliation with their transsexual sisters and leave the Berdache Society.

Transvestites: Approximately twenty-five transvestites were actively associated with the Berdache Society at the time of my research. Their participation in the Berdache Society was moderated by the desire to cross-dress that varies in intensity during the individual's life. The Berdache Society, with its weekly meetings, provided an opportunity to cross-dress in a familiar and friendly atmosphere. This was particularly important for transvestites whose living arrangements may have necessitated secrecy (i.e., whose wife or significant other did not know). The transvestites in the group were all overtly heterosexual and many were married with children and successful careers. They characteristically had no desire to give up the male role or seek surgical conversion.

Transvestite ethno-theory attributes the pressure to perform aggressively in the male role as a causal factor in cross-dressing. By assuming the female role for an evening or an afternoon, the male role strain, measured in terms of personal stress, may be reduced. A sense of relaxation results from the act of cross-dressing. This is a concomitant

of the stereotypical impression the transvestite has of women since it is assumed that the female role is a passive one with far fewer demands than the male role. When cross-dressing, transvestites frequently reported "feeling like a lady" and they enjoyed being "treated like one." When dressed as a woman, relief from the implicit requirements of the male role was felt. It should be pointed out, however, that in addition to this tension reduction aspect of cross-dressing, a feeling of excitement often accompanies the act.

One possible component of this excitement is its sexual (fetishistic) aspect. This well-reported corollary of heterosexual cross-dressing was certainly applicable to some of the gay transvestites I have known. Another source of excitement is the potential for discovery when cross-dressing in a public place. Transvestites enjoyed recounting tales in which they were in a restaurant or other public setting and escaped detection as a genetic male in disguise. In this way, some of the stigma associated with transvestism can be reversed. Those who would discriminate against the transvestite, if they only knew, were placed in the position of being "fools" because of their inability to recognize a cross-dressed man. In this "passing for fun" (see Goffman 1963: 79, 135), the transvestite derives a great deal of pleasure from fooling the rest of the world. This may also be a mechanism for seizing some form of control or power in a situation of stigma where some status can be gained from successful passing.

Every type of motive for cross-dressing discussed here was found among the transvestites in the research population. As the transvestites themselves stated, "There are no two of us alike." There was a great deal of variation in the population in terms of cross-dressing excitement and presentation of self. Some really passed as women, others enjoyed only partially cross-dressing, wearing panty-hose under a nightgown but without a wig or makeup, or with false breasts under a man's attire.

It is generally agreed among transvestites that one can never cure cross-dressing. The advice given is to learn to live with it and keep it under control. Many a transvestite at group meetings has voiced the opinion that the best way of looking at one's cross-dressing is to consider it a hobby and nothing more.

The most widespread definition of transvestism found in the literature is that the transvestite is someone who obtains erotic pleasure by dressing in women's clothing (Green 1974a: 82; Kessler and McKenna 1978: 14). Money and Tucker (1975), however, provide a

different slant on the definition, viewing him as having a "dual gender identity," almost a split personality. He is ". . . a sort of Dr. Jekyll and Miss Hyde alternation, each with its own name and personality, and with the clothes, voice, gait, and mannerisms to match" (1975: 29).

While there are a number of different ways to experience and express transvestism, reflecting a variety of motives, there is still a major distinction that segregates transvestites from transsexuals. Transvestites do not desire to be rid of their penises and live as women. Zara (the female name of a transvestite in his late forties) described it in this way:

> I have an intense desire to dress up and play the role of a woman occasionally. I thoroughly enjoy the feeling I derive from dressing up and actually playing the role of a woman. Whereas I do not hate the male role I live most of the time, I do enjoy and crave expressing the other part of me which consists of wearing nylons, high heels, skirts and using makeup. I cannot explain why.

TRANSSEXUALS: Through affiliation and interaction within the Berdache Society, emic definitions have originated that polarize transvestism and transsexualsm as two distinct categories of persons with different life goals and strategies. As will be discussed (see chapter six), the Berdache Society operates as an identity broker, clearly segregating transsexuals from transvestites and drag queens. There are no drag queens in the Berdache Society. Self-labeling allows for one of only two possibilites ("TV" or "TS" in the vocabulary of the Berdache cross-dressers) and this serves to strengthen the commitment to a particular category.

The division of Berdache members into either transvestites or transsexuals was part of a system that cajoled those unsure of which label best fits into a decision. This is not to say that there was no identity and behavioral continuum of cross-dressers with people falling somewhere in between transsexualism and transvestism as defined here. But in the Berdache Society, transsexualism and transvestism were regarded as non-overlapping and distinct categories; people should be one or the other.

Benjamin proposes a typology of transvestism and transsexualism that represents a continuum of cross-dressing behavior and gender identity. Based on research on over 200 clients, he suggests that trans-

sexualism and transvestism are ". . . symptoms or syndromes of the same underlying psychopathological conditions, that of sex or gender role disorientation and indecision" (1966: 17–19). His continuum consists of six types of cross-dressers organized into three groups. Group 1 consists of three types of transvestites (the Pseudo TV, the Fetishistic TV, and the True TV). This group of people appease their gender confusion by cross-dressing. Group 2, type IV, is the Nonsurgical Transsexual. According to Benjamin, "group 2 constitutes a more severe stage of emotional disturbance." These people are intermediate between transvestites and transsexuals. This type is characterized by the need for more than cross-dressing and desires some physical changes, such as those produced by taking female hormones. Group 3, type V, Moderate Intensity TS, and type VI, High Intensity TS ". . . constitute fully developed transsexualism." These individuals desire to live in the female role and, characteristically, desire surgery (1966: 18–22).

Despite elaborate categorization and syndrome explication, the final and ultimate criteria for transsexualism are the individual's desire and request for surgery. Although Benjamin's continuum suggests a quantitative difference in gender identity confusion and the pursuit of surgery, transsexuals regard the latter as a qualitative difference between transsexuals and transvestites; for if a person is not willing to move heaven and earth in quest of surgery, and lets age, finances, marriage, or other excuses prevent him from transition, then transsexuals regard that individual as a transvestite.

Clinicians must also rely on self-reports of transsexualism for evaluation purposes. Kessler and McKenna point out that projective tests attempting to assess identity are methods of ascertaining stereotype endorsement. They believe "[t]he only way to ascertain someone's gender identity is to ask her/him" (1978: 9). It is the transsexual's feeling that she is a female trapped in a male body who cannot continue to live as a man that distinguishes the transsexual from the transvestite. The transsexuals in this research population were all in various stages of transition into the female role. They were people with a goal and a strategic plan for reaching that goal.

The transsexual strategy for sex reassignment includes: counseling or therapy in order to achieve the all important psychological evaluation whereby the request for surgery is legitimized by a mental health professional, living and working in the role of the female or assuming

the female role part-time but anticipating full-time involvement, electrolysis (removal of hair in the male growth pattern), and hormone therapy (female hormones of the estrogen and/or progesterone type). Some preliminary surgery may be undertaken such as bilateral castration, facial cosmetic surgery, trachial shave, and/or breast implants.

Transsexuals differ from transvestites in other significant ways. Their sexual object choice varies; some prefer men, some women, and some are bisexual as opposed to heterosexual transvestites. Their gender identity as female is a disparate, discrete entity from their sexual object choice. Unlike transvestites, their affiliation with the Berdache Society was not organized around heterosexuality, which is why transvestites participated in the Berdache Society and not the gay community. Transsexuals reject the gay community because they are not homosexual men. If they are homosexual at all, then some of them are lesbians, based on their female gender identity and sexual interest in women. Unlike transvestites, transsexuals never pass (present themselves as genetic women) just for fun. Transsexuals don women's apparel in order to foster isomorphism between their female identity and somatic presentation. For transsexuals, successfully passing as women is a critical test of their eligibility for surgery.

Quotations from several transsexuals seem a fitting way to conclude this section on definitions, as perhaps there is some truth to the transsexual axiom that "you really have to be there to understand what it means to be a transsexual."

Eunice, a transsexual living and working in the role of a woman for over two and a half years, stated that:

> A transsexual is a person whose mind, thoughts, feelings, soul if you will, are in opposition to his or her physical body. This person usually has a clear psychosexual identity, but the disharmony of body to this identity is endless frustration. The only solution to this situation is for the person to have body altering surgery, thus matching as best as can be done the mind and the body.

Amara, a transsexual recently living in the role of a woman full-time, observed:

> A transsexual wants to be a member of the opposite genetic sex; clothing may be enjoyable but is not a motivator. Sexual pleasure

is derived from activity ascribed to the chosen genetic sex. Gay, straight, or bisexual are all possible if viewed from the adopted sex.

Sasha, director of the Berdache Society and living in the female role for two years, said that:

Because of my transsexualism I have suffered, but I also have learned many wonderful things about life and the human spirit. I have learned to accept my condition and to love myself. I think of myself as a woman whose condition can be corrected through surgery.

One transsexual wrote a most poignant letter to a female friend explaining her transsexualism. It was written four years ago.

You read me fairly well on our brief reunion. I am very depressed, and yes possibly somewhat lost at this point in my life. However, I think most people would never come close to my source of trouble. I feel I must write to you and inform you of what and where my head is at right now. What I am about to tell you will probably be the mind blower of all time—seriously! I want you to realize that because of that super week we had together and because of the way the future looks I feel obligated to write this letter. This is by far one of the most difficult things I have ever done—something only five other people that have crossed my life have even known about.

I am a transsexual. That is a person who feels he is in the body of the wrong sex. I have had this internal war—and I do mean war—going on inside of me since I was 5 or 6 years old. I desire very strongly to live as a woman. Incredible? Believe me, it has been living hell at times. It is only because of my huge size and masculinity that I haven't pursued a sex change operation. This relationship I have with Margaret is far from what the average person thinks it is. I finally told her everything about me. She still wanted to be with me in spite of the fact that I wear female clothing part of the time. We have been together for two and a half years now, and the warmth that once filled our relationship is gone.

I have mental powers far above the average that have kept me from coming apart—but I'm becoming weak. Margaret allowed me to dress as a woman as often as I wanted to—well nearly. She loves me so much that she has endured this punishment for all this time. I feel she thought she could cure me with time. Just this moment

she came home—I'm dressed as a woman now—icicles!!! She wanted me to go out to eat with her, but when she saw I was dressed she just left again. Does that give you any idea of how terrible this whole business is?

I've still got a full beard right now, so I look kind of strange when I dress up. Margaret really likes my beard and body hair—the very things I despise. So when I shave my beard, I can dress and make the complete change into the world of the feminine, and I also lose a lot of the "symbols" of my masculinity at the same time. I have a female wardrobe that is nearly twice as large as my male one. Seriously. The transformation is quite dramatic. I am quite good with makeup and stuff. I go out in public on occasion—only the times I don't have a beard. I have to dress as often as my male life will allow—certainly not a good thing to be in a relationship if the other partner isn't enjoying it too. I am *not* a *homosexual* and have never been. My true feelings toward sex would be to make love as a woman—beyond that I couldn't say.

This is not some sort of illness I have. I feel it is the result of all the things I was exposed to in my early years. If one thinks about his or her sexuality one notices that the things that make a female a woman are things that they are taught from birth on. So, the things that make my male body a man are also learned. Interesting isn't it? When I dress I feel awkward because I never learned all the little things girls are taught. I am much improved in mannerisms as compared to a few years ago since appearing in public forces one to learn fast or get in trouble. Several years ago I was living with roommates. Since I could never dress during normal hours, I would get up at midnight or one and dress. I would then go to a park just to sit by the water. I did this every other night. This was my only form of release and it often was my only moment of rest, as I would stay out till sunrise. The park closes at 10:30 so I shouldn't have been going there. Plus, women just don't go to parks at 3 in the morning. I got caught by the police and arrested. In those days it was against the law for a man to appear in public dressed as a woman. The police made me take all sorts of psychological tests and I had to see a shrink—plus one year with a probation officer. I swore off dressing and threw away hundreds of dollars worth of female clothing. That's when I grew my beard as a deterrent. It lasted three years with hardly an incident. But, I just got depressed beyond belief.

About the time you last wrote I had decided I was going to let this female thing out and see why it had this power over me. That's when Margaret showed up. Somehow we both needed each other then. My strength and gentleness were what she needed. She offered me the chance to dress in front of someone in a non-hostile environment then. I might have even thought she was the girl that was going to snap me out of all of this stuff. . . . But it didn't work.

I hope this letter hasn't shattered your feeling for me as I treasure what we had. I just didn't want you coming here without knowing about me.

Since writing this letter, she has successfully managed to live and work as a female. At the time of this writing she was cross-dressing on a parttime basis. The letter itself was never sent as it was just too frightening a thing for her to confess at the time.

Notes

1. Feminine pronouns are used in reference to transsexuals throughout this work, in keeping with their self-definition as "women trapped in male bodies."
2. Berdache is a term found in the anthropological literature that refers to a cross-cultural institutionalized role in which the occupant dresses in the clothing of the opposite sex and may adopt certain opposite sex role behaviors. Another pseudonym I have used previously for this transsexual-transvestite support group is the Cross-Dresser's Society.
3. "[G]ender identity: The sameness, unity, and persistence of one's individuality as male or female (or ambivalent), in greater or lesser degree, especially as it is experienced in self-awareness and behavior" (Money and Ehrhardt 1972: 284).
4. Pomeroy reports a range of male to female ratios found in the literature. These include 50:1, 15:1, and 4:1 (1975: 217). Green calculates figures as high as three to six males for every female (1974: 14), while Walinder suggests the equivalent ratio of 1:1 (in Pomeroy 1975: 217). Pauly's 4:1 ratio is frequently cited and referred to in the literature (1969: 56; Raymond 1979: xxi).

Green accounts for variation in the number of males vs. females desiring sex conversion in four ways:
 a. Neuroendocrinologists point to the greater chance of errors in psychosexual development of males in consequence of the additional component necessary for masculinization, the gonadal hormone.

b. Females are allowed more latitude in cross-gender behavior. It is less necessary for them to seek radical means of disguise.

c. The first person the child identifies with is the mother and a subsequent shift in identity is required only of males.

d. There is a technical limit in the surgery. As one surgeon states: "It's easier to make a hole than a pole" (1974: 101).

5. Estimates of transsexuals in the total population also vary. In Sweden Walinder reckons 1:37,000 for males and 1:103,000 for females (in Pauly 1969: 57). Pauly proposes the ratio of 1:100,000 for males and 1:130,000 for females (Pauly 1969: 56; Pauly 1974 in Masters, Johnson and Kolodny 1982: 219).

6. Benjamin does, however, note an earlier use of the term transsexual: "[the] late Dr. D. O. Cauldwell had related in *Sexology* magazine (Cauldwell, 1949) the case of a girl who obsessively wanted to be a boy, and he called her condition 'psychopathia transsexualis.' Whether I had ever read that article and the expression had remained in my subconsciousness, frankly, I do not know" (1969: 4).

7. There are several different usages for the terms "emic" and "etic." I use them as they have been traditionally defined by ethnographers.

> Emic: A research strategy that seeks the native viewpoint; relies on informants to say what is and isn't significant; actor oriented.
> Etic: A research strategy that relies on scientist's criteria of significance; shows reasons and results of behavior and beliefs that natives may not recognize; observer oriented (Kottak 1982: 491).

8. Portions of the definitions of transvestism and transsexualism were originally presented in Anne Bolin, "Advocacy with a Stigmatized Minority," *Practicing Anthropology* 4, no. 2 (1982): 12–13.

9. Information about drag queens was collected as part of an investigation of a gay male community and subsequently presented in my Master's Thesis: *God Save the Queen: An Investigation of a Homosexual Subculture* (1974). See Ch. VI, "Variation: Gay Lifestyle Alternatives," pp. 129–45.

TWO

Perspective

The present study was stimulated by an etiological model of gender dysphoria. But I found myself, upon entering the field, asking basic *ethnographic* questions and beginning to take a sociocultural approach to the subject of transsexualism. As the research progressed, it became obvious that the genetic males I was studying focused their lives around one issue: becoming women. If they were not already in a process of transformation from their male *social* personae, they were anxiously anticipating when they could begin the process. Their gender metamorphosis provided a new slant on the traditional ethnographic "womb to tomb" description as it was inverted for the purposes of this research. It became apparent that I was watching a "tomb to womb" transformation; males died a social death and were reborn as women. This death and rebirth was symbolic and actual as the transsexuals severed themselves from a male past, forged new identities as women, and feminized their bodies through a hormonal management program. The culmination of this process was surgical conversion.

As I became increasingly immersed in the lives of the transsexuals, and the passage of time facilitated retrospective analysis of the indi-

vidual's pursuit of womanhood, I was able to comprehend an orderly stage of progressions. This conformed to transsexuals' perceptions of their transition as a series of stages in which womanhood emerges. In sorting out the salient features of their transition and the social and structural relations impinging on their status change, a number of significant factors became apparent. Medical policy very obviously imposed a system for organizing and moderating the transsexual's journey into womanhood, for without medical and mental health supervision and evaluation the transsexual cannot qualify for the sex-change operation. Medical policy clearly imposes a series of agendas outlining steps and events and ultimately provides sanctions and a formalization of procedures that must be followed. Thus medical policy presses a structure upon the transsexual's transition from male to female.

Yet this alone cannot account for a rich, shared cultural meaning of gender-to-gender experience common to transsexuals. Their association with one another as part of a social network whose interconnectedness was facilitated by a local support group, the Berdache Society, was a powerful factor contributing to the structure and content of the transsexual's transition.

I found myself, therefore, describing a gender transformation that has formal and informal parameters. The informal parameters of meaning, norms, rules, rituals, and folklore derived from transsexual association are as significant as the formal medical parameters in shaping the way the transsexual becomes a woman. In this way, transsexuals actively participate in creating a set of rules for the proper way a man is transformed into a woman.

In order to interpret, analyze, and explain the transsexual's gender transformation and go beyond an emic description and analysis, a theoretical orientation for transforming emic information into an etic analysis is necessary. This is provided by the rites-of-passage model originated by Van Gennep in 1909 (English translation 1960) and later refined by Chapple and Coon (1942) and several of the symbolic anthropologists, most notably Turner (1967).

The rites-of-passage model offers a trifold conceptualization of stages: separation, transition, and incorporation, that accompany status changes (Van Gennep 1960; Chapple and Coon 1942). It seems more than appropriate for transsexuals who do indeed separate themselves from their prior world where they were men, undergo a transition where they, through a series of stages, gradually adopt the female role

until they assume the role completely, and finally are incorporated into society as women through the sex-change operation that gives them access to areas of interaction previously denied (e.g., sexual intimacy as women).

The rites-of-passage model very elegantly provides a framework for understanding the dynamics and processes of the transsexual's transition from male to female. This model is a significant asset in revealing the cultural components of the transsexual's passage into womanhood.

In addition, I have found symbolic interaction a valuable interpretative and analytic tool in combination with the rites-of-passage model. Symbolic interaction (devised by G. H. Mead in 1934), as it is presently articulated in the works of Goffman (e.g., 1963), is particularly useful in examining transsexual rites of passage for two reasons. First, it shares some of the underlying assumptions of the rites-of-passage model and therefore meshes rather well. Second, it can help explain the personal and social identity transformations that accompany status change, and in this case it incorporates stigma as an important fact of the transsexual's transition.

A synthesized rites-of-passage model with the symbolic interactionist approach results in a focused ethnography with descriptive, interpretive, and explanatory components in which an emic analysis is enhanced and given wider conceptual power through incorporation of etic formulations. The following sections provide a brief review of the rites of passage model and symbolic interactionism, highlighting the major points and precepts of each. A discussion of the synthesis of the two concludes the presentation of the perspective employed in this study of transsexuals.

Rites of Passage

The rites-of-passage scheme is a potent analytic tool first outlined by Van Gennep (1960). Very simply, Van Gennep devised the rites-of-passage system as a tripartite model accounting for the ordering and patterning of the ritual and ceremonial life of non-technologically complex peoples who are confronted with the inevitability of unsettling biological and social change. Van Gennep (1960: 3) summarizes the underlying premise for his framework in the following:

Transitions from group to group and from one social situation to the next are looked on as implicit in the very fact of existence, so that a man's [and a woman's] life come to be made up of a succession of stages with similar ends and beginnings: birth, social puberty, marriage, fatherhood and motherhood, advancement to higher class, occupational specialization, and death. For every one of these events there are ceremonies whose essential purpose is to enable the individual to pass from one defined position to another which is equally well defined.

Van Gennep's rites-of-passage scheme is a suggestive framework for viewing and interpreting the similarities in ceremonial and ritual activities that indigenous peoples devise to cope with the life crises associated with change in social position in the group. These are conceived of as rites of passage that mark an individual's transition from one social world to another. According to Van Gennep, rites of passage in their complete form have three distinct phases, each of which may in itself be a bona fide rite; thus a rite of transition could have its own three phases of separation, transition, and incorporation (1960: 12). Each of the three phases marks the individual's change of status in the group and is imbued with supernatural and symbolic components that dramatize the phases of the neophyte's social movement.

The rites of separation symbolically remove "an individual from a previous world." The transition rites or "marge," in Van Gennep's original usage, are liminal, or "threshold," rites that prepare an individual "for his or her reunion with society." The rites of incorporation or "aggregation" are those which integrate the status passenger back into his or her society or group.

Incorporation may be a physical return of a neophyte to group and/or village life from which he or she may have been physically removed through a rite of separation and/or symbolically removed, but it is primarily a social return. The rites are construed by Van Gennep as expressive metaphors of change of social position saturated with symbols of "death, rebirth, and resurrection" (1960: 21, 46, 67).

Having devised this conceptual framework, Van Gennep interpreted the importance of symbolic expression as reflecting and ramifying the basic tenets of cultural life which are "to separate and to be reunited, to change forms and conditions, to die and be reborn." Van Gennep

was furthermore interested in the "patterns and significance of rites of passage as ritual solutions to the problems of human change and movement and their relations to the total ritual and ceremonial practices of the people" (1960: 189, 191).

Although the rites-of-passage model is certainly a major contribution of both idiographic (case studies, descriptive) and nomothetic (universal laws) value, it was not until 1942 in the work of Chapple and Coon that any serious application and refinement of the model was advanced. Chapple and Coon continued Van Gennep's interest in the ritual and symbolic components of rites of passage. They, however, focused on the significance of social relations which underlie the tripartite scheme (Posinsky 1962: 387).[1]

They regarded changes in personal and social relations in society as inherently disturbing and, in keeping with this argument, considered how elements of symbolism in the rituals and ceremonials in rites of passage eased and facilitated individuals' transitions from one position to the next and enhanced the capacity of the broader cultural group to adjust to these disquieting changes (Chapple and Coon 1942: 308). The individual benefited personally from the ritual and symbolic components of a rite of passage that provided him or her the opportunity to practice and learn about the new social relations associated with change of status (1942: 485). The ritual and ceremonial aspects were considered by Chapple and Coon as crucial mechanisms "for transporting an individual from a previous state of equilibrium to a final state" (1942: 484).

Van Gennep's and Chapple and Coon's subsequent refinement of the model has been largely neglected except by the school of symbolic anthropology, and by some anthropologists working in American culture. The symbolic anthropologists' contribution is specifically related to their interest in the ritual and ceremonial aspects of rites of passage. Although there are a number of prominent anthropologists absorbed with the symbolic aspects of ritual (e.g., Geertz 1972; Douglas 1973; Needham 1973), Victor Turner's work (1962, 1967, 1969, 1974) is particularly relevant because of his concern with rites of transition. Turner has labeled the rite of transition as a liminal rite. He considers it a special phase of transition in which the individual is in a process of transformation: a "becoming" by a neophyte who is in a unique but temporary cultural position of being "betwixt and between" statuses (Turner 1967: 93; 1974: 13, 14, 231–33; Middleton 1973: 388).

Although the rites-of-passage model, as first devised and later revised, appears to be a valuable heuristic device for conceptualizing change of status, it has not gained in popularity nor has it been applied to societies other than tribal and peasant groups, except in a handful of cases. This is no doubt due in part to the fact that Van Gennep originally applied his model to technologically simple societies and himself felt that rites of passage were limited to these types of societies. Rites of passage in such indigenous groups have come to be associated with the transformation the neophyte undergoes symbolically as he or she leaves a profane and secular world or plane of existence and enters a sacred state (Kimball 1960: viii). Ritual and ceremony have been regarded by anthropologists as inextricably tied to the sacred and supernatural which are, in turn, considered pervasive components of the cultures of nontechnologically complex people. By this line of reasoning it has been assumed that since contemporary western societies are secular in orientation, they are devoid of ritual or vice versa (see Gluckman 1962: 1–52 for arguments against ritual in contemporary society). Burnett (1975: 43) believes it is just this type of thinking that has inhibited anthropologists from applying the rites of passage scheme to contemporary urban life.

Whether from an unconscious or conscious elitism or from the idea that secularism and ritual are mutually exclusive, Chapple and Coon's (1942: v) position, that theoretical and conceptual frameworks that seem to apply in understanding the machinations of "primitive" society should also be apropos in our own, has been largely ignored until very recently. Yet Kimball, in the introduction to the English translation of Van Gennep's work, reiterates Chapple and Coon's request for a further examination of rites of passage beyond the "primitive" milieu. Kimball suggests that rites of passage should be investigated in an urban setting (1960: xvii, xxvi), and that these rites

> deserve attention themselves. The critical problems of becoming a male and female . . . are related to societal strategies to adjust to new status . . . [Furthermore Van Gennep's] analysis of rites of incorporation is valid for understanding the problems associated with the "alienated" and "unclaimed" of modern societies.

Within the last three decades, there has been a renewed interest in rites of passage, ritual, and ceremonial in contemporary urban Amer-

ica. These studies reflect a new conception of ritual and ceremony as secularized or "desanctified" (see Burnett 1975: 44). Nadel, for example, defines ritual as: "any type of behavior [that is] stylized or formalized, and made repetitive in form" (1954: 99 in Burnett 1975: 44). Others such as Goody have followed suit, viewing ritual as a general category of action (1961: 142–64 in Burnett 1975: 46). There is also Montague and Arens's concept of ritual as a "standardized performance" (1981: x) and Turner's view of rituals as a symbolic expression or statement of the individual's perceptions and feeling about his or her world and its natural and cultural relations (1969: 61). Posinsky (1962: 388), on behalf of secularized rituals, maintains:

> It cannot be argued too strenuously that ritual is not merely an exotic, archaic, or reactionary accretion to technology but a universal process and aspect of culture, which by reinforcing technological adaptations (and the related social interactions and values which stem from technological adaptations) is directly involved in group and individual survival.

These definitions share the supposition that ritual is not necessarily religious and therefore is a perfectly useful construct for analyzing social relations and beliefs in urban American society. By freeing ritual and ceremony from religion, a number of authors have provided interesting studies on American society and the secular rituals of social relations (e.g., Montague and Arens 1981; Spradley and Rynkiewich 1975). The rites-of-passage model also benefited from the desanctification of ritual, and several authors have applied the rites-of-passage scheme to contemporary America. Burnett utilizes the rites-of-passage model in understanding the student system in an American high school (1975: 43–54). Fiske (1975: 55–68) regards football as a rite of passage from boyhood into manhood, and Schwartz and Merten's (1975: 195–212) study of high school sorority initiation rites also includes Van Gennep's concept of separation. These analyses suggest the relevance of the rites-of-passage model for elucidating phenomena in contemporary American society, including transsexual rites of passage.

Symbolic Interaction

Erving Goffman, although not the founder of the school of symbolic interaction, was certainly one of the most well-known proponents and

popularizers of the approach (see Goffman 1961, 1963, 1967, 1969, 1970, among others). Goffman was untroubled by anthropological reluctance to examine secularized rituals, and with little ado, Goffman did just that by conceptualizing secular rituals in much the same way as the anthropologists cited previously (e.g., Nadel 1954; Arens and Montagu 1981). Goffman's definition of ritual (rather elusive if one seeks an exact statement) emerges as congruent with Burnett's secularized anthropological definition of "formalized interpersonal behavior" (1975: 46). For Goffman, rituals are firmly entrenched in the social relations of interaction. Like the symbolic interactionists preceding him, his focus is on individuals whose statuses and identities are actively and creatively negotiated in ritualized and standardized presentations. People are the dynamic facilitators of their cultural environment as it is translated, manipulated, and given meaning in human interplay.[2]

Social relations are viewed as the continual process of interpretation of others' actions and self's actions in which meaning is an essential attribute of this process. People are envisaged as active participants in their cultural matrix in which meaning is not merely superorganically imposed but inculcated by individuals "creating their social reality and sense of self as they engage in community life and as they interpret and evaluate the meaning of their interactions with others" (Kaufman 1981: 54).[3] Thus symbolic interaction as a school of thought focuses on the dynamic aspects of the creation of meaning and as an ongoing *modus operandi* of the self (see also McCall 1966 and Blumer 1969).

This school of thought has also made another major contribution, that of putting the "symbol" in symbolic interaction which is characterized by Goffman's recognition of ritual in everyday life. Goffman is most notable for having emphasized the importance of symbolic associations in the interaction process. Although concern with the symbolic response of the action in society is not new in understanding behavior, as the symbolic anthropologists testify, it is an important addition to contemporary studies of people in complex societies. The concept of rituals in everyday life emerges as a component of symbolic interaction in which conventionalized expressions of meaning are presented.

Goffmanesque postulates of symbolic interaction have already been established in the literature as a worthwhile way of looking at the transsexual's gender journey (discussed in the Appendix).[4]

This investigation continues in the tradition of work on transsexuals that incorporates concepts formulated by the school of symbolic interaction.

A Synthesis

Several of the sociological treatments of transsexualism have referred to the transsexual's transition into womanhood as a rite of passage. Garfinkel (1967: 116), Kando (1973: 5), and Feinbloom (1976: 174) all make reference to the transsexual as participant in a "status passage." Yet none of these researchers extends the notion of status passage to include the anthropological rite of passage as a tripartite scheme. The term "status passage" as opposed to "rite of passage" underplays the profound and dramatic change transsexuals undergo as they journey into a new gender and experience what for most humans is ineffable, knowing what it is like to be both a man and a woman. The symbolic facets of the transsexual's transformation, the meaning they give to the shared experience, the ritualization of the gender change and beliefs inherent in the foregoing can all be more clearly expressed by the broader concerns of the rites of passage model than in the concept of status passage.

Combining the rites of passage model with symbolic interaction yields a greater understanding of the transsexual's transition into womanhood than either analytical tool used independently. Thus a broader analysis is possible since a more holistic view of status change is fostered because both cultural dynamics and individual interactions are taken into account. This is possible because the two approaches are complementary and share basic assumptions and precepts.

Anthropologists tend to focus their interest on the cultural meaning of the symbolic aspects of rituals and what these reveal about the change of status. However, a status transformation also includes the personal and private sector as well as the sociocultural facets of face-to-face interaction with others. The school of symbolic interaction focuses on the identity transformation of the individual using the concept of the personal identity.[5] Personal identity is the individual's self image or concept of "self," which is active, self aware, and conscious of the social persona. The self also interacts with its situation and context by having the ability to see the self through other's eyes. In this way social

identity feeds back into personal identity (i.e., Cooley's [1920] looking-glass self) and an aware personal identity in turn manipulates social identity. Status change as the organizing principle of the rites-of-passage model can therefore be augmented by including identity as an active and reflective agent.

The rites-of-passage model in turn enhances this perspective by adding the cultural component to symbolic interaction. A symbolic interactionist's analysis posits that all meaning derives from interaction and underrates the power of existing cultural symbols and metaphors, which have a significant impact upon social identity as well as personal identity. Yet the rites-of-passage model and symbolic interaction are complementary because they share many of the same underlying assumptions and premises, although there is little evidence of any interdisciplinary and theoretical cross-fertilization between the two approaches by the later proponents of each (see n. 5).

Symbolic interaction has come to be associated with the dramaturgical metaphor. People are perceived as actors involved in self-conscious performances of status presentations (Goffman 1963: 100). Yet this premise, upon which much of Goffman's interest with symbol and ritual lies, was voiced much earlier by Chapple and Coon (1942: 405) in their statement: "A context of a situation may be compared to the stage properties in which an act or a drama takes place." This perspective, in which rituals are viewed as dramas of group relations, interlaces with the symbolic interactionist perspective by focusing on the acting out of these relations and belief systems.

Other sources of compatibility between the rites-of-passage model and symbolic interaction reside in Goffman's (1963: 32) thesis of the moral career of an individual in which life strategies and experiences are represented by stages, phases, and cycles replete with agendas and career plans (see also McCall 1966: 244–45). It takes little imagination to see that the rites-of-passage model that describes ways in which people move and change statuses in primitive societies can be conceived in modern interactionist terminology as native careers or vice versa.

At the root of Chapple and Coon's (1942: 418) as well as Turner's (1967: 93) formulation of rites of passage is the notion that change in status is problematic. The symbolic interactionist equivalent of this is that interaction is problematic when identities or statuses become questioned (McCall 1966: 95) (i.e., the social identity includes roles and

statuses). While the symbolic interactionists regard change as problematic because interaction between individuals and others is disrupted when identities are impugned, Chapple and Coon (1942: 36–42) introduced the idea of interrupted rates of frequency of interaction in rites of passage as culturally troublesome.

Like Goffman (1967: 19) and McCall (1966: 64, 88), but anticipating them, Chapple and Coon saw interaction as intimately tied to the smooth functioning of social relations. Chapple and Coon (1942: 540) proposed that regular rates of interaction between the individual and the other members of society were disrupted due to status change. The difference between the two is in the domains affected by the disruption. The anthropologist is focused on the group affected while the symbolic interactionist is more concerned with the individual.

Embedded in the idea of interaction and disruption as a result of status or identity change, is the theme of disequilibrium in social relations (Chapple and Coon 1942: 418). Again, the domains affected by disequilibrium reflect the anthropologist's interest in cultural dynamics and the symbolic interactionist's interests in the vicissitudes of face-to-face interaction. Rituals are regarded by the anthropologists concerned with rites of passage and symbolic analysis as the cultural solution to disequilibrium caused by change. For symbolic interactionists like Goffman, individual rituals in presentation of self are used to maintain the delicate balance in the interaction sphere where identities are negotiated so as to maintain an even flow of social discourse. Both approaches regard ritual expressions as pivotal mechanisms in fostering equilibrium in social relations and exacerbating the problematic nature of disequilibrium. Thus, rituals in the cultural setting are thought to bring about and ease transitions into and between statuses, just as conventionalized behaviors between individuals, ritualized and repeated in various circumstances, are seen to inhibit conflict in interaction caused by evidence of a discrediting social identity attribute.

Finally, the rites-of-passage model and symbolic interaction acknowledge the importance of symbol in public presentations and encounters (Van Gennep 1960: 3; Goffman 1963: 25–28). As the indigenous neophyte is presented with symbolic expression of his or her new status, such as symbolic death and rebirth (Turner 1967: 96–97), so the contemporary American choreographs a symbolic presentation of his or her social identity (Goffman 1963: 100). Implicit

in both approaches is a notion that symbolic expression is intimately interconnected with interaction as a component of status or identity reference (Chapple and Coon 1942: 460–72; Goffman 1963: 42–43). Symbolic referents are considered representations of human relations. The symbols expressed in rites of passage have referents to past and future statuses and affiliations just as symbolic expressions in inter-action rituals have reference to statuses and affiliations negotiated by the actor to establish, facilitate, and lend credibility to his or her presentation of the social self (Chapple and Coon 1942: 505; Goffman 1967: 77; McCall 1966: 223).

Notes

1. Chapple and Coon refined Van Gennep's conceptual scheme in two important ways. By concentrating on social relations as underlying the expres-sion of rites of passage, they added rites of intensification as a conceptual framework for expanding the life crisis to include the whole human system (i.e., cultural group) that may be affected simultaneously by external sources of potential conflict such as environmental change. They also retained and refined rites of passage as a model for explicating individuals' life crises, which they continued to view as the result of internal social change that affects the individual and as a consequence the group. While rites of intensification are not appropriate to this study, their elaboration of the rites-of-passage frame-work is; particularly as they integrated the concept of rates of interaction to add to the interpretive vigor of Van Gennep's three-phase model.

The concept of interaction rates added a dynamic facet to the model and brought human relations explicitly into the cultural system. Separation was viewed not only in symbolic terms but also as a phase in which interaction was reduced or completely eliminated between the neophyte and his/her previous field of social relations (Chapple and Coon 1942: 48). In transition the individual interacts with the new system of which he or she will eventually become a part, and finally in incorporation the individual is returned to his or her previous field and rate of interaction, but in a new status and new field of symbolic relations between people (1942: 506). Chapple and Coon's conceptualization of interaction rates is intricately tied to the notion that change can be disturbing to individuals in society. Consequently, when rates of interaction are disrupted by rites of separation, and changed in the rite of transition, then equilibrium will be restored through incorporation when the individual is returned to his or her former rate of interaction (Chapple and Coon 1942: 418).

2. Goffman's perspective is in the tradition of G. H. Mead who is credited with establishing the symbolic interactionist school of thought in his work, *Mind, Self and Society* (1934). He contributed the concept of the "self" as an important dynamic in understanding interaction, and interaction itself as crucial in the ascription of meaning as an experiential domain (Blumer 1969: 5). The self as a self-conscious, interpretive facet of the individual who is able to separate him/herself from others, yet has the capacity to take the part of the other, is considered the significant variable in understanding the dynamics of meaning in the interactive process (Blumer 1969: 80). Mead's three underlying premises which characterize the school of symbolic interaction and the relations of self, interaction, and meaning are as follows (Blumer 1969: 1):

1. Human beings act toward things on the basis the meanings have for them.
2. The meaning of such things is derived from or arises out of the social interaction that one has with one's fellows.
3. These meanings are handled in and modified through, an interpretive process used by the person in dealing with the things he [she] encounters.

3. Because people are active, not only reactive, agents in the creation of meaning, their situation and context or the social environment in which they interact assumes meaning also as part of the interpretive process (Kaufman 1981: 54).

4. Kando (1973), Feinbloom (1976), and Kessler and McKenna (1978) have found Goffman's (1963) symbolic interactionist's approach to stigma a fruitful perspective in describing the dynamics of the transsexual's transition. Their application of Goffman's (1963) concepts of identity (actual, virtual, social, and personal), role relations and expression, context and passing, to name a few, have contributed greatly to the understanding of the transsexual's identity and role transformations and adaptation to the female role both pre- and postoperatively.

5. Schwartz and Merten's (1975: 195–212) analysis of a high school sorority's initiation rites provides an excellent symbolic interpretation of the rituals of social identity transformation as well as a revealing insight into how personal identity figures in the process of status transformation. This study represents the value of combining the anthropological rites-of-passage approach with its emphasis on symbolic and ritual components from a cultural point of view, with principles of personal and social identity established by the school of symbolic interaction.

THREE

Hanging Out: The Art and Method of Participant-Observation

The anthropological method of participant-observation fosters a relativistic perspective. It requires that one become a part of the lives of the people one is studying. It is the elegant art of "hanging out" and becoming entrenched in the lives of the observed. By becoming involved in the social relations of people one is investigating and by getting to know them intimately as people, real rapport can develop and insight gained, above and beyond that gleaned by survey and short one-shot interview techniques.

The ethnographer becomes a special kind of insider. Simmel's concept of the stranger seems most analogous to the role of ethnographer who is both inside and outside by virtue of his or her quest of a scientific and objective understanding. Simmel's (1950: 402–04) stranger embodies this opposition as a

> person who comes today and stays tommorrow. He [she] is, so to speak, the potential wanderer. . . . he [she] is fixed within a particular spatial group, or within a group whose boundaries are similar to spatial boundaries. But his [her] position in this group is determined, essentially, by the fact that he [she] has not belonged to it

from the beginning. . . . For, to be a stranger is naturally a very positive relation; it is a specific form of interaction. . . . The stranger, like the poor and like sundry "inner enemies," is an element of the group itself. His [her] position as a full-fledged member involves both being outside it and confronting it. . . . [The] synthesis of nearness and distance . . . constitutes the formal position of the stranger.[1]

Simmel (1950: 404) continues his discussion noting that the stranger is an individual who has a certain objectivity which "does not simply involve passivity and detachment; it is a particular structure composed of distance and nearness. . . ." "Distance and nearness" is perhaps the crux of participant-observation. This type of juxtaposition, which represents a synthesis of the emic and etic perspective, has been termed "disciplined subjectivity" by Bateson (1980: 272), "empathetic observation" by Schwartz and Schwartz (1955: 351), and "reflective subjectivity" by Warren (1974:168). Warren's definition of reflective subjectivity characterizes the essence of these conceptualizations of participant-observation: "Reflective subjectivity acknowledges the humanness of the [social scientist] . . . while increasing the reflective observation of everyday life through special training and special tools such as field notes and interviews" (1974: 168).

Needless to say, the ethnographer engaged in this form of research is in a double bind. If one does not become involved in the lives of the research population, one is not likely to get honest answers to questions, but then affective involvement with the research population calls into question the scientific objectivity of the researcher (Humphreys 1970: 25). The desirability for an optimum balance between detached and affective participation and a balance between the "personal and objective" approach to research has concerned anthropologists for many years (see Honigmann 1978: 302–29).

While anthropological research may not always achieve this delicate balance of nearness and distance, it is an ideal for which to strive. Participant-observation was the method of choice for my work.

The Field

My entry into the world of transsexuals began on a December evening in 1979. I was anxiously awaiting three people whom I had not met

before. They were guest lecturers who were to present a discussion at a gender workshop I had organized. When they came to my office I scrutinized them closely looking for clues as to their "real" identities, for I knew one of these people was a transsexual. The other was a transvestite and the third, a therapist whose specialty was counseling transsexuals. With this information regarding my guests, I had experienced a conceptual transformation. Nevermore would I be able to take gender for granted and asssume that gender and genitalia were inextricably connected. The importance of the social parameters of sex roles and social identity assumed new prominence, not just as intellectual rhetoric, but as a way of really thinking about gender and sex. At the time of my first meeting with a transsexual and a transvestite, I did not, however, realize the magnitude of that simple understanding and what it would mean for my acceptance among a group of people whose experience violated the cultural belief that gender is an eternal verity.

I knew that only one of the three people I was meeting was a genetic female. All three were very attractive women, two in their mid to late forties and the other perhaps in her late twenties. It was not until they spoke that I was able to establish their identities on the basis of their voices. Hope identified herself as the therapist; the other middle-aged "woman" was Leah, a heterosexual transvestite; the third, Elise, the transsexual. I had not, until that evening, been introduced to anyone I knew to be a transsexual. The meeting was positive and afforded quick entrance into the lives of transsexuals and, to a lesser extent, transvestites.

Leah and Elise invited me to a Christmas party. The people who attended were all active participants in a support group to be known here as the Berdache Society. That December the group was approximately a year old; it had been founded by Sasha, a transsexual. Meetings were held at her house bi-monthly, although in the course of research these increased to four times a month. All the people I met at the party were pre-operative transsexuals and heterosexual transvestites.

I was fairly nervous about entering this party but Leah and Elise took care of introductions and established my affiliation by referring to the lecture they presented at my workshop. As far as I could tell I was the only genetic woman present. That seemed to make little difference to anyone and I was not to feel like an outsider for long since

everyone seemed most intent on welcoming me. They expressed their delight that I had actually invited Leah and Elise to speak and that I was interested in their lives.

I was later invited to attend one of their meetings where I voiced an interest in an anthropological study of transsexualism and possibly transvestism, although the latter proved beyond the scope of a single in-depth study. A vote was taken at the first meeting I attended to see if anyone had objections to my entering the group. The Berdache Society was very clearly for insiders only and any outsider who wished to attend had to be voted in. This began my initiation into the group and a two-year sojourn of active investigation and participation. The research endeavor continued until December 1981, when I began the process of assembling my data and concentrated fully on interpretation and analysis. My affiliation did, however, continue, although my participation was greatly reduced.

Tools of Research

The bulk of the data was gathered in natural settings in which I recorded information as an overt participant-observer. In Berdache Society meetings, I took notes on ongoing interaction and tape recorded interviews and discussions in some casual and informal situations. At other times I transcribed field notes or recorded information as soon as possible after events. I also kept a written record of phone conversations. At all times the individual knew that I was in the process of research. If the conversation progressed to a point where intimate information was provided, which it usually did, I felt it ethical to remind the individual of my role as researcher. This was a frequent necessity as the ambience of the interactions was rarely regarded as one of ongoing research by transsexuals. I was incorporated in the social relations of transsexuals affiliated through the Berdache Society and that made me part of an extant social network of transsexual friends and confidantes. The interactions were mutually empathetic and close. Seldom did my role as researcher interfere. I think this was because I was Anne, the friend, asking permission to record information about transsexualism. As a result my research role, though visible, was overshadowed by my role as friend and member of a social network. Thus the major portion of data for this investigation was gathered in natural

and ongoing interaction. It emerged situationally, and I recorded it on anything handy—a tape recorder, a notebook, scraps of paper, napkins, etc.

As the research progressed and I became a fixed part of the meetings and a regular participant in transsexual activities, I used more formal methods for gathering data, including structured interviews for which I constructed a series of questions around a central issue (e.g., the effects of female hormones, passing, etc.). These interviews were conducted in person or by phone, and responses were either taped or recorded in a notebook.

The most structured and formal level of investigation provided information that could be quantified, but that was also rich in detailed qualitative data. This information was gathered through several questionnaires including: the Bem Sex Role Inventory (Bem 1977: 320–21), a masculinity-femininity index, a request for a letter, a friendship network questionnaire, and a medical expenditure questionnaire. Also included was a rather long and arduous life history questionnaire eliciting psychosexual history, development, values, and beliefs.[2]

Information from these questionnaires provided access to quantifiable data that were used as a cross-check on information gathered in participant-observation. In addition, through immersion in the lives of transsexuals, I was better able to place in perspective and context the questionnaire-derived material. The synthesis of the qualitative and the quantitative research methods lends greater credibility to each. First, the questionnaire-derived information seems to balance data gathered by affective participation with objectivity. And secondly, information gleaned from questionnaires that is quantified can be crosschecked by detailed field notes to ascertain continuity between the formal, questionnaire-elicited response and the informal, situationally derived information.

Data that are quantified and/or analyzed with simple statistics in this work are not intended as the primary focus of interest. They are presented in the form of tables to indicate trends and/or variation and to illustrate points of interest that were originally determined by participant-observation and qualitative analysis. It is important to remember the small sample size responding to the questionnaires and that this population is probably subject to regional variation and other factors which make it unique in some respects (such as their affiliation through the Berdache Society) and hence unrepresentative of the total transsexual population.

My Role

Initially my role among transsexuals was as an anthropological intern bent on learning everything I could about transsexuals and transvestites. Although my role changed in some ways as the research progressed, one aspect of it did not. I was an anthropologist interested in transsexualism, and this was crucial. I suspect my anthropological status may well have been responsible for my subsequent role as friend which, once established, overshadowed the former. As an anthropologist, once I explained the rudiments of ethnographic analysis to the transsexuals, I was clearly juxtaposed to other outsiders who are involved with transsexuals. I was not only an anthropologist interested in their daily lives, but I was more importantly *not* a therapist or a psychiatrist. I had no formal relationship required by medical policy that must be fulfilled in order for the transsexual to have her surgery. I had no power in any form over whether they would, in fact, be evaluated favorably for the conversion operation. This voluntary association with transsexuals, with whom I was on equal footing in terms of power relations, fostered the development of the kind of candor that is restricted to deep and personal friendships. At any rate the people with whom I researched had no vested interest in fabricating or lying to me about certain aspects of their lives. Information they gave me in confidence with permission to use for research could never be used in judging their eligibility for surgery. This, I believe, set the stage for a kind of freedom in my relations and communications with transsexuals.

In addition to simple acceptance, my sex as a female may have been a significant factor in the research. As a woman, undoubtedly I had access to relationships that would not have been possible if I had been a male. This is in part due to the nature of sex roles in our society and the seeming ever-present and frequently intrusive sexual issue that has the potential to affect the caliber of male-female friendships. But more important was the fact that transsexuals highly value genetic women. For "g.g.s" (transsexual argot meaning "genetic girls") have been women all their lives and have spent a lifetime involved in the cultural back regions of women's worlds. These are the sectors of women's lives that would bear the signs "for women only" and include an immense amount of information about the cultural baggage of women, their intimate ideas, beliefs, cosmology, etc., that perhaps they would only tell another woman (or, in the male sector, an intimate

other or spouse). Transsexuals feel they have a short period to make up for the time they lost being men and to learn about being women. The g.g. can give them much insight into sectors of women's experience that men usually do not have. Consequently, genetic women friends are highly valued by transsexuals. Genetic women have a sort of *mana* (power) in the eyes of transsexuals by virtue of their lifelong history as women, and some of this is regarded as transferable through association with and direct teaching by genetic women.

This attitude certainly facilitated my involvement in transsexuals' social networks. As friend and researcher I initiated reciprocity. Since I was trained by a cosmetic company to do professional makeup and since this expertise was something appreciated by both transsexuals and transvestites, the very minimum I could do was help with makeup in return for all they had given me. A vast amount of technology is spent on women's appearances, and those of us who have matured as females in a traditional culture cannot help being acquainted with it in some capacity. I was able to help transsexuals curl their hair and style it in different ways, give advice on wardrobes, and generally serve as a role model and reliable source of information.

In other ways I found I could do research and help my transsexual friends with very specific needs. On occasion I served as a cover for transsexuals who were going out in public for the first time or first few times. This encompassed taking over the conversation so the transsexual male voice did not give her away or discredit her female identity. (Voice alteration usually takes longer to accomplish than learning other aspects of passing undetected as a woman.)[3] Such experiences were gratifying because they allowed me to do something in return for people who so willingly contributed to my research, as well as to have some firsthand experience with initial passing strategies.

In the course of research, I was presented with the opportunity to make a transition from my academic role as researcher and my affective role as friend to that of advocate.[4] This occurred with the formation of the Center for Identity Anomalies (a pseudonym), which is another brainchild of Sasha, the transsexual founder of the Berdache Society. In the summer of 1981, Sasha and Elise invited me to be vice-president of the Center and to be active in its development. The Center, as conceived by Sasha, was to be an umbrella kind of organization through which broader endeavors could be accomplished on behalf of transsexuals and transvestites, such as workshops and other educational

activities directed at the local medical and mental health sectors con-
cerned with transsexuals and transvestites, and basically any other type
of effort which might benefit the cross-dressing community in personal
or group terms.

I agreed to the role of vice-president and made explicit that I would
act as an advocate for the group, an intermediary who facilitates the
group in establishing goals and implementing plans to achieve these
goals. In this way, my role as ethnographer expanded to that of advocate
as a natural consequence of the reciprocity inherent in ethnographic
research. I will continue my obligation as advocate for the Center as
long as it remains a support and advocate organization for and by
transsexuals and transvestites.

Notes

1. Simmel's concept of the stranger as analogous to the role of the ethnog-
rapher and several of the other ideas presented on the subject of participant-
observation were initially presented in *God Save the Queen: An Investigation
of a Homosexual Subculture* (Bolin 1974: 1–32).
2. The Life History Questionnaire and other questionnaires are available
upon request.
3. Voice alteration comes with a great deal of concentration and practice.
Several transsexuals have taken voice lessons at speech centers where, through
vocal exercises, they have been able to elevate the pitch of their voices.
4. Discussion of my role as advocate is presented in my article, "Advocacy
with a Stigmatized Minority," *Practicing Anthropology* 4, no. 2 (1982): 12–13.

FOUR

The Research Population

The current study rests on information solicited from a variety of sources in addition to transsexual informants. A number of professionals in the field of gender dysphoria contributed information. I have interviewed local medical-mental health professionals who provided information and insight on the subject. Also, several nationally known researchers, with whom I became acquainted at the 7th International Gender Dysphoria Association (Lake Tahoe, Nevada, March 1981), shared ideas and research and later corresponded, answering questions and providing invaluable comments.

The exact number of transsexuals who participated in this study is difficult to assess since information from transsexuals was not confined to those who associated with the Berdache Society. Four types of transsexual informants may be described as reflecting, in an impressionistic way, the relative degree to which they are discussed in this work and the amount of information they contributed. The four types of transsexuals were:

1. Several transsexuals whom I met at the 7th International Gender Dysphoria Association meetings. During the meetings and in corre-

spondence, they provided data on their transitions. Also included in this category were transsexuals who visited the Berdache Society meetings during their vacations or on other trips and who were part of a transsexual network of affiliations extending throughout the United States.

2. Three local postoperative transsexuals and several preoperative transsexuals. The latter, because of time schedules, could not attend the Berdache Society meetings, but furnished data. The three postoperative individuals, two of whom visited the Berdache Society on special occasions, have all provided information on the transsexual's transition and postoperative life and adjustment.

3. Four transsexuals, preoperative, who joined the Berdache Society approximately a year and a half into the research. They were as significant to this study as the core group of transsexuals, all of whom I have known for a year and three months to two years. However, by comparison, I knew these four less intimately than the core group, although a great deal of information on their development and progress into the female gender was included. Data from this group fit within the pattern established by the core group and substantiated the core group's transition strategy.

4. A core group of twelve transsexuals, the major actresses in this drama of transition. These people were all either in the Berdache Society or joined within nine months of the first meeting I attended. One, whom I had met in December 1979, relocated a year and a half into the research. Thus the bulk of this core population was remarkably stable geographically, although this is not to say that their participation in the Berdache Society was as stable. There was an evolution in participation in the Berdache Society. The closer the transsexual got to adopting the female role as a full-time role occupant and the more ensconced she became as a full-time female role occupant, the less her degree of active participation in the Berdache Society.

This small sample size of approximately sixteen, plus three who contributed more peripherally, is representative of the small sample size of many transsexual studies. Although a number of gender clinic investigations involved much larger sample sizes, such as Dixon's 1981 study of 1,400 transsexuals, most research populations are much smaller. Green's (1974: 65) population consisted of thirty adults and thirty-eight children; Money and Ehrhardt's (1972: xi) population numbered twenty-five; Driscoll (1971: 21) and Kando (1973: vii) studied

seventeen transsexuals; Walinder (1967 in Pauly 1969: 41) investigated forty-three, and Raymond (1979: 15) based her research on thirteen.

Of the core group of twelve, five were living as women when I met them through the Berdache Society. Of these, one moved out of state and one had the sex-change surgery in the fall of 1981. During the course of the research, seven transsexuals who were living dual roles, working as males and cross-dressing as women on a part-time basis, adopted the female role 100 percent of the time. One of these, Lydia, did not adopt the role full-time in the same sense as the other transsexuals. Instead, she chose a course of action known as androgyny, under the guidance of her therapist, Hope. Androgyny, in which the transsexual gradually feminizes herself to the point of becoming a full-time female role occupant, necessarily includes a stage where she is "hypothetically androgynous," appearing neither male nor female. It was frowned upon by most transsexuals as a violation of the "proper" course of events in pursuing womanhood (see chapter eleven for discussion). One transsexual in this group of seven, who went full-time shortly after I met her in September of 1980, had her surgical conversion in the fall of 1981. And, finally, the four who joined the Berdache Society approximately a year and a half into the research were living dual roles, working as males but undergoing therapy and preparing for the time they would live as women full-time. Of these four, one was under a program of female hormone management in efforts to feminize her body in preparation for full-time status. Aside from the three who were in the early stages of their transformation and were not taking female hormones, the rest of the total contributing research population were undergoing hormonal therapy, including the three postoperative transsexuals, since some hormonal therapy is necessary the rest of their lives in order to maintain feminization of the body despite surgical removal of the testes. All of the transsexuals had electrolysis to varying degrees to remove facial and/or body hair.

Two transsexuals had bilateral castrations. One underwent her bilateral castration in the winter of 1980. In the spring of 1981 she had breast augmentation surgery, followed by her sex-change in the fall of that year. This transsexual chose, for several reasons, the castration as a prelude to surgery, instead of the usual one-step castration and vaginal construction of the standard sex-change procedure. It was a step in the process of becoming a genital woman and psychologically gratifying to have the testes as a symbol of masculinity (via their male hormone-

producing function) removed. Retrospectively she felt this was a wise step to have taken because it allowed her to prepare for the later surgery by coping with emotional changes she claimed were the result of the withdrawal of male hormones accompanying castration. It is difficult to assess how true this was since the other transsexual, after her sex conversion operation, claimed no emotional changes as a result of removal of the testes. Certainly individual variation may be important as well as expectation.

Another transsexual underwent the castration at approximately the same time as the former; however, her reasons were medical ones. The castration allows the transsexual to reduce the dosage of female hormones, since a good percentage of the male hormonal influence is dissipated by removal of the testes (see chapter nine for discussion). Because she was at high risk for heart problems and her doctor felt that the female hormones could exacerbate her condition, she chose the castration in order to reduce her dosage of female hormones and reduce the risk of heart disorder. In the spring of 1981, she had rhinoplasty to improve the appearance of her nose and a tracheal shave in which the thyroid cartilage, more commonly known as the Adam's apple, is reduced in size to be almost unnoticeable. This surgery was in preparation for her adoption of the female role in a full-time capacity.

One other transsexual, Ophelia, who was full-time status when I met her, had rhinoplasty. Ophelia, due to beatings during childhood and multiple breaks in her nose, found the rhinoplasty improved her appearance and self-image considerably.

The Berdache Society affiliates came in all ages, sizes, shapes, educational and economic backgrounds. The ages ranged from twenty-six through forty-eight, with the majority over thirty. The range of education varied, as did job status, from blue-collar to white-collar types, from salaried to self-employed. As for physical appearance, again there were no trends. One transsexual was 6 feet 3 inches tall and the shortest was 5 feet 4 inches tall. Some were as slender as a high-fashion model, and others were plump. Some were extraordinarily beautiful by the standards of our society, and others were average. All tried to present themselves attractively. They were a heterogeneous group in many respects who shared one major characteristic. They wanted to be complete women, and that could only be achieved by having the sex-change surgery.

Anne Bolin

TABLE 1

Age Transsexuals First Recognized
Wish To Be Female
(N = 11)

TRANSSEXUAL NUMBER	AGE
1	9
2	7–8
3	5
4	5
5	4
6	6
7	5–6
8	4–5
9	3
10	6
11	5

This population, like all the other transsexual populations in the literature, reported an early appearance of gender identity conflict. I asked eleven of the transsexuals how old they were when they first knew they wanted to be a female. This information is presented in Table 1. The ages range from three years to nine with five as the modal age. Although the modal age of five is supported by the literature of early cross-sex identity in transsexuals, it must be kept in mind that these were adult constructions made in light of an adult identity as transsexual. Informal discussions with transsexuals made it clear that some expressed unequivocally an early age of recognition of the desire to be a female. Two reported that they thought of themselves as little girls and were rather rudely awakened when their parents pointed out differently. Others maintained it was a process of recognition; that a pervasive sense of confusion, discomfort, and difference was gradually consolidated into the awareness of feeling like, and wishing to be, a female. This may account for the transsexuals who gave ages of over six for recognition of cross-sex identity. The later ages (six and over) in Table 1 indicate that identity ambiguity may have occurred in these individuals. The range of professional opinion as to the age that gender identity is formed varies from around two and a half to four years old,

TABLE 2

Age Adult Transsexuals First Felt Desire to Cross-Dress and Age First Cross-Dressed (N = 11)

TRANSSEXUAL NUMBER	AGE FIRST FELT DESIRE	AGE FIRST CROSS-DRESSED
1	9	9
2	5	5
3	5	5
4	3–4	3–4
5	8	8
6	6–7	6–7
7	5–7	8
8	NA	30*
9	3	3
10	6	6
11	13	17

*#8 reports ony two or three minor incidents as a child.

and by five years old it is generally agreed that gender identity is firmly established (Rosen 1969: 663; Pomeroy 1978: 219; Money and Tucker 1975: 87, 109; Money and Ehrhardt 1972: 16; Beach 1973: 341). Information for this population supports Green's (1969: 34) contention that transsexuals either have a firm cross-sex identity, or at least an ambiguous identity, by five years of age.

In addition to reports of early childhood cross-sex identity, or ambiguity, transsexuals in this population shared an early history of cross-dressing. It is a rare transsexual who did not report childhood cross-dressing, and almost all had stories to tell of cross-dressing incidents. This, again, was in conformity with the literature on childhood evidence of cross-dressing among transsexuals (Green 1974a: 47, 51; Driscoll 1971: 29–31). Eleven transsexuals provided specific data on the ages of first wanting to cross-dress and of actually experiencing it (see Table 2). Ages of the first desire to cross-dress ranged from three years old to thirteen with ages of five to seven as predominant. The clustering of ages for the first cross-dressing experience varied from three to nine years old, with seventeen and thirty as clearly outside the range of

childhood cross-dressing. However, in conversations with these two transsexuals, both noted a few incidences of childhood cross-dressing but each waited until fortuitous living situations made cross-dressing more feasible and more regular: one when she moved away from home and the other when she got divorced. These two individuals probably had a higher regard for potential parental opprobrium than their colleagues.

The sample presented long histories of gender discomfort and in the majority of cases a lifetime of cross-dressing in secret. In this sense, the sample shared the common history of gender dysphoria established in the literature. They were, however, quite diverse in many other ways and more heterogeneous than the literature reports. On the other hand, they had a common strategy for coping with transsexualism and resolving it.

Transsexuals have developed a system for transformation that is regarded as the good, right, and proper way to pursue surgery. If transsexuals did not cut corners and did follow the rules developed in their intragroup association, then it was believed they would become complete women at the end of their journey. The Berdache Society provided a formal structure where norms were solidified through group interaction and dispersed throughout the transsexual social network. The Society also provided a mechanism whereby identities were solidified and where meanings of identities were clearly stated.

The Berdache Society was an opportunity for transsexuals to end their loneliness by finding others like themselves. It was at Berdache Society meetings that transsexuals could for the first time share their feelings and interpret their self-concepts and identities vis-a-vis the other transsexuals and transvestites in the group. There they found friends and others who accepted them as they were or wished to be. In time, transsexuals advanced beyond what the group provided. They were well on their way to becoming women, and they shunned their transsexual identities, opting instead to concentrate on becoming females through living, working, and developing social networks in which they could be known as women, not transsexuals. Thus, they tended to drop out of the meetings of the Berdache Society as they approached and entered full-time status, although they continued friendships with other transsexuals who were in the same stage of development towards the surgery. A great deal of sharing, socializing, learning, and exchange of information continued outside the meetings,

even after their attendance waned and eventually ceased (except for ceremonial visits). There was not one transsexual who did not state that finding the Berdache Society was a significant step in her life and very important in her transition.

FIVE

Transsexuals and Medical-Mental Health Caretakers

Apart from the Berdache Society, two other reference groups have a major impact on transsexuals: the medical community (psychiatrists, surgeons, endocrinologists, etc.) and the mental health professions (psychologists, counselors, social workers, etc.). The interaction of transsexuals and their medical-mental health caretakers is the focus of this chapter.

The medical and mental health caretakers are crucial to the transsexual's transition from male to female. They provide the services of therapy, hormonal management, and surgical reassignment. The link betweeen caretaker and client is established through medical policy that directly bears on the transsexual client consumers, a policy formulated by the Harry Benjamin International Gender Dysphoria Association, whose membership consists of psychiatrists, surgeons, endocrinologists, and mental health professionals.

The formalized *Standards of Care* (Berger et al. 1980) that transsexuals must follow outlines the rite of transition, providing agenda and ordeals. These standards are ritualistic in the sense that they are "prescribed, rigid [and uniform] and have a sense of rightness about

them" (see Bossard and Boll 1950: 14). Chapple suggests "[m]uch of what is being developed under the name of therapy, administrative medicine and the like is ritual in disguise . . ." (1970: 302). Indeed the guidelines set forth for the care of transsexuals can be viewed as the medical and mental health caretakers' "management of life crisis" through ritual mediation (cf. Chapple 1970: 302). The medical and mental health sectors are providing medical policy that in a general sense helps modern people cope with change by formulating procedures that, if followed, make things right. By devising medical policy that provides guidelines for the transsexual's transition, the caretakers are regularizing the transsexual's transition in the form of stages and schedules for changing status (cf. Chapple 1970: 303). They are specialists of change, operating in the role of "officiating personages" in their own secular rituals, restoring equilibrium and stability to individuals' lives and to their relations to society; they are akin in many ways to the role functions of the shaman (see Posinsky 1962: 384–85; Chapple and Coon 1942: 397).

The medical requirements that the transsexual must fulfill are functionally equivalent to rites in less technologically sophisticated societies, as these ensure a greater chance of success. To follow the ritualized requirements set forth by the Harry Benjamin International Gender Dysphoria Association is to avoid disaster. These ritualized ordeals are based on medical-mental health research to date and are designed to weed out the poor surgical risks. If the transsexual accomplishes all the requirements in the *Standards of Care*, she is considered to be a good risk for surgery.

The *Standards of Care: The Hormonal and Surgical Sex Reassignment of Gender Dysphoric Persons* (Berger et al. 1980) is a document, the first of its kind, initially approved by the attendees of the Sixth International Gender Dysphoria Symposium in 1979, and subsequently revised and approved in 1980 and 1981. The purpose of the *Standards of Care* is to provide an "explicit statement of the appropriate . . . [treatment] to be offered to applicants for hormonal and surgical reassignment." It is an effort to provide uniform care where previously a plethora of ideas on the subject abounded and is, therefore, a document that may be referred to by the caretakers and whose minimal requirements are recommended strongly (Berger et al. 1980: 2, 5).

The item described in *Standards of Care* as most important to the pre-operative individual is the "psychological evaluation." It is simply

the caretaker's estimation of whether the applicant is a good risk for hormonal and surgical reassignment. Before she may obtain hormones, the transsexual must procure a written recommendation for such therapy from a psychiatrist or psychologist who has known her in a "psychotherapeutic relationship" for a minimum of three months. In order to qualify for surgical reassignment, she must present the surgeon with two written recommendations: one from a psychiatrist and the other from a psychologist or psychiatrist. One of these recommenders must have known the client in a psychotherapeutic relationship for six months. In addition, the transsexual must provide evidence that she has lived for one year in a full-time capacity as a female (Berger et al. 1980: 7, 9).[1]

Living full-time as a woman means adapting to the female gender role 100 percent of the time. This is the "real life test" in which the transsexual must demonstrate that she has been "rehabilitated hormonally, socially, vocationally, financially and interpersonally" in her new role as a woman (Money and Walker 1977: 1292). Any surgeon who performs surgical sex reassignment without obtaining two recommendations indicating these requirements have been fulfilled and that the transsexual in both the psychiatrist's and/or psychologist's estimation is a good risk for surgery is considered guilty of "professional misconduct" (1980: 5, 7–9).[2]

The *DSM-III*, the *Diagnostic and Statistical Manual of Mental Disorders*, published and endorsed by the American Psychiatric Association (3rd ed., 1980), justified the *Standards of Care*. It is a manual of criteria to aid the medical and mental health caretakers in assigning a client to a psychiatric category. An "accurate diagnosis" of a client's psychiatric condition is considered a prerequisite for therapy (MacRae 1976: 204). In this sense, the *Standards of Care* require that the psychological evaluation

> for hormonal and/or surgical sex reassignment should, in part, be based upon . . . how well the patient fits the diagnostic criteria for transsexualism . . . in the *DSM-III* category 302.5X to wit:
>
> A. Sense of discomfort and inappropriateness about one's anatomic sex.
> B. Wish to be rid of one's own genitals and to live as a member of the other sex.
> C. The disturbance has been continuous (not limited to periods of stress) for at least two years.

D. Absence of physical intersex or genetic abnormality.
E. Not due to another mental disorder, such as schizophrenia (1980: 5).

It is undeniable that the *Standards of Care* are valuable in preventing irreversible surgical mistakes. These guidelines ideally provide protection for both the clients and the caretakers. Yet, inherent in the *Standards of Care* and in the policy relations of caretaker to client is an inequity in power relations such that the recommendation for surgery is completely dependent on the caretaker's evaluation. This results in a situation in which the psychological evaluation may be, and often is, wielded like a club over the head of the transsexual who so desperately wants the surgery.

Such power dynamics often breed hostility on the part of transsexual clients. Amara, a transsexual, summarizes her feelings of anger typical of transsexuals toward caretakers:

If, as a preteen you express your desires, you'll be told it's a "phase" and you'll grow out of it. And if you don't grow out of it, you'll be sent to a doctor who will "put you away" for being crazy. Since at this point you can't even put a label on your feelings, how can you argue? As a teenager you'll probably discover the label for what you think you might be, but because most of the information available is written for professionals, you won't be mad. Should you again present your thoughts to your parents/doctors/teachers/counselors you'll probably be told you're not transsexual, you're gay and even if you are transsexual, couldn't you please switch to gay anyway? As an adult, you'll not only figure out what you are, you'll take some action to correct what you perceive to be a gross injustice. At this point you will be told you will have to convince two "mental health specialists" that your feelings are real and you are emotionally stable, that you must work at a job for which you were not trained since your job skill will not be transferrable, you must save a year's wages or more for the surgery since insurance companies define it as voluntary, cosmetic, non-essential surgery, that you must do all this while conforming to the doctor's idea of a woman, . . . not necessarily yours, and that even if you meet all the requirements and go ahead with the surgery you'll be no happier than you are now—in effect, all the hassle will produce no net change in your life so why do you want to bother? And through it all, you'll get

the impression the "professionals" not only know less about the subject than you, they're more interested in protecting their malpractice insurance than your well being. The attentive listener will have noted one common element about the preceding scenario: at no point are the transsexual's feelings acknowledged as legitimate and deserving of action. How else could we feel but hostile?

While Amara's hostility may be more open and articulate than most, I have noticed generalized animosity toward the psychiatric profession indicative of an inherent imbalance in power between mental health caretakers and transsexuals. Taking this into consideration, many of the professionals' claims that transsexuals are resistant to counseling may be viewed in light of such dynamics (Star 1982: 18; Pomeroy 1975: 217). Inequity in transsexual power relations, vis-a-vis their caretakers, is a far more reasonable interpretation for resistance to therapy than resorting to psychodynamic explanations such as "immaturity and inability to separate from her mother" (Star 1981: 182) or the inability to want to deal with "deep seated conflictive tensions, desiring only superficial treatment by a sympathetic professional" (name withheld).[3] My own research indicates that most transsexuals have spent a significant portion of their time coping with their existential gender *angst*. Finding the label transsexual and applying it is not an overnight event. Transsexuals are consequently deeply analytical, based on a long history of self-questioning.

In order to protect the practitioners and the transsexual from an irreversible mistake, power weighs on the side of the caretaker, and this fosters resentment by transsexuals. It is certainly a dilemma, especially in light of Pomeroy's view that one of the major tasks of a therapist in treating a transsexual is to promote a nonevaluative and nonjudgmental therapeutic encounter (1975: 3218). Yet this evaluation is at the crux of the unequal power relations and one that is unavoidable.

In this lopsided interaction the client is vulnerable to the caretaker's subjective conceptions about what constitutes evidence for a *DSM-III* classification of transsexualism and a good surgical risk. As innocuous as the *DSM-III* criteria for diagnosis appear, a great deal of reading between the lines occurs via the transsexual literature that is used by the professional in a subjective estimation of the client's status.

It is at the interface of diagnosis and the psychological evaluation

that the problems of theoretical misconception, stereotypical expectation, and generalization occur. The mental health caretakers struggle to understand a phenomenon that in its surgical resolution dates from 1953. In order to treat a client they must rely on the research in the field of gender dysphoria. This research includes alleged commonalities of transsexualism that become elevated to the level of diagnostic criteria. My own research, including a reading of the literature, attendance at the 7th International Gender Dysphoria Association meetings, and communication with transsexual caretakers, suggests the widespread use of etiological correlates and behavioral characteristics attributed to transsexuals as diagnostic criteria.

Stereotyping clients occurs on two levels. One is the presumed homogeneity of transsexuals, but another more fundamental assumption about the phenomena is embodied in the *DSM-III*. Germane to the *DSM-III* is a "mental illness paradigm" for diagnosing an individual's problems (Smith 1981: 23). "[It] . . . assumes a priori an intraorganismic locus of all psychic ills" (Schacht and Nathan 1977 in Smith 1981: 23). Social and cultural variables are then necessarily subordinated to the mental illness perspective (Sarason 1981: 827). It is paradoxical that concepts of mental illness are actually rooted in the sociocultural matrix that then spawns a "social policy that has called people sick, and therefore, has had to find illnesses for them (MacRae 1976: 230).

The transsexual is labeled mentally ill and ipso facto in need of psychiatric care. This premise is formalized through the psychological evaluation requirements in the *Standards of Care*. The problems of stigma and the possible impact of the mental illness label are overlooked. The "intraorganismic" or person-centered approach considers the therapeutic encounter as the primary factor in transsexual mental health, yet a great deal of conflict resolution occurs simply through adopting the full-time female role. Living and working as a woman for a year may be the single most important factor in resolving gender identity conflict. In fact, in a personal communication to Feinbloom, Richard Green "suggested from his follow-up of transsexuals, that presurgical counseling was not necessarily the major factor in postsurgical adjustment" (1976: 54). I am by no means intimating that the presurgical counseling is not necessary as a concomitant of a real life test, but that the mental illness model overestimates the importance of psychiatrists and other mental health professionals as diagnosticians.

Perhaps their importance resides instead in their roles as caretakers, gatekeepers, and legitimizers. These roles of practitioners are a major contribution to the transsexual rite of transition, providing order and invaluable cultural support. Mental health caretakers, like medical professionals, provide symbolic and hence "real" validation for the transsexual's pursuit of womanhood. They legitimize the societally held beliefs that people who are women should have vaginas. Like shamans in other cultures, the medical and mental health practitioners "heal and protect the community from harm. . . ." (Miller and Weitz 1979: 555–56) supplying an official and dramatic way for people with penises to become people with vaginas, the only proper claimants of the female gender role. This protects our cultural notions of the relations of genitalia and gender role and ensures that the female gender will not be profaned by a permanent class of genital imposters.

Practitioners are possibly overlooking their important ritual functions in assisting the transsexual's transition by providing guidelines and ordeals that are interpreted symbolically as acts of becoming by the transsexual and validation for her claim as heiress to the female role. At the same time, the *DSM-III* categorization of transsexualism as a mental disorder lends propriety and respectability to the role of the caretaker, particularly to psychiatrists, legitimizing their affiliation with transsexuals. Transsexualism is now recognized as a bona fide medical and psychiatric condition. One psychiatrist's comment at the 7th International Gender Dysphoria Symposium indicates the priority of caretakers' concerns for their own validation within their profession via the *DSM-III*. This particular psychiatrist, a most sensitive therapist and advocate of transsexuals, states:

> Although consumers don't like the *DSM-III* classification . . . it has legitimized gender dysphoria . . . in that it is now a legitimate psychiatric diagnosis. While the surgeons of gender dysphoria are feeling out of mainstream medicine . . . , the psychiatrists have been getting more acceptance now that they are validated by the *DSM-III*.

Thus psychiatrists have enhanced their own credibility at the expense of stigmatizing their clients as mentally ill.

Of course, caretakers within their own professions are victims of the pollution of stigma attached to their clients (see Goffman 1963: 30).

The caretakers, by giving psychiatric status to transsexuals, are engaged in their own stigma management. The gender dysphoria professionals validate their own position by declaring transsexualism a medical problem rather than a moral or social problem. Medical labeling through the *DSM-III* is a mechanism whereby psychiatrists, psychologists, and other mental health workers can keep their own identities pure and uncontaminated.

The imbalance of power relations germane to transsexual-caretaker interaction along with transsexual resentment of psychiatric classification as a mental illness has culminated in transsexual hostility and distrust towards caretakers, particularly psychiatrists. Such feelings unfortunately override, and in some ways offset, the great concern and advocacy efforts of many psychiatrists and psychologists.

The *DSM-III* classification is one mechanism whereby all transsexuals are lumped together and pigeonholed. Concepts of transsexual homogeneity are perpetuated in other ways, such as the application of popular and prevalent notions about etiological and behavioral concomitants. I have isolated four such alleged attributes proposed by well-known researchers of gender dysphoria. These are: 1. dominant and overprotective mothers in association with absent fathers, in a physical or emotional sense (Stoller 1968; Green 1974a and 1974b); 2. effeminate childhoods (Green 1974a and 1974b; Stoller 1968; Money and Primrose 1969); 3. the penis as an organ of hate and disgust (Benjamin 1966; Green 1974a and 1974b); and 4. heterosexual orientation; males are deemed the appropriate sexual object choice for the transsexual since her gender identity is female (Benjamin 1966; Walinder et al. 1978; Pomeroy 1975; Kando 1973; Raymond 1979).

I have found no support in my own research that any of these conceptions are invariably associated with transsexualism. What is significant is the *heterogeneity* of careers in the transsexual research population. They could not be typified except in the sense they each have had a long history both of wanting to become a woman and of cross-dressing. They are a diverse group with complex biographies, psychosexual histories, and a variety of strategies for coping with gender identity conflict. While some evinced one or more of these characteristics, others conformed to none. Among the transsexuals I have questioned on these items, I found no justification for the use of any of these characteristics, either alone or in combination as diagnostic markers, predictive of transsexualism.

My research on these four attributes of transsexualism is subject to the same critique as much of the literature on transsexualism. Statistical analysis of transsexual correlates is largely dependent on sample size.[4] To base etiological correlates on a small and obviously self-selected sample is certainly methodologically unsound. Much of the research is unfortunately grounded on just such samples, and even where sample size is large, a number of confounding variables can affect the results such that bias and the question of representativeness are pertinent.

Although the results of my research on these four attributes of transsexualism may be influenced by regional bias and the uniqueness of the research population, one cannot attribute the heterogeneity of this population solely to these factors. This heterogeneity bears some scrutiny.

Mother-Blame Theories

The first of these correlates is what I shall refer to as the "smother mother," absent-father theories, or theories of mother-blame.[5] My data on mother-blame etiological theories, as in the case of the other three diagnostic markers of transsexualism, come from interpretation of psychosexual history questionnaires and through participant-observation that serves as a check on the questionnaire data. Transsexuals, in discussion and in questionnaire responses, do not resort to mother-blame/absent-father theories as an emic explanation for the phenomenon. They simply state they just do not know, although they are certainly aware of popular etiological theories. In their own histories, transsexuals were for the most part struck by their own normal lives. Eleven transsexuals responded to questions about their family histories and relations formulated to assess the impact of dominant mothers and absent fathers. Of these, one is from a divorced family and another's father died when she was twelve. The former individual was without a father between the ages of nine and twelve, at which point the mother remarried. The stepfather in this case traveled a great deal and was not a significant influence in this transsexual's subsequent junior high and high school years. The latter individual's father was a solid partner in the family until his death when the transsexual was twelve. Thus two transsexuals had a physically absent father after nine and twelve,

respectively. The remaining nine transsexuals grew up in rather mundane, two-parent households, reflected in Eunice's quip: "I grew up in an Ozzie and Harriet family."

The fathers emerged as traditional males who were disciplinarians. They were not overly warm or affectionate in the families of eight transsexuals. The other three transsexuals report close, warm, and loving relationships with their fathers.[6]

Relationships with mothers also run the gamut of parent-child relations. The transsexual who lost her father at twelve grew to resent her mother's expressions of love, although as adults they have a very warm and loving relationship. Her mother is one of the few mothers who unequivocally accepted her child as a female. The others' relationships may be categorized as warm and loving (N = 5), solid but not particularly close (N = 3), rocky (N = 1), and distant (N = 1). Nine of the eleven have stable relationships with their mothers expressing variation in terms of maternal expressions of love. Two have distant and unpleasant relationships with their mothers.

In assessing dominance in family dynamics as an indicator of smothering mothers, mothers and fathers are equally dominant in different domains or in the same spheres of influence (N = 8), mother dominant (N = 1), and father dominant (N = 2). The eight relationships in which dominance and authority are shared reflect traditional concepts of fathers' formal authority and role as disciplinarian and mothers' informal power in child rearing and other areas of decision making. Additionally, none of the transsexuals slept in the same bed with the mother, a characteristic sometimes associated with smothering, overly close, and protective mothers (Green 1974a: 231–32).

In searching for other evidence of dominant and overprotective mothers, transsexuals were asked, in an open-ended fashion, if any had a special relationship with a family member. Of these, one mother is cited as the source of a special relationship in that she would talk and play a great deal with the child. The others responded: no special relationship with any particular family member (N = 7), a special relationship with sister (N = 2), and a special relationship with grandmother (N = 1). Of those who had special relationships with women (N = 4), none reported excessive physical contact.

Illness is a possible concomitant of maternal overprotection. I found nothing unusual in the medical history of childhood and adolescence in eight of the eleven transsexuals. Of those with unusual medical

histories, one transsexual noted an undescended testicle that was re-
moved at age six. Another had constriction of the urethra at about age
three, and one had yellow fever when she was nine years old. These
three illnesses afforded opportunities for overprotectiveness, yet their
descriptions indicate that this did not occur.

A variant of the "smother mother" theme and another source of
mother-blame theories found in the literature relates to the issue of
cross-dressing. The mother who suffers her own gender conflict (Stoller
1975: 38–55; Rosen 1969: 661), who desired a female child, or who,
for any reason, may dress the boy in female clothing (Green 1974a:
217–19) is, however, not the only source of cross-dressing for the little
boy. Regardless of motivation, Green (1974a: 217–19), Rosen (1969:
661), and Driscoll (1971: 30) note the influence of other people who
facilitate the prototranssexual's cross-dressing. Green has found moth-
ers (in 15 percent of the cases), sisters (in 18 percent of the cases) and
grandparents (in 10 percent of the cases) cross-dressed the child,
thereby setting a precedent for future feminine behavior. In contrast,
my research revealed not a single transsexual in the present population
had been aided or encouraged in cross-dressing by a family member
or external source.

The outcome of my research into dominant-mother/absent-father
etiological correlates suggests that this theory is not necessarily a pre-
dictor or correlate of transsexualism. Transsexuals may have average
family histories and still suffer gender identity conflict. An unremark-
able family history is not necessarily a contraindication of a transsex-
ual's status.

Effeminate-Childhood Theories

It has also been proposed that one characteristic of transsexuals is an
"effeminate" childhood (Stoller 1968: 251; Green 1974a: 212–13;
Money and Primrose 1969: 131). Stoller goes so far as to suggest that
only the most effeminate males with a history of effeminacy should
be operated on (1968: 251). Effeminacy can be expressed in a number
of ways, but Green believes that accusations of "sissy" are a good
indicator of effeminacy and a source of later gender confusion (Green
1974a: 241; Money and Primrose 1969: 119). The label sissy can
exacerbate other aspects of the child's life that enhance confusion and

prevent normal social relations with other children. Of those who responded to a question on this subject (N = 11), five had been called sissy on occasion in their childhood and six had not. The insult sissy was used by other children generally as a result of the transsexual's avoidance of contact sports. Those who were not labeled sissy were active in sports, and several transsexuals used sports to hide their secret. Others report thinking that if they engaged in male sports activities, pursuing the male role with a vengeance, their conflict would go away and they would become males like other boys. This latter strategy is akin to imitative magic whereby the male role carries with it an identity that can be coopted; thus to act as a male was to be a male.

It is difficult to assess whether an individual was called a sissy because she was an effeminate boy or because she did not participate in traditional male sports activities. One transsexual, who was called a sissy in grammar school, later pursued the role of a "brain" in high school. The sissy name calling ceased when she found another male role option outside the traditional athletic sector.

Of the ten transsexuals I saw in their male roles prior to significant changes as a result of hormonal reassignment, only one was effeminate in a manner associated with effeminate or "nellie" homosexual men. This individual revealed a long history of being called sissy. She also is the only transsexual who has trouble passing as a full-time woman. She no longer is called sissy but when in public is called by the adult insult equivalent of "queer" or "faggot."

The labeling of sissy and later homosexual is an important issue in the diagnosis of secondary transsexualism. According to Person and Ovesey (1977: 316–24) and Money and Walker (1977: 1289–90), the secondary transsexual is an individual whose sexual object choice is male, who is effeminate in mannerisms, and whose transsexual identity is evoked in response to stress, such as losing a significant other. Secondary transsexuals may seek the surgery as a more legitimate expression of their male-to-male sexual object choice than being a homosexual. Effeminacy must therefore be carefully evaluated as a characteristic of secondary transsexualism that calls into question surgery. If transsexualism is a homosexual solution to stigma or stress, then will the surgery fulfill its purpose as conceptualized in the *Standards of Care* as "improving the quality of life as subsequently experienced . . ." (Berger et al. 1980: 4)? Some, such as Gottlieb (1980: 11–12), have questioned whether an effeminate childhood is a nec-

essary concomitant of primary transsexualism defined by Person and Ovesey as neither predominantly heterosexual or homosexual in history of sexual object choice and essentially neutral in gender presentation (1974: 316–24). Such a definition questions effeminacy as a diagnostic marker in primary transsexualism.

The Penis as an Organ of Hate and Disgust

Benjamin is largely responsible for suggesting that transsexuals view their penises as organs of hate and disgust (1966: 21, also Green 1974a: 190). My own research population holds a variety of attitudes, from those endorsing Benjamin's views to those who perceive the organ as simply there, although unwanted. The latter have a more relaxed attitude about it such that an individual can masturbate without guilt, enjoy the sensations of pleasure and orgasm, and mitigate sexual utilization of the penis through fantasy by imagining penetration or manipulation as a woman with vagina.

In the responses of eleven transsexuals, three prevalent attitudes about the penis and its sexual use emerged. One individual did not use her penis at all as a sexual organ. In this regard she stated: "I can't stand to use it any more even for those necessary daily functions." Two masturbated with the penis, but felt guilty about it afterward, such as one who revealed: "After masturbation I feel extreme distaste, and immediately after the waves [of orgasm] I feel dirty and sick." Others (N = 8) use the penis in masturbation or in a sexual encounter. They would rather be rid of it but had the perspective that "it's there," "it gives one pleasure, so why not use it?" These transsexuals fantasize that the penis is a vagina and they are women. Several quotations from transsexuals illustrate this perspective:

> I view my penis as eventually being my vagina so the pleasure I am deriving from it now just happens to have the form it has. While masturbating I don't see it as my male organ.

> I don't feel bad about using any part of my body for physical pleasure.

> The penis is part of my body and it is capable of giving me pleasure. Why should it not be used for that purpose?

These transsexuals did not suppport Benjamin's idea that the penis is an organ of hate and disgust. This may be a result not only of greater tolerance and acceptance of one's sexuality pervasive in society, but of small group dynamics, whereby masturbation is approved, given credibility, and viewed as a natural outlet that did not jeopardize the individual's status as a transsexual.

In addition, transsexual folklore about masturbation has developed that provided additional validation for the majority attitude. It is most difficult to ascertain whether there is any truth to this lore at all, but the important point is that it is accepted by many of the members of the group. This lore was summarized by one transsexual who said: "If you don't use it [the penis] you'll lose it." One of the side effects of female hormones is atrophy of the genital tissue. It is this penile tissue that is inverted to form the vagina and the testicular tissue is used as the basis of the labia. Transsexuals in the group were concerned about the possibility that their penises might atrophy and that there would not be enough penile tissue to create an adequate vagina. Therefore, in order to rectify this potentially hazardous situation, the folklore stated it was important to masturbate to keep penile tissue healthy and to keep the penis from shrinking. This reflects the transsexual's concern over surgical issues and also provides a subcultural validation for the prevalence of masturbation among this group. However, this lore also may be used as explanation to the medical-mental health caretakers who question the authenticity of a transsexual who uses her penis as a source of pleasure. In any case, transsexuals are people who can use their penises for sexual gratification without jeopardizing their personal identity or self-concept.

Heterosexuality

A final correlate of male-to-female transsexualism often cited in the literature is heterosexuality; that is, a hetrosexual object choice for a transsexual is a male. A lesbian sexual object for a male-to-female transsexual is a woman. This scheme regards gender identity as primary in defining gender rather than genetic or genital attributes. A concept of hetrosexuality as the appropriate choice is embedded in this correlate.

Benjamin's work on the sexual preferences of transsexuals relies on

FIGURE 1

FIGURE 1

Orientation Typology

Exclusively heterosexual	1
Heterosexual preference but open to bisexuality	1
Bisexual but prefers males	1
Bisexual	6
Exclusively lesbian	6
Lesbian preference but open to bisexuality	1
Don't know	1

a typology of transvestite and transsexual preferences. As the classifi-cation proceeds toward the classic transsexual, sexual orientation (translated here according to gender identity, not *genetic* sex as in Benjamin's original formulation) proceeds from bisexuality favoring heterosexuality to exclusive heterosexuality for the classic transsexual (1966: 22). Thus a long-term and deeply abiding attraction to genetic males is viewed as intrinsic to true transsexualism. And this charac-teristic is one most ingrained in the hearts of heterosexual caretakers.

Seventeen transsexuals have provided data on sexual orientation (see Figure 1). Of the seventeen only one was exclusively heterosexual. Three of the six exclusive lesbians were living with women (genetic), one bisexual was living with a lesbian female, and two transsexuals were living with each other in a lesbian relationship.

The assumption behind the conception of transsexual heterosex-uality is that if one wants to be a woman then the only appropriate sexual object choice is male. One vignette of a caretaker-client inter-action is illuminating in this repsect. Tanya, a preoperative transsexual, saw a psychiatrist as part of an agency employment requirement. Be-cause in this situation the psychiatrist was not going to conduct her psychological evaluation, Tanya, a bisexual, discussed a recent lesbian encounter and her openness to a lesbian relationship postoperatively. The psychiatrist was incredulous. He asked, "Why do you want to go through all the pain of surgery if you are going to be with a female lover?"

My data indicate a high degree of acceptance of bisexuality in this

population as well as evidence of exclusively lesbian choices. Transsexual lesbianism, much less bisexuality, is, however, largely unreported in the literature, although it is common knowledge among transsexuals (see also Casey 1981). Despite data presented here and reports from a few other professionals, it is still considered an "aberrant" choice for transsexuals and places the bisexual or lesbian transsexual as a poor risk for surgery.

Does aberrant sexual preference increase postsurgical risk? Walinder et al. (1978: 16–29) in a study of 100 transsexuals found five who regretted their decision for surgery. According to these researchers, one of the concomitants shared by the five was a history of sexual relationships with women. Although sample size was small (N = 5), the results could easily be interpreted as mitigating against the surgery. An alternative view would acknowledge that transsexuals who have relationships with women (even as men) might well do so out of lesbian interests. This attitude of caretakers toward transsexual lesbians is exemplified in the statement of one psychiatrist who described his transsexual lesbian client as "overidentifying with mother's feminine behavior and expressing hostility to males." Such interpretations overlook the broad range of sexual orientation among humans and confuse what every transsexual knows: her female identity is independent of her sexual object choice.

How, then, are these misconceptions perpetuated? The preoperative individual recognizes the importance of fulfilling caretaker expectations in order to achieve a favorable recommendation for surgery, and this may be the single most important factor responsible for the prevalent medical-mental health conceptions of transsexualism. Transsexuals feel that they cannot reveal information at odds with caretaker impressions without suffering adverse consequences. They freely admitted to lying to their caretakers about sexual orientation and other issues.

Although caretakers are often aware that transsexuals will present information carefully manipulated to ensure surgery (Money and Walker 1977: 1290), they have only to scrutinize several of their most prominent diagnostic markers available in the literature to realize the reason for the deceit. If caretakers would divorce themselves from these widely held beliefs, they would probably receive more honest information.

Transsexuals are patently aware of most caretaker expectations due to their voracious appetite for reading anything and everything about transsexualism, including the medical literature. As a consequence of their awareness and concern for saying nothing that could possibly interfere with a favorable psychological evaluation, they are active agents in contributing to the maintenance of caretaker diagnostic criteria. The majority of transsexuals with whom I worked had either read or had some familiarity with the distinguished scientists in the field of gender dysphoria (Kando 1973: 43). Feinbloom notes this in her work, pointing out that such availability of medical-mental health diagnostic criteria may be used by transsexuals to "provide a schema to sell oneself appropriately to those who hold the key to sex reassignment" (1976: 231).

Information about caretaker expectations is gleaned and spread through transsexual interaction, and this information becomes part of transsexual lore. Transsexuals have widespread networks extending nationwide. They keep tabs on what the caretakers are up to and on what their latest theories are. Transsexual lore is rich with information on manipulation and utilization of caretaker stereotypes. Transsexuals know what they can honestly reveal and what they must withhold. This lore consists of "recipes" for dealing with caretakers and the management of information that they know would discredit them in the eyes of their caretakers should it be revealed. They necessarily exploit caretakers' expectations for their own ends by presenting a transsexual identity in conformity with caretakers' conceptions of classic transsexualism. In so doing they unfortunately validated the caretakers' stereotypes about transsexuals (cf. Goffman 1963: 10, 91, 112, 138; Braroe 1965: 166–67).

In the process of interacting with the caretakers, transsexuals are merely engaging in something they have learned as a consequence of transsexualism. They are fabricating personal identities in order to present caretakers a picture consistent with caretakers' own research and the literature on transsexualism. The therapeutic encounter is ideal for such false oral documentation and "biographical editing" (see Goffman 1963: 61–62, 83).

Transsexuals have learned through the literature, personal experience, and the grapevine to be dishonest with therapists. Kass, a preoperative transsexual is typical in her remarks:

[Psychiatrists and therapists] . . . use you, suck you dry, and tell you their pitiful opinions, and my response is: What right do you have to determine whether I live or die? Ultimately the person you have to answer to is yourself and I think I'm too important to leave my fate up to anyone else. I'll lie my ass off to get what I have to . . . [surgery].

Caretaker-client interaction is fraught with dishonesty, distrust, and hostility that undermines the benefits of the therapeutic encounter. Effective therapy cannot occur in a climate in which transsexuals feel they must superficially conform by hiding significant portions of their lives such as their sexual history and experience. In addition, they now have the extra burden of the stigma of the *DSM-III* label of mental illness. Their only recourse is one in which they contribute to the perpetuation of stereotypes and generalizations and thereby foster impressions of a homogeneous population. This leads to a self-fulfilling prophecy and promotes a situation in which both caretakers and clients suffer.

This is not to say all caretaker-client relationships are of this nature. In this population some honest therapy also occurs. Several transsexuals were seeing women therapists who were neither psychologists (Ph.D.) nor psychiatrists, but rather social workers or clinical psychologists (MAs). For the most part, these therapists were unfamiliar with transsexualism until they met their clients and hence had no professionally preconceived notions. Hope, who counseled eight of the transsexuals in this research population, is such a therapist. One transsexual had successful therapy with a male psychiatrist for three years. That psychiatrist, like several of the women therapists, had no previous experience with transsexualism.

Word spread about various local therapists. One psychiatrist had a bad reputation among transsexuals because of their belief that he did not like to recommend clients for surgery. Another psychologist was liked and endorsed by many who went to him for testing on the Minnesota Multiphasic Personality Inventory and for evaluation of masculinity and femininity. His analysis in a favorable direction was well known among transsexuals who used the evaluation to obtain hormones; one had only to take the test and interview with this psychologist for a few sessions. Another psychiatrist also had a reputation

for fast and favorable psychological evaluations. These particular care-takers did not generate hostility but rather were looked upon as kindly men who facilitated the transsexual's transition. Because of the brevity of the therapeutic encounters, no deep relationships developed. On the other hand, neither was used as a *primary* evaluator for surgery.

Among this population of transsexuals, women caretakers were pre-ferred. Because the available women therapists were not psychiatrists or psychologists, their rates were lower, which a financially burdened population preparing for surgery appreciated. Additionally, transsex-uals for the most part distrusted male caretakers whom they believed imposed their male views of womanhood on transsexuals. Women therapists were preferred simply because they were women. They had something to offer besides therapy. They were role models for the transsexual and by virtue of their own history as women knew what all genetic women know, something highly valued by transsexuals.

In addition, female therapists, like women in general, were regarded as more accepting of transsexuals and less threatened by their gender switch. These therapists were effective because of the transsexual's loneliness. In efforts at stigma management, transsexuals segregated themselves from former networks and friends. While they were living two roles it was difficult for them to be close and intimate with people lest their secret be discovered. As they anticipated going full-time and actually adopted the female role full-time, it was still difficult to es-tablish new friendship networks. Thus female therapists could fill a void in the transsexual's sparse network of people who knew and who accepted them. Transsexuals preferred female therapists because they felt they could be more honest with them and at the same time develop rapport in woman-to-woman interactions. It was also felt that women therapists had few preconceived notions about them because women themselves were aware of their own heterogeneity and were inherently more tolerant of variation.

What has emerged in this discussion of the alleged correlates of transsexualism is a portrait of transsexual heterogeneity, people whose conformity to caretaker's expectations is superficial and a result of dynamics that fostered deceit. There is diversity in this population in terms of personal history, sexual orientation, etc., yet there is conti-nuity and consistency in their transformation into women. Diversity is integrated and organized by the common threads of meaning, sym-bol, and agenda embedded in the rite of transition.

Notes

1. These time frames are considered minimum requirements. Other caretakers suggest longer qualifying periods; Money and Walker advise two years of living full-time in the role of the female (1977: 1292).
2. The *Standards of Care* explicitly states: "The analysis or evaluation of reasons, motives, attitudes, purposes, etc., requires skills not usually associated with the professional training of persons other than psychiatrists and psychologists" (1980: 4). Furthermore:

> Hormonal and/or surgical sex reassignment is performed for the purpose of improving the quality of life as subsequently experienced and such experiences are most properly studied and evaluated by the behavioral scientists (psychiatrists or psychologists) (1980: 4).

This apparent medical and psychological (in many states a psychologist legally can be a Ph.D. only) colonialism is a sore point for many of the helping mental health professions who are members of the Harry Benjamin International Gender Dysphoria Association and actively involved as caretakers of the gender dysphoric. The requirement that one evaluator must be a psychiatrist has clear implications of male control in medical policy relating to transsexuals. The psychiatric profession under the auspices of the medical sector is clearly male dominated and oriented (see Raymond 1979 for a discussion of male sovereignty and jurisdiction by the medical community in the lives of transsexuals). The majority of mental health professionals at the 1981 meetings of the Harry Benjamin International Gender Dysphoria Association such as MSWs, guidance counselors, and MAs in clinical psychology were women and they strongly objected to their exclusion in the *Standards of Care*. Transsexuals also objected to this state of affairs. The Center for Identity Anomalies prepared a position paper on the *Standards of Care* that was placed in the appropriate channels in the Harry Benjamin International Gender Dysphoria Association for review and consideration. An excerpt from this position paper reflects not only this population's views but those of many other transsexuals:

> The strongest recommendation for revision of the *Standards of Care* that we would make at this time has to do with the restriction on the psychological diagnosis of gender dysphoria to psychiatrists and psychologists. It has been the experience of many of our members that the best and most experienced therapists they have been able to come in contact with were either clinical psychologists with MAs, or licensed social workers with MSWs. . . . [Y]our consistent references to psychiatrists and psychologists in combination with restrictive state laws provides a heavy burden for a

population which is in your own words, "In a financial status which does not permit them to pay excessive professional fees." . . . [I]n the absence of a clearly defined, scientifically validated body of knowledge, we have discovered that the most important qualification for a successful psychological therapy are an educated concern and open mind, qualities as likely to be found in licensed social workers and clinical psychologists as psychiatrists and PhD psychologists.

Transsexuals preferred women therapists in the mental health professions and could better afford their therapy that generally cost (in the area of this research) approximately \$30–35 an hour versus psychiatrists who locally charged \$55–65 an hour.

3. Transsexual caretakers must also be granted anonymity like their clients but for different reasons. Because of the perspective taken in this chapter, should the views of these caretakers become common knowledge to transsexual clients, their efficacy as therapists might be adversely affected.

4. For a discussion of sample size in transsexual research, refer to chapter three. Glantz also provides an outstanding review of the general medical misuse of statistical methods (1980: 1–6).

5. "Smother mother" is an expression used by the therapist referred to as Hope in the present work.

6. These figures include a description of father relations of the two transsexuals whose fathers were absent after nine and twelve years of age as do subsequent analysis of family relations focusing on the periods in which their fathers were present.

SIX

The Rite of Transition:
A Becoming

The transsexuals in this study were participants in a rite of passage that dramatized their movement from one status to another. The rite of passage was specifically a rite of transition in which transsexuals become women. Their becoming was a multifaceted transition; it was a total process and it implied much more than a simple switch of status. "Becoming" included the transmutation of the personal identity, defined here as how a person conceives of her/himself including gender identity, gender role identity ("a set of expectations about what behaviors are appropriate for people of one gender" [Kessler and McKenna 1978: 11–12]), self-concept, and world view ("the way we see ourselves in relation to all else") (Redfield 1953: 85–86). The transformation of personal identity was linked to the conversion of social identity. Social identity is defined as a "pattern of observable or inferable attributes [that] 'identifies' . . . the self and others; his [her] identity is a socially labeled object which is of great concern and frequently revaluated both by the person and others in the groups in which he [she] is a member" (Miller 1963 in Schwartz and Merten 1975: 196). It also includes the construct of gender role (sex role) as those culturally approved behaviors associated with males and females,

69

and facets of gender role or sex role defined as "interests, activities, dress [and] skills . . ." socially approved for the two genders (Kessler and McKenna 1978: 2, 11, 12). Social identity is how an audience perceives and endorses the individual as a role occupant or member of a category fulfilling role prescriptions, meanings, and scripts (Goffman 1963: 2; Vernon 1965: 125).

Personal identity is closely tied to social identity, since self-perception is in part determined through interaction whereby others respond to the social identity performance. This has been called the "looking-glass self" (Cooley 1928); we see ourselves (to some degree) as others see us (in Vernon 1965: 145). The transsexual's rite of transition is characterized by the transformation of personal and social identity as integrated components of the whole, such that change in one identity influences the other.

Personal identity is envisaged as a hierarchy of identities such that one identity is primary and others are subidentities around which one organizes the self. The transsexual's identity transformation is one in which the primary identity of "transsexual" gains ascendancy with an attached subidentity of "female." This emergence is facilitated through interaction in the Berdache Society where what it means to be a member of the category transsexual becomes clear. This is enhanced by other transsexuals furnishing social identity reinforcement for one's presentation (social identity) as transsexual.

The female subidentity is a *felt* but not a *lived* identity at the time most individuals join the Berdache Society. As transsexuals become entrenched in the Berdache Society and as they enter the rite of transition, their social identity undergoes change. They dress more and more as females, attempt to pass in public more and more, and, in effect, live two lives. At some point they "go full-time" and live as females 100 percent of the time. As they gain reinforcement for their social identity performances (from their own and unknowing audiences), this feeds into their personal identity as females through living the female social identity. The female identity becomes a primary identity once the transsexual label is accepted and mediated via group interaction.

The primary identity of female, for a time, carries the subidentity transsexual. This is associated with transsexuals' focus on passing, a central theme in the rite of transition. With passing they learn to hide their transsexual stigma. They engage in techniques of information

control to hide male phenotype, history, and past social identity. At some point during full-time status, they transform their personal and social identity to the point that they view themselves as natural women, comfortable occupants of the female role, and reject their transsexual identity as well as the term passing, for they are now merely being who they really are: females. This had been accomplished with the aid of hormones that feminize their bodies. Physical feminization is an important part of their becoming and their personal and social identity transformation, for it enhances their self-perception as females as well as their role performances.

The rite of transition is endowed with symbol and meaning expressed in rituals punctuating the transsexuals' transformation into woman-hood. Ritual referents are manifested as symbols of the birth of woman and the death of man. Emically, the rite of transition is one in which the male (as an identity and role) is an efferent symbol (flowing outward and dissipating), while the becoming of woman is an afferent female symbol (flowing inward and culminating), dramatized in ritual acts recognized and undersigned by the transsexual group. These accent the transsexual's progress in the rite of transition. The identity trans-formation mirrors the three stages in the rite of passage. The rite of transition is specifically a rite of exit from a former male role and entrance into a female role. It is a journey through liminality, where transsexuals are "betwixt and between," for they are no longer males and not yet complete women. They become, in transition, women with penises. The resolution is the rite of incorporation in which a "neovagina" is constructed and they conform to the cultural minimal requirement for claim to the female gender. Their transformation is one of order out of disorder and normalcy out of stigma (cf. Turner 1967: 94; Middleton 1973: 388).

Becoming is the crux of the rite of transition. It is a multidimensional passage including the components of: personal identity, social identity, and phenotypic transformation shadowed by phases in their rites of passage whereby one status is transformed into another. Figure 2 pro-vides a schematic representation of becoming. Becoming is an inside-outside transformation whereby the development of the personal iden-tity (psyche, mind) is matched with a social identity transformation (role, sex role identity, etc.) and phenotypic transformation (soma, body) and these three domains of becoming dovetail into a paradigm of passages.

FIGURE 2

Schematic Representation of Becoming

| | COMPONENTS | | | |
| | INSIDE | OUTSIDE | | |
STAGES	PERSONAL IDENTITY TRANSFORMATION	SOCIAL IDENTITY TRANSFORMATION	PHENOTYPIC TRANSFORMATION	RITE OF TRANSITION
1	Gender confusion, and/ or self concept that one is more like little girls than little boys	Occupying male role, secret dressing as a female	Male	
2	Transsexual primary identity, female subidentity	Dressing as female more and more, dual role occupancy, passing in public, self-conscious	Male, but feminizing from hormonal reassignment	Separation and transition, liminality, disorder
3	Female primary identity, transsexual subidentity	Dual role occupancy, anticipating full-time status as female, successful passing, less self-conscious	Hormonal reassignment, increasing feminization and feminized	Separation and transition, liminality out of disorder
4	Female primary identity, rejection of transsexual identity, a natural woman	Full-time status as female, successful passing, rejects notion of passing, role performance as female natural and unself-natural and unself-	Increasing feminization and feminized, anticipates, and undergoes surgical construction of vagina	Incorporation, normalcy, and order

Becoming Transsexual

Finding and applying the label transsexual and consolidating one's identity around the label is a process of acquisition that takes time. The label is tried on and used as a mechanism of identity mediation (cf. Kemnitzer 1977: 300). It is first available through the media to the young prototranssexual in search of who and what she is. Through subsequent interaction with other transsexuals in the Berdache Society, the label is elaborated as a special category of people with certain characteristics who must behave and act in certain ways. The tag transsexual is a means of organizing and developing the female identity component epitomized in the transsexual notion that she is a woman trapped in a man's body. Before the transsexual arrives at the point of affiliation with her own category, she has a childhood history of knowing she is different. According to Goffman, this perception of difference is a burden of stigma that fosters "similar learning experiences regarding their plight, and similar changes in conception of self—a similar 'moral career' that is both cause and effect of commitment to a similar sequence of personal adjustments" (1963: 32).

As children, and later in life, transsexuals report feeling like the only people in the world who have such confusion. They are often perplexed and disoriented, some not really knowing they feel like females, and others clearly knowing they are more like females than males. Several of their comments describe these feelings of alienation:

I seemed so alone and thought I was the only person in the world like me until I heard of the term transsexual, and a somewhat bare description of the subject, so I kind of knew that there were a few, but I didn't know how to contact them.

Until I found out there were others, I knew I was alone.

I felt like I was the only one when I was a kid, it's hard to describe.

I felt completely isolated as a kid.

When I was much younger I felt like the only one in the world. To be honest it scared the hell out of me. I didn't understand why I felt as I did, nor why I wanted to dress. I knew I was different from the other boys, but not exactly what.

The sense of difference as a child is undoubtedly linked to children's conceptions of gender identity and role.[1] It is through interaction with other transsexuals as adults that conceptions of women as a category are crystallized. Briefly, adult transsexuals view men and women as disparate beings, above and beyond sex-role dichotomies. To transsexuals, a woman has an inner essence, a way of thinking, feeling, and perceiving the world that is different from a male's quite apart from sex, although it most certainly includes sex-role attributes such as verbal and nonverbal behaviors. Thus transsexuals recognize, for example, that there is a major divergence between working on a car as a man and working on a car as a woman. This illustrates their belief that gender transcends sex roles to include an inner world of femaleness.

Childhood precepts about males and females as discrete categories are due to a number of factors: sex dichotomous socialization, self-socialization (e.g., children's observation of sex–typed behavior) (Maccoby and Jacklin 1974: 364), and culturally available images and stereotypes about the differences between the sexes. From these sources children assume gender dichotomies in sex role, behavior, and appearance (male and female children simply look different, including hair style, clothing, etc.). Little girls are perceived as being different from little boys. Later as *adults* these differences are viewed by transsexuals as occurring on a much more *profound* and *inner psychic level*, including ethno-theories that males and females have different world views.

As children, the sense of gender confusion or the feeling that they are more like little girls is clearly linked to the desire to wear the clothes of little girls and secondarily to looking like and acting like little girls. As previously mentioned, almost every transsexual has cross-dressed as a child. This is the most obvious behavioral indicator of their conflict, although it is difficult to ascertain the significance of cross-dressing in relationship to gender dysphoria. It is not possible at this time to determine if cross-dressing is a source of gender confusion or if gender confusion is a source of cross-dressing. From my research, cross-dressing and awareness that they were different from other children appeared synchronically. Transsexuals knew that it was "wrong" for them to wear girls' clothing. They knew this from watching other children and from direct parental sanctions. They found ingenious ways to gain access to the mothers' and sisters' clothing. One reported

hiding in the bathroom and locking the door. She would then rifle through the dirty clothes hamper and put on her mother's garments. Others would abscond with one article of clothing at a time and have a secret "stash" of female clothes in a toy chest or a drawer. Most of the transsexuals interviewed were caught at some point. Although the parental responses varied, all can be described as negative. One transsexual listed the phases of her mother's reactions: "It's a phase—you'll grow out of it." "It is wrong! If you do it again I'll take you to see the doctor." "Why? Why *me*? What did I do wrong?"

Another transsexual, discovered at fifteen, shrewdly told her father: "I want to be a girl so I won't get drafted." He responded with anger and confusion. Still another stated: "The first time I was beaten on the tail pretty good and the last time I was caught with girl's clothes on, my parents threatened to send me away to the nut house." One father, when finding his son cross-dressed as a woman at seventeen years old, would not talk to "her" for over a year.

Throughout childhood and adolescence parents often negatively sanction their children's cross-dressing. Some transsexuals are clever enough not to get caught, but still know it is wrong. An occasional parent lectures, then ignores, and refuses to discuss the female clothing hidden in the child's toy box, hoping it will go away.

I have uncovered some evidence of sexual arousal as a phase of cross-dressing in some individual's lives, although others reported having never experienced sexual stimulation from female clothing. Several examples presented below indicate the diversity of transsexual cross-dressing experience:

When I first started dressing [transsexual argot for wearing female clothing] simply putting on the clothes was enough to bring on an erection, particularly those that were constricting.

Sometimes the arousal has come from imagining being with a man and having sex with him as a real woman.

At first when I cross-dressed, the arousal was my inner self coming to the surface, but the only outlet was unfortunately the male parts.

At first it didn't matter what I wore, it brought out my inner self.

For a long time I thought I was a transvestite because I was aroused by female clothing. On some occasions I am still aroused but I think it is because of my being female, feeling my sexuality as a woman, and loving it.

It appears the arousal associated with dressing is more complicated than simple fetishism. The fear of getting caught may contribute to the excitement as children. However, as a more mature response, feeling like a female is itself an exciting aspect of cross-dressing. Transsexuals often outgrow whatever arousal is associated with it, although for some there does appear to be a sexual component at some point.

One transsexual summarized her adult views on the subject:

> As I am dressed more now as a female and very comfortable with it, I am seldom excited dressing except by a very good feeling of "being together" and that in itself is a special sense of excitement.

Cross-dressing and the desire to cross-dress are attributes shared by transsexuals in their developmental careers prior to group affiliation. They grow up confused, possibly thinking that they are more like little girls and uncomfortable as little boys, and having an awareness that they are different.

So profound is the sense of alienation that the possibility of suicide is a salient feature in their lives. This is confirmed by researchers who record a high incidence of suicide (Money and Schwartz 1969: 268), suicidal feelings (Randell 1969: 366), and suicide attempts (Pauly 1969: 43) among preoperative transsexuals. Estimates of attempted suicide by transsexuals range from 17 percent (Pauly 1965) to 20 percent (Walinder 1967, in Pauly 1969: 43). In a group meeting, Sasha asked approximately fifteen preoperative transsexuals if they had ever contemplated suicide; all had. Of the core group of twelve transsexuals, all had considered suicide, and four had attempted it. The methods included: 1. attempting to jump off bridge, but restrained by police; 2. barbiturate overdose, taken to hospital; 3. sleeping pills, found by friend and taken to hospital; and 4. passive attempt by stopping medication necessary for survival.

These attempts are indicative of the deep-seated alienation and isolation these people feel as they are growing up and trying to determine who and what they are. Coming to the awareness that their confusion is located in identity and role is a developmental process. Undoubtedly, the idea that they feel more like females becomes increasingly clear as they mature. The label transsexual helps explain their discomfort and increases their awareness of a female identity. It also provides a mechanism for consolidating their identities as females

trapped in male bodies and allows them to focus on their identity confusion as a specific issue of mind/body discrepancy.

Transsexuals find the label at various ages in puberty and adulthood and in different ways, although the media seems to be the most prominent source of information. Nationally known transsexuals such as Christine Jorgensen and Renee Richards (and others well-known locally) have had their stories in newspapers and magazines and have appeared on television. One transsexual described the experience poignantly:

> In 1973 I saw a magazine on a newsstand with an article entitled "Trapped in a Man's Body." Of course this touched me directly, so I bought it with, I'm certain, a brilliantly crimsoned face. It was a "true story" type of magazine and the story was surprisingly well written. The individual involved reminded me of myself more than once, and I remember crying after I'd finished reading the story.

Recognizing oneself as a transsexual serves as a centrally defining concept that reinforces the individual's concern over gender identity and gender role. Maccoby and Jacklin note that male or female gender identity may be more important as an essential "self-defining attribute for some people and not others" (1974: 359). While being a male or female may not be the pivotal core around which everyone organizes his or her personal identity, it is for transsexuals. The label transsexual, with its connotations of a female identity, exacerbates transsexuals' concern and sharpens their focus on the issue. I suspect that transsexuals are more interested in identity and gender role than most other groups of people. This becomes increasingly important as they have to prove to psychological evaluators that they indeed have a female core identity. Feinbloom suggests that gender identity is "at the core of all life and career choices" (1976: 148). This certainly was true for my research population, particularly when they found the label and each other. The whole process of becoming transsexual, and later becoming women, heightened their interest and awareness of personal and social identity.

The Berdache Society

The Berdache Society, consisting of transsexuals and transvestites, helps to refine and hone the transsexual identity. The meaning ascribed

to the label transsexual identifies what a transsexual is and what she is not. Affiliation with the Berdache Society is crucial for the transsexuals becoming first transsexuals and second women. Prior to transition, and in the early stages of exploring what it means to be a transsexual, people in my sample had a "virtual social identity" (how others saw them) as a "normal" male and an "actual social identity" ("[t]he category and attributes he [she] could in fact be proved to possess") as transsexual (Goffman 1963: 2). By virtue of the stigma of cross-dressing and not being homosexual, transsexuals and transvestites are predisposed to coming together outside the gay community (cf. Goffman 1963: 23–24). Once consolidated, groups based on the superficial stigma of cross-dressing can segregate and stratify identities more precisely and limit membership if they choose to do so.

It is not clear how transsexuals find one another or support groups, but transsexual networks are extensive throughout the United States. Support groups and organizations advertise in nationally known publications representing several large organizations for transvestites, transsexuals, or both. Because transsexuals and transvestites read everything they can find on the subject of cross-dressing, they are likely to find organizations catering to cross-dressers. Transsexuals also find each other rather inadvertently. Two transsexuals in this study met through a mutual friend in whom each had confided. The friend made arrangements for them to meet. Ironically, these two transsexuals had known each other when they were living in their male roles, having worked together.

Neither Drag Queen Nor Gay Man

Through intragroup interaction, notions of how transsexuals are special emerge as a consequence of the conceptual segregation of Berdache Society members from gay drag queens. This includes folklore and codes of behavior that differentiate transsexuals from gay female impersonators as well as from transvestites. Transsexuals rarely miss an opportunity to point out to a naive observer the distinctions between transsexuals and drag queens. Transsexuals define themselves as a special kind of woman occupying the wrong body. Their identity is female, which contrasts with gay cross-dressers who are not women inside, but are males without gender identity conflict. Newton dis-

cusses the drag queen opposition as an inside-outside dichotomy; the male is inside, beneath the sartorial system of the female that is outside. The inner or real self is male and the social self is an illusion of presentation (1977: 338–39). Transsexuals view themselves as the real participants in the inside-outside dilemma. Drag queens are perceived as only playfully fooling around with the system of gender identity and gender role.

Transsexual rhetoric about identities embodies the ideal state of becoming but does not represent the *process* of developing a sub-identity as a woman into a primary identity. A primary female identity occurs as a gradual development through the rite of transition that is in part a result of feminizing the body through hormones, dressing as women more and more, passing, and going full-time. This refers to the "doing" of the female identity in interaction (see Kessler and McKenna 1978: 126). But it is this formal line of rhetoric that also precipitates the metamorphosis of the subidentity into a primary identity as female. It operates as a perceived focus for organizing the transsexual's self concept.

Thus transsexual definitions, established in the Berdache Society and formalized into an official party line, stress that the transsexual, as opposed to the drag queen, has an inner female essence, covered by a male body. The transsexual is therefore not engaging in an illusion but in a concrete representation of her inner self, a formal explanation of the behavioral component of transsexual's internal condition. [2]

A second source of identity scrutiny that enhances the transsexual's identity as a female is through the drag queen as a member of the gay male community. Transsexuals do not perceive themselves as homosexual men, since, as women, they can choose males as sexual object choices, but not in the same way gay men choose other men. They also recognize cultural differences. They do not want to be part of the gay male homosexual community. They reject gay men because they treat them as men in women's clothing: drag queens. Time and again they point out that gay men, including female impersonators, just do not see the difference. For the transsexual, the difference is critical.

Therefore, not only are drag queens used as a counterpoint for identities, but so is the broader gay male community. These identities are used as boundaries for the transsexual identity because of the superficial similarities that are shared.

Transsexuals have developed lore about the differences in how drag queens (and other gay men who impersonate women) dress and present themselves as women, that further exemplifies a difference in inner essence. Transsexuals criticize one another for wearing what they called "drag queen clothes." Drag queen clothes are glamorous evening-type apparel, decorated with feathers, glitter, rhinestones, and anything else along that line. They include the kind of fashions that can best be described as "Frederick's of Hollywood": pants slit to the waist, plunging necklines to the waist, etc. This fashion is considered the kind drag queens wear, when presenting themselves as glamorous impersonations of women, more extreme and glamorous than genetic women. Transsexuals who dress this way are considered to have a suspect identity and are questioned by other transsexuals because real women—their ideal—do not dress that way.

Some allowance is made for a period of overdoing it (i.e., too much makeup, clothes too much akin to drag queens). Transsexuals recognize that dressing like a drag queen is part of a temporary learning phase in their transition. This mode of dressing is considered an expression of a fantasy of "how women are" that is replaced later by the doing of the female, accomplished by passing in public, and other lived aspects of being a woman. Exaggerated femininity in the style of the glamorous drag queen is considered part of learning to be a woman. As will be discussed later in chapter seven, exaggerated femininity is viewed by transsexuals as something that young females do in their own rite of passage into womanhood and which they, too, outgrow. Therefore, transsexuals are expected to outgrow hyper-feminine dress as part of a broader cultural norm based on genetic females' own transformation.

In the Berdache Society, one transsexual stood out as the "in-group deviant" (cf. Goffman 1963: 142–43). She violated transsexual concepts of their own normalcy as protowomen and women. This individual was known for her high-fashion hairstyles, reliance on wigs (even though she had a full head of hair), chic and extensive use of makeup, penchant for black satin and spandex, and clawlike, long fingernails. Even though she had been repeatedly sanctioned on these grounds and had tried to alter her choice in clothing, she continued to transform an average outfit through accessories into a glamorous high-fashion ensemble. This individual was suspect as to the authenticity of her transsexualism because she presented herself in drag queen

style. Like drag queens, her *modus operandi* was one of artifice and impersonation rather than naturalness.[3] Naturalness was the premise upon which transsexuals "stratified their own" (cf. Goffman 1963: 107). The absence of progress in the presentation of self as a natural woman, then, was the basis of in-group stigmatization.

The gay male community, in general, also serves as a defining characteristic of what transsexuals are not. Transsexuals in this research population, for the most part, were adamant about their disaffiliation with the gay male community, although its public outlets were occasionally used as an opportunity to cross-dress and test how well one was passing in a nonthreatening environment. For the majority, the gay community was not directly a source of identity brokerage as proposed by Driscoll (1971) and Newton (1972). Both Driscoll and Newton suggest that transsexuals consolidate their identities as part of a temporary sojourn in the gay male community. Driscoll proposes such a residency as a stage in the transsexual's career, attracting the transsexual because it provides the opportunity for and instruction in cross-dressing as well as the role of female impersonator (1971: 34). Through this temporary sojourn in the gay community, the transsexual learns she is not a male homosexual; through self-discovery and gay community sanctions she is a female and not a male. At that point, she leaves the gay community, according to these authors (Driscoll 1971: 66–68; Newton 1972: 51, 102).

Driscoll's inclusion of a homosexual stage may represent regional variation in transsexual career strategies. However, in my research population, only one transsexual, Sasha, spent any time in the gay community and actively participated in female impersonation. Certainly, the dynamics described by Driscoll and Newton are accurate, for the gay community is intolerant of transsexuals. But transsexuals locally have not had to participate actively in the gay male public outlets to find this out. The Berdache Society made information readily available that could be used by transsexuals to contrast their own identities with gay male identities. Here the Berdache Society was the identity broker, rather than the gay community, and it served the same functions that Newton and Driscoll report are a result of experience in the gay subculture.

Transsexuals independently report that they had in the past considered the possibility that they were male homosexuals. But because transsexuals familiarized themselves with the literature on cross-dress-

ing and because information was also readily available about the gay
male community, most did not have to enter the gay community
directly to recognize that they were not gay. For those who might
harbor any doubts, the Berdache Society presents ideal types of iden-
tities and domains for contrasting those identities. It becomes evident
to bisexual or heterosexual transsexuals that their interest in males is
as females, not as males. For others the sense of gender discomfort is
so prevalent that the issue of sexual object choice is only a secondary
consideration, subordinate to the problem of identity. Time and again
the motto is repeated: "We are transsexuals and our identity as women
is discrete from our sexual object choice of males, females, or both."

Sasha, the only transsexual to have spent any time in the gay com-
munity, originally met several gay female impersonators through a gay
public outlet catering to drag queens. In the process of getting involved
in female impersonation she came to realize that she was not like these
people. Her own homosexual stage precipitated her interest in forming
a support group for those like herself who liked to cross-dress but did
not relate as men to the gay male community. In December 1978,
one year prior to my own entrance into the Berdache Society, Sasha
began having meetings for nongay cross-dressers. She had no trouble
finding others who wanted such a support group. A gay community
center helped her out by providing information about her newly formed
group through their information service. The gay community center
had, in fact, been receiving phone calls from those who knew they
liked to cross-dress but who did not want to be part of the gay world.
In Sasha's words, "the gay community center just didn't know what
to do about them" so they were more than happy to provide her with
assistance.

Between December 1978 and September 1979, Sasha underwent
an identity transformation. She suspected she was a transvestite, but
was not quite sure. Meetings of her support group began with about
six individuals and rapidly grew. As the group evolved, two types of
cross-dressers attended the meetings: transvestites and transsexuals.
These people were living and breathing examples of two identity
choices available if one did not fit into the gay community. Through
group discussion and through the presence of transsexual and trans-
vestite role models, an ethno-theory of identity choice developed. The
unsure could pick one of two options. Sasha herself questioned her
own self-labeling as a transvestite. She cross-dressed more and more.

The more I dressed, the more I related to life as a female. I was looking at myself real hard. I had a difficult time being a male. I wanted to be a woman and it was hard to stop. I really didn't want to be a transsexual, I felt it was too hard to go through. I continued to talk in the group about thinking of myself now as a transsexual rather than a transvestite. We would argue back and forth, sort of like group therapy or a group encounter.

By September 1979, she had decided she was a transsexual. In April 1980 Sasha went full-time.

Through group interaction in the Berdache Society, transvestism and transsexualism emerge as two discrete identities with clearly defined attributes, associated lifestyles, and coping strategies. Members in the group who are clearly transvestites or transsexuals serve as role models, whereby identity choices are contrasted and played off one another. By removing obviously gay drag queens from the Berdache Society through a process of self-elimination and channeling, only two options remain: transvestism and transsexualism. Transvestites are heterosexual men who have an urge to cross-dress, but who do not become women; the Berdache Society provides them with an opportunity to learn how to cross-dress while offering support for their stigmatized behavior. Transsexuals, on the other hand, have an identity problem. Dressing as a female is something they continued to do as part of passing as women. They share cross-dressing with transvestites but are really totally different kinds of people with different needs from transvestites.

Strategies for actualizing these identities as disparate options are a product of small group interaction. Meyer has found that "opinions converge through group discussion." Thus, not only are the individuals' attitudes strengthened through group discussion, but these attitudes are polarized in the process of interaction through reinforcement of "shared dispositions" (Meyer 1979: 35–37).

The meetings, held twice a month, had become so large that shortly after I joined the Berdache Society, Sasha decided to have the meetings once a week. Because transsexuals wanted to talk about things that concerned them but held no interest for transvestites (such as getting hormones, going full-time, etc.) and vice versa, Sasha decided to alternate the meetings every other week so that one meeting focused on transvestite issues and the other on transsexual issues. In the jargon,

one was referred to as TV night and the other TS night. Anyone was welcome at the meetings, and there were always some transvestites who attended the transsexual meetings and vice versa because the meetings still provided an opportunity desired by everyone: cross-dressing.

The division of get-togethers into TV night and TS night polarized both groups and strengthened the commitment to each respective identity category. It also spotlighted the notion of identity discreteness. This polarization of transsexualism was at variance with Benjamin's etic model of a transvestite-transsexual continuum representing differences in the degree of gender disturbance (1966: 22) (see chapter one). Emically, there was no continuum, only two discrete identities that were culturally labeled and defined. Individuals could apply the label and assess its appropriateness via role models in the group, who were enacting the subculturally constituted definitions.

This polarization filtered out people who were somewhere in between these ideal types. I am not suggesting that the perspective of a continuum of transvestism-transsexualism is inaccurate. My focus is on the impact of an emic dichotomization that polarizes the two identity categories as qualitatively distinct and, in this research population, presents people with only two legitimate choices for ways to experience cross-dressing. There are no halfway measures. If one is transsexual, then pursuit of surgery accompanies one's transition. There is no identity option of living and working as a female without anticipating surgery, although people certainly exist who have adopted that lifestyle. This latter option would deny an individual status as a transsexual within this particular research population. In fact, the question of whether a person will have the surgery is a question of authenticity to transsexuals. Despite the difficulty in acquiring the funds to have the expensive surgical operation, transsexuals believe that if one really wants to have the surgery, a way will be found eventually. Thus, definitions of transsexualism and self-concept as a category "emerge from group interaction, which includes definition of people's actions and situations" (Kaufman 1981: 55). To be a transsexual is to participate in a strategy of action that culminates in surgery; not to do so is to be transvestite.

It is interesting to note that the political line, explained to new group members who might be unsure as to how they fit into this bimodal system of classification, was that the Berdache Society, unlike the

medical profession, does not pigeonhole people. Sasha's introduction at the beginning of every meeting included the statement: "The group will not tell you who or what you are." Yet the dynamics inherent in transsexual-transvestite interaction mitigated against this noble ideal. New members were presented with a well-formulated ideology of differences between transsexuals and transvestites as well as role models illustrating the reality of the dichotomization. There was structural pressure to conform to this idealized dual system and reinforcement for conforming.

The events at one Berdache Society gathering were indicative. An individual presented a biographical history of his cross-dressing, and it was not clear from his description whether he was a transsexual or a transvestite. Subsequently one of the group members came right out and asked him whether he was a transsexual or a transvestite. This was one of the more direct expressions of group concern over fitting people into a dual model of the cross-dressing world. However, this same categorizing occurred on a more subtle level whenever new people who were unclear as to where they stood attended meetings. Members who attended regularly would question them in such a way that it was obvious that they were attempting to ascertain the individual's status within the TV/TS format. Labeling someone transsexual or transvestite had become a metaphor for an identity and lifestyle and provided members with a script for how to relate to new people (e.g., what topics would they be interested in talking about, how could the member be helpful to that person, did they have common grounds for associating outside the group meetings, etc.). Members were more comfortable interacting with others who fell within the confines of the established classification system. Neophytes in the group became aware of this normative expectation and quickly learned that assuming one of the labels facilitated their incorporation into the group. They, too, found themselves attending more regularly either the TV or the TS night meetings and forming friendships on the basis of self-labeling and labeling of others.

The disparity between the two options was manifested in a number of inconspicuous ways. Transsexual humor and folklore illustrate some of the social and behavioral components associated with the transsexual identity that serve to further demarcate and segregate the boundaries between transsexuals and transvestites. Transsexuals tease one another by remarking that the transsexual in question is really nothing more

than a transvestite, or that she certainly passes well for a TV. This teasing occurs when the shadow of doubt has been removed, that is, when the transsexual is actively involved in the rite of transition and is living full-time. When the transsexual is living full-time, she has engaged in a behavioral analogue reflecting the depth of her female essence. She is doing something transvestites never do—living in the role of the female full-time. By living full-time she is doing the woman, not just occasionally expressing her fantasy of womanhood, like the transvestite. Transsexual banter expresses the sentiment that the individual really is a transsexual and a woman, for she has proved herself by going full-time. Although there are a number of transvestites who, when dressed as women, are remarkably realistic, transsexual ideology suggests that transsexuals would be better at it, after all, they are women inside. Additionally, the experience of feminizing their bodies hormonally, actually living in the role of women, and of being responded to as females, all contribute to a naturalness, a lack of artificiality in their social identity presentation that they believe transvestites can never equal.

A humorous story told throughout the transsexual grapevine illustrates this theme. Garnet, a transsexual who was living full-time, and a transvestite friend who was fairly good at passing, visited a local nightclub one evening. Garnet had gone to the ladies room and was standing at the mirror combing her hair and putting on lipstick. A woman was standing next to Garnet, also primping. The transvestite entered the bathroom and went immediately to the stall. Seeing the woman next to Garnet, "he" got nervous and left the bathroom, quickly passing directly behind the two standing at the mirror. As soon as the transvestite left, the woman grabbed Garnet by the arm and said, "Did you see that? That was a man dressed as a woman!" This narrative embodies the idea that transvestites, no matter how good they may be at passing, cannot compete with a transsexual who is living as a woman because she has the inside edge on naturalness.

Another humorous anecdote reveals the transsexual's total female core as opposed to the transvestite's male core. One transsexual, who was a makeup consultant for several transvestites, disclosed: "I can always tell when one of the transvestites has visited because the toilet seat is always left up." This tale demonstrates the transsexual's total concern with being a female including those sectors where no one sees her.

Personal pronouns used in reference further distinguish transsexuals from transvestites. Transsexuals insist on referring to themselves and one another with feminine pronouns. They seldom slip up and lapse into masculine pronouns. They prefer references consistent with the female identity, so that even when dressed in the male role, as might unavoidably occur at a meeting, they appreciate being referred to by feminine pronouns and by their female names. As transsexuals become more involved in the rite of transition, they increasingly view their male role as the masquerade; female names and female pronouns are considered symbols of the real self as a female and are cherished. When living full-time, transsexuals expect only female gender references, and correct those who might use the pronouns "he" or "him."

Transvestites are not consistent in pronoun reference with one another nor with transsexuals. The loose rule-of-thumb for transvestites is: as you are dressed, so you are. Thus, dressed as a female, female references are used, and, dressed as a male, male references are used. This general rule is casually and frequently violated as it is not uncommon to hear transvestites referred to as "she" and "he" in a single dialogue. Seldom do transvestites correct the speaker using mixed pronouns. Transsexuals find this inconsistency in pronouns aggravating and irritating when applied to themselves, but get confused and lapse into mixed pronominal usage in interaction with transvestites.

Because transsexuals are unwavering in their propensity for female gender references, certain problems arise when they are in their male role in public. There are certain situations they might not wish to disrupt by pronoun confusion, referring to an alleged male by her female name and feminine pronouns. It is far more difficult to keep transvestite gender and names straight because the rule of reference is so loosely observed. Everyone has difficulty as the following scenario illustrates:

One evening the Berdache Society had a special dinner in a gay restaurant.[4] Twelve transsexuals and transvestites attended, along with several wives of transvestites. All were dressed as women that particular night. After dinner, Leah, a transvestite, Nicole, "his" wife, and I went to the cloak room to collect our coats. Leah asked for the coats and then left to get something "he" had left on the table. The young man in the cloak room then asked Nicole if she wanted our coats now or would we wait. Nicole responded: "Not right this minute, I'll wait until my husband returns," whereupon she immediately corrected

herself: "I mean my wife." Realizing that was not satisfactory, she dissolved into giggles and said, "My spouse."

Notes

1. See Kessler and McKenna for a related discussion on how children attribute gender (1978: 81–111).
2. The formal explanation presents the ideal type. The individual did not really feel that she was expressing her inner essence until she assumed full-time status. Being full-time allowed for the final elaboration of the primary female identity at which point she rejected the label transsexual and the term passing and she appeared as what she was. See also chapter seven.
3. Becoming a natural woman includes learning and performing natural behavior (Kessler and McKenna 1978: 139). Transsexuals, through the rite of transition, learn to routinize their self-conscious performance as women so that at some point they become habituated to the presentation of self as female and it is no longer self-conscious. Becoming a natural female corresponds to a natural attitude toward gender prevalent in our society: that there are only two genders; these are not transferable; and "membership in one gender or another is natural" (Kessler and McKenna 1978: 113). People just are one sex or the other. Transsexuals, by the time they are ready for surgery, are what they have become and therefore must have vaginal construction as an essential symbol of their gender.
4. The gay community supplies one of the few public outlets where transsexuals and transvestites can venture out as a group. It is considered unthinkable for twelve transsexuals and transvestites to go out to dinner in a heterosexual restaurant. Transsexuals' passing lore maintains that for every transsexual (and/or transvestite) added to an outing, the chances of not passing increases. The gay community is regarded as a free zone because, even if they are recognized as cross-dressers, it does not really matter since gays are also stigmatized.

SEVEN

Becoming a Woman

Separation, according to Chapple and Coon, is a phase in which a "reduction or cessation of interaction occurs between the actor and his [her] previous interaction field" (1942: 485). Separation for transsexuals is a necessary prelude and attendant phase of transition. The Berdache Society is critical in this, for to be transsexual is defined by the group as equivalent with pursuing surgery. Through affiliation with the Berdache Society, transsexuals are presented with all the information they need to know to go about doing this. Because they know they must live as women, they must prepare to negotiate their social networks around this fact. Transsexuals whom they meet in the Berdache Society tell them about the importance of separation from their former networks as males and give them inside information on how to manage this separation. Separation is perceived as a practical solution to audience management and information control. It is also an important rite and symbolic expression of separation from a former identity.

The world is filled with people who expect transsexuals to be men and who will continue to relate to them as men, not women, even

when they go full-time. Transsexuals recognize that it is almost impossible for people who knew them as males to relate to them in their new roles as females, underscoring Kessler and McKenna's contention that "gender is a necessary background to every act" (1978: 136). Part of separation is to remove oneself from former male interaction fields. Transsexuals understand that people do not, in the majority of situations, relate to one another as just people, but as people of a particular gender. Transsexuals acknowledge that gender is responsible for sometimes profound and sometimes subtle differences in the way interactions unfold. Although gender may not make a difference in some situations, I suggest that it makes a difference in the majority of situations. Transsexuals state that they are treated differently as women, and this is borne out by those who have gone full-time. It is important to transsexuals that they be regarded as authentic women and this, at the very minimum, requires that the audience not know about their past. Cutting themselves off from former interaction fields increases their odds of being treated as females when they go full-time.

The audience is an important factor in their transformation as women. To be around people who only relate to them as females facilitates the ascendence of the female subidentity to a primary identity and helps them perfect their social identity performance. To divorce themselves from networks in which they are known as males is to divorce themselves symbolically from reminders of their past.

The audience is important for transsexuals in another way. They are engaging in a stigmatizing act which violates our society's "natural attitude" about gender (Kessler and McKenna 1978: 113). Not only do former associates have to be filtered out because of their continuing relation to them as males, but also because they would not understand or sympathize with them and would always be potential discreditors of their hard-won female identities. Transsexuals, in the course of separation, must therefore decide which part of their interaction fields will be "knowing," and which will not be (cf. Goffman 1963: 1,66). Separation is not just disavowal of former networks, but is a phase of distillation that includes informing certain people. Transsexuals are most careful about whom they tell. Once informed, the audience can be active in the phase of separation and choose themselves to sever ties with the transsexual. For those people of sufficient intimacy to be visitors to their homes, informing is preferable to an unexplained withdrawal. These people must be told because, in transition, trans-

sexuals will dress more and more as females, although they still lead double lives and work as males. For such friends, it can be more than embarrassing to have them drop by after work and to greet them at the door cross-dressed.

One audience that transsexuals always inform, if contact is maintained, is the family. Since none of the transsexuals with whom I worked were married or maintained relationships with former spouses and children, family consisted of parent(s), siblings and their children, as well as other peripheral relatives. The core group with whom transsexuals were concerned were parents and siblings. Informing the family of one's impending transition was particularly important if the family was local. Families who lived elsewhere could be kept in the dark, usually until transsexuals went full-time or were anticipating surgery in the near future. Needless to say, out-of-town visits could cause crises. Such impending events, when transsexuals are living full-time, necessitate informing parents prior to the visit. During full-time it is most difficult for transsexuals to revert to their male roles and hide female cultural baggage evident in their residences. Transsexuals prefer a gradual process of informing the parents and siblings before appearing in the female role.

Gaining acceptance and support from family members is very important. My research indicates that family response is rarely enthusiastic, although transsexuals desperately hope relatives will come to understand. In a few cases, parents completely accepted the transsexual's decision and were remarkably supportive, as in the case of Amara's mother who helped her with sewing and referred to her as "my daughter," although this occurred over a two-year period. The most general trend seemed to be a gradual acceptance over time (see Pomeroy 1975: 222–23), although complete and total rejection, as in the case of one transsexual's mother, was not unheard of. Most of their families reflected different degrees of acceptance but were in the process of becoming increasingly supportive.

Sometimes the family members will accept the impending transformation, but are concerned about the reactions of family friends and/ or other relatives. Very often the families are reconciled to the idea of transsexualism in theory, but are not able to confront actually seeing them dressed as females and/or are concerned over what their neighbors might think when they appear in female garb. Thus, some separation from the family occurs as a result of parental request. Transsexuals

are aware that family endorsement will occur only gradually and are patient in the hope that acceptance will follow.

Younger and older brothers stand out as the family members most resistant to the transsexual's quest for womanhood, while sisters and mothers seem to accept the transsexuals sooner than other family members. This trend seems to follow gender lines where transsexuals report that females were generally more understanding and sympathetic. Transsexuals invariably take a stance of patient waiting coupled with persistent but polite insistence that womanhood is their only option.

They are confronted with a myriad of responses from "Couldn't you be a homosexual?" and "Couldn't you be a transvestite?" to "Couldn't you just live as a woman, do you have to have the surgery?" While parents are concerned with the stigmatizing effects of transsexualism, they appear more concerned with the irrevocable surgery. There is general worry over the severity of the surgical conversion and that their offspring may make a mistake and be miserable afterward. They would prefer that their transsexual children live as women and risk stigmatization rather than have the surgery.

Time does seem to be the answer. Transsexuals work carefully on cultivating familial support. Transsexual strategies for coping with the family include the belief that they are indeed engaging in a most unusual experience and that it will take time for the family to understand it. Therefore, transsexual norms include never pushing themselves on their families. They continue to be loving and responsive to parents despite their rejection. If transsexuals are not visiting their families, they continue telephone contact. Transsexual ideology maintains that transsexuals should take a great deal of the responsibility for family acceptance on their own shoulders and assures transsexuals that it will eventually pay off, although this might take several years. And this strategy seems to work, for I have seen remarkable strides in familial acceptance and support over two years.

Familial acceptance is, however, a double-edged sword, for acceptance can also be a source of discreditation of the transsexuals' social identity as females. Transsexuals work overtime for acceptance into their family homes in their roles as females, yet because of history their families continue to refer to them by their male names and with masculine pronouns. Transsexuals are adept at politely but steadfastly correcting these misnomers. While transsexuals have purged from their

social network those who are likely to respond to them as males, their families are too important to them to eliminate for those reasons. Here, instead of separation, they engage in education. They understand that, for their families, male references are the most difficult habit to break. They strive to look as passable before their families as they can to encourage correct reference and conception of themselves as women. The use of male names and male pronouns is not only disruptive to the transsexuals' social identity performance as females, but is regarded as indicative of lack of acceptance of them as women. Transsexuals in transition regard their male roles and history as a charade. The use of male gender reference is a reminder of this charade, one they want to forget. Part of the forgetting is to have their audience, including their families, interact with them as females. The family is a critical theater in which they assert that they are women and have always been women despite family memories to the contrary.

The family is an arena in which a transsexual drama is enacted, one in which transsexuals hope they will be accepted, accepted as daughters and sisters. Separation from the family occurs as a last resort only if their families do the rejecting. Transsexuals are willing to engage in a process of re-education and put up with what they consider gender slurs in order to remain a part of their families with the hope that some day they will be accepted as daughters and sisters.

In meetings of the Berdache Society, parental and familial responses were often a focus of discussion. Transsexuals were congratulated on parental acceptance, and it was often a source of good news in the group meetings. Transsexuals consider it an important day in their lives when their parents refer to them by female names and use female pronouns. Some families are quicker to use female names and pronouns than others.

One transsexual remarked that a troublesome disparity might arise later between her relationship with her family and her attempts at maintaining her "line" as a woman with others who were nonknowing. If transsexuals bring unknowing friends into their families, their families may then cast aspersions upon the transsexuals' social identity by calling them by their male names and referring to them as "him" or "he." On the other hand, family members can be cohorts in their social identity performances. In fact, the family can be a most important source of authenticating their female role performances by legitimizing their biographies and history as women.

Familial acceptance is important on a symbolic level also. The family is the source of transsexuals' birth and nurturance as males and symbolically can be a source of their birth and nurturance as females. Thus, when their families accept them as females, refer to them by their female names, and use feminine gender references, it is a profound event in the transsexuals' lives, one in which their gender identity as females is given a retroactive credence. Through acceptance, the family contributes to the transsexuals' symbolic separation from a former field of interaction where they were born males and lived as males. The family is a significant battleground on which a symbolic identity war is waged. Familial reaction to transsexuals as females provides transsexuals with personal and social identity coherence: they not only "are" but "have been" females.

Familial regard of them as women is important, for the family has been their incubator and has the ability to negate their past roles as sons and brothers. The mother is especially important for her role in this symbolic rebirth. Just as their mothers once gave birth physically to sons, they can bestow symbolic social birth to daughters. Because an individual can only be a son or daughter, conferral of daughterhood by a mother is a statement of the death of a son. Separation, like transition, is alive with such metaphors of death and birth. The family facilitates transsexuals' separation from a symbolic field of interaction (life as men) and is active in contributing to transsexuals' recreation of their history as women.

During the phase of separation, transsexuals are separated to some degree from all former social networks. This includes male friends who would have trouble accepting the loss of a star intramural football player in a "good-old-boy" system. It is a matter of transsexual lore that former male friends have the greatest trouble accepting their transformation and are likely to be a source of rejection. Transsexuals then sift through their friendship networks and anticipate the individuals likely to be unable to adjust to their change. This serves several purposes: they do not have to cope with outright rejection; they eliminate those who would spoil their identity by revealing to other acquaintances what they are doing; and they eliminate those who would continue to relate to them as males. On the basis of experience it is presumed that males make the least effort to relate to transsexuals as women.

Transsexuals screen their female acquaintances in the same manner and divide them into the knowing and unknowing. In general, it is

anticipated which women friends and acquaintances will be accepting or rejecting. Transsexual ideology supports the contention that females are more understanding and will try harder to relate to transsexuals as women. This, too, is borne out by transsexual experience, where more female friendships are left intact than male friendships. Friendships with genetic women, like family, are highly valued by transsexuals. As will be discussed in the following section on transition, g.g.s possess a special magic, not by virtue of their vaginas but by their history as social women. Friendships with women are believed to facilitate the transsexuals' social identity performance where they can gain much in the way of learning to "think" like women and "act" like women by hanging out with women.

Finally, transsexuals need to prepare for a formal separation that is a necessary concomitant of assuming full-time status in the phase of transition. Transsexuals regard "changing over" (transsexual argot for going full-time) while remaining in the same work situation as the worst possible strategy, but it is one that some individuals take nevertheless. This is considered a terrible approach to information management, because work peers will continue to relate to transsexuals as males. Having an unknowing audience is considered essential for the transsexuals' development of their social identity as females. A new work situation where no one knows is considered an ideal opportunity to interact as if they were natural born women. (Identity management in the work sector will be discussed in detail in chapter twelve.)

The Rite of Transition

The term *transition* is a double entendre of etic and emic meanings. In the rites-of-passage model it is the liminal phase between statuses, where the individual is no longer in a previous status and not yet of a new status. It is a state of ambiguity reconciled by incorporation into the new position in society (Turner 1967: 94, 1974: 13–14; Middleton 1973: 388). The medical and mental health caretakers use the term to describe the period in transsexuals' lives when they seek caretaker surveillance over the agenda designed to weed out the women from the men. It is a period characterized by transsexuals' self-recognition as members of that category and one in which they set about the task of pursuing the surgery. From the caretaker perspective, transsexuals

are "in transition" when they go into therapy, begin taking hormones, prepare for and actually go full-time and work in the role of women. Transsexuals accept this medical-mental health terminology and will refer to themselves as in transition, using the same parameters.

Whether consciously or unconsciously, the caretaker's choice of this term also reflects symbolic equivalence with birth. Transition is a medical term associated with childbirth. It refers to the period of maximal cervical expansion prior to the actual birth of the child. Correspondingly, transition for transsexuals is the period prior to their final rebirth, when they become complete females, both socially and somatically. They return once more to the setting of their first birth, the hospital; this rebirth, overseen by representatives of the medical profession who first declared, "It's a boy," now declares them female. If this analogy has escaped the caretakers, then it must still be seen as more than just an ironic coincidence, reflecting the power of symbolic expression where changes in life situations are often expressed through biological analogues (see Van Gennep 1960: 3).

Transsexuals are self-consciously aware in many instances of their symbolic rebirth and are active participants in creating their own birth, overtly using biological and social metaphors to explain their progress in becoming women. In this manner, inner transformations are reinterpreted through outer changes as they become feminized and socialized into their social role as women. The medical agenda of transition that marks their progressive integration into society as women is transformed into something more than the mere accomplishment of tasks such as passing and going full-time. These are symbolic "enactments of cultural myths about sex roles" (cf. Read 1980:16), gender, and identity such that transsexuals become women by reference to genetic women.

When transsexuals enter transition, they lead double lives for a time. At work, they continue to present themselves as males, but at home the actual social identity of emergent women is articulated by dressing more and more as females and learning to pass. At the same time, their bodies are becoming feminized as a result of the hormones. When in the female role and in the process of learning to pass in public, transsexuals learn a myriad of techniques to cover their male physical attributes, verbal and nonverbal aspects of the male role they so long occupied, and any other information from their male past likely to disrupt their female role performance. The more they practice passing,

the more naturally they act as females, so that during the dual role phase, they gradually become habituated to their performance as women, and it no longer requires the self-consciousness that it did at first. Full-time provides the opportunity for their role presentation to become almost second nature. This, however, is a process beginning in the early phases of dual role occupancy and continuing through full-time.

Needless to say, the male role can become problematic for transsexuals as their bodies feminize and they become more natural and less self-conscious in their social identity performance as women. However, as passing increases, the male social identity is also in increasing jeopardy. The results of physical feminization can be hidden to some degree for some time, although changes become noticeable as body fat is distributed in the female direction, breasts develop and the results of electrolysis become apparent. Other indications of changes occur during the dual role in preparation for full-time. Transsexuals often grow their hair longer in anticipation of a more female hairdo. Many take voice lessons and learn to alter the pitch and intonation patterns of speech. Because transsexuals work on learning to alter their voices, it becomes difficult for them to switch back and forth between the male and female voices and speech patterns demanded by their double lives.[1] These factors, along with their growing habituation to general modes of behavior characteristically associated with females, can have a dramatic effect on their presentation as normal men. They then take pains to hide the effects of feminization so as not to discredit their status as males. Unfortunately, co-workers are often alerted to the changes in their appearance and performance. Homosexual seems to be the suspicion most likely aroused in co-workers, according to transsexuals.

The transsexual's progress is from a discreditable phase prior to transition, where the stigma of cross-dressing is hidden, to a dual role status, also discreditable, with an increment in visible stigma. The double life ceases when transsexuals feel they have feminized to the point that it would discredit their male status. The additional effort required, on the one hand, to conceal their female attributes when in the male role and, on the other, to conceal the male attributes as they learn to pass, triggers going full-time. At this point, they make the decision to change jobs and set aside money for a period of unemployment or notify people at work that they will be changing genders.[2]

In addition to a social identity transformation caused by hormones and a marked improvement in passing, a personal identity transformation occurs. The female identity is in the process of gaining ascendence over the primary transsexual identity. As they dress more and more as women, they feel they are really female. The male role now requires extra initiative in order to pass. This produces an internal stress that propels transsexuals into full-time status. One transsexual felt "positively schizophrenic." Dressed as a woman in public, she had to pass as a female; dressed as a male, she had to present herself as the man she no longer considered herself to be.

The period in which they are becoming females hormonally and are learning the art of passing by spending more and more time in the female role is a time of personal identity growth that ultimately leads to the rejection of the label transsexual. This occurs with and is exacerbated by full-time status. But again this is a gradual process of rejection coterminous with the emergence of a full-fledged female identity. Certainly, dressing the part of women, habituation to the role, and an unknowing audience reinforcing their performance as females, all feed back into the waxing of their personal identity as females. One major mechanism fostering their becoming, in terms of personal and social identity, lies in transsexual ideology where physical feminization and learning to pass is reinterpreted not as something peculiar to transsexuals, but inherent in womanhood itself. Thus they embellish their own biological metaphor. Transsexuals perceive themselves as undergoing the same rite of passage that genetic females participate in as they become women. This ideology is built on a biocultural model of womanhood, as well as on their own experience watching and observing young females as they are growing up.

A Biocultural Model of Becoming

Genetic females' maturation is a biological and a cultural development, marked by physical and social changes in status whereby biological growth is culturally designated and given broader social meaning (see Turner 1967: 93). Puberty for genetic females is a period of transition in which they will emerge as women from the previous state of being young females.

Although physically transsexuals are transforming themselves into

hermaphrodites as a result of female hormones, transsexual ideology reinterprets this as a maturation period or a period of puberty in which they are approaching womanhood analogous to genetic females. As a result of hormones, fat is redistributed so that transsexuals develop breasts and hips, and the waist, as a consequence, appears smaller (and may also actually become smaller) in proportion to their other dimensions. According to Gottlieb, these changes take about as long as genetic females' puberty (1980: 6).

Transsexuals' biological maturation is a metaphor for their womanhood. Feminization thus becomes more than just a biological change; it is a symbolic referent expressing cultural perceptions of the meaning of biological changes and facilitating the development of a primary identity as female. The metaphor, through the meaning transsexuals derive by comparison to genetic females, is transformed into something more: they are in reality becoming women, not just "like" but "as" genetic females. The analogy is internalized and integrated into transsexuals' self-concept such that an identity inversion occurs, the primary transsexual identity assumes an increasingly subordinate position, and the female subidentity becomes crystallized into a primary identity.

Their physical puberty is recognized as a life stage that all women encounter. They are, in fact, becoming women as women do, not like drag queens and transvestites who are creatures of artifice and impersonators of women. Transvestites and drag queens are considered ersatz women, while transsexuals are becoming real women, for they are encountering the same somatic changes that accompany young females' transition into womanhood. This aspect of the phase of transition is one possibility in which the phenotypic changes are a symbol of transsexual parturition as women. It is a symbol of an inner process given substance by the outer change.

Transsexuals turn the outward inward. Their maturation is not just a key to passing (although it certainly gives credibility to the social identity dance), but to naturalness, where they no longer need breast and/or hip padding. The development of a female somatotype eventually leads transsexuals to reject the notion of passing and the label transsexual, for they are merely presenting themselves as they are—as women.

Transsexuals are self-conscious about their maturation. They wear their newly developing breasts proudly, declaring: "That's all me."

They are keenly aware of their own breast development and that of other transsexuals, too. Again they are "as" genetic women, developing at different rates with maximum breast development varying between individuals. As soon as some breast development is perceivable, they discard the padding and brassiere inserts, and wear thin bras or no bras at all. They keep track of growth by brassiere cup size. Changing from an AA cup to an A, or from an A to a B cup size, is a significant event shared and announced. Their fascination with their breast development is akin to that of genetic females in puberty who evince their concern in much the same manner as transsexuals.[3]

Despite the drop in libido that is a concomitant of hormone therapy, transsexuals' breast growth is accompanied by a sense of impending sexuality. Because their breasts become tender and sensitive as they enlarge and because in our society breasts are erotic symbols, transsexuals are imminently aware of themselves as sensual beings. In plain words, they feel sexy about having breasts on their bodies even though libidinal interest has declined. In this way they view themselves as genetic females whose puberty is culturally regarded as a period of sexual and sensual awakenings.

The period in transition in which they are developing is verbally acknowledged as their own puberty. They say, "I'm in puberty now," or "I'm just a teenager," reckoning age not on actual chronology but on the biosocial analogy.

In the present discussion, then, puberty is viewed not just as a biological event but one that is rich in cultural denotation. Transsexuals utilize the concepts of their own culture to construe their own transgender experience. This fosters a metamorphosis from the cocoon of a little girl, where their female identities are mere fantasies, to full womanhood, where the female identity emerges as cause and effect of the social meaning given to their neopuberty.

Puberty is also regarded as a period of socialization. As pubescent females, transsexuals experiment with the available images of adult womanhood in American society. They explain that the female in puberty will also wobble in high heels and wear outlandish high-fashion makeup and exaggerated clothing as they investigate women's cultural baggage (see n.3). Transsexuals view their own early passing attempts as analogous to this experience. They look back on their hyper-feminine and super-chic clothing, exaggerated makeup and hairdos, and learning to walk in high heels as part of their puberty.

These extremes are regarded as legitimate because genetic females themselves must experiment as teenagers before a mode of presentation is finally reached.

For transsexuals, genetic females' rites of passage into womanhood are their own. It is part of transsexual rhetoric that physical and social maturation is the idiom of their own becoming. Their puberty is not just a metaphor but a reality of transformation that accompanies and organizes the development of a female gender identity and the learned parameters of that identity.

No Longer a Transsexual

Full-time is the period in which the final transformation of the female identity ensues. During full-time, transsexuals have the opportunity to become completely habituated to their female role performance. They become much less self-conscious about passing. Passing during full-time unfolds as an incrementally spontaneous performance that becomes natural. By extension they also become natural women. This is a process of creating a lived history as women, women who have undergone puberty and who are establishing their adult status as women. Their transition is a reiteration of their progress out of ambiguity and into coherence. They are on their way to becoming whole people.

Going full-time is an important event in the lives of transsexuals, and it is regarded as a very special phase of their identity development. After their dual role, in which they become more like women as a consequence of the dynamics previously described, going full-time gives transsexuals access to really being women. It is here that the doing of the female every day, including interacting with others only as females, gives transsexuals an inside edge on knowing how it feels to be female. Transsexuals agree that there is something magical about the full-time position because of the internal changes in identity and perspective that occur. By analogy with genetic women, part of what makes them women is their doing of womanhood everyday, and this then is what all transsexuals must do if they were are really ever to become women.

As transsexuals feel, act, portray, and approximate genetic women, they begin to reject the label transsexual. This is manifested in "af-

filiation cycles" (Goffman 1963: 20,38) in the Berdache Society where affiliation with their own declines. They had, through their own becoming in full-time, tasted normalcy and were accepted by naive audiences as natural women. And "[p]resumably the more an individual is allied with normals, the more he [she] will see him [her]self in non-stigmatic terms . . ." (Goffman 1963: 107). Transsexuals are presented with the choice of remaining transsexual and hence being stigmatized by continuing group association, or becoming women, normal members of society.[4]

The desire of all transsexuals in the group is to disappear into society as women. They have spent a lifetime of not belonging and feeling out of place in their male gender roles. Unlike many other minorities, they wish to escape their stigmatized transsexual status, not to destigmatize transsexualism. Continual affiliation with other transsexuals in the Berdache Society meetings is therefore a situation where they will continue to be labeled transsexual. Although they have learned a great deal from the Berdache Society, it has outlived its usefulness. In response to the question of why they did not continue to attend meetings, transsexuals replied: "They are all younger than me"; "I've outgrown the group"; "It has nothing more to teach me"; "I've been through all the stuff they're talking about, and it bores me."

During full-time, transsexuals continue to associate with their own age mates construed in terms of physical feminization and passing ability. These are people who in transsexual argot are as far along; who, in this case, are either rapidly approaching full-time or who are full-time. Full-time (and even postoperative) transsexuals would return to the group meetings for ceremonial visits where they acted as models of "normalization," (see Goffman 1963: 30, 31), showing the younger transsexuals what they could look forward to as they progressed through transition. By returning to the group they acted as models of becoming for the other younger transsexuals and revealed inside information about problems and successes in full-time.

The Berdache Society is regarded then as a temporary association, coterminous with a temporary phase in a transsexual identity formation. It provides support, reinforcement, information, instruction on passing, role models, and an ideological system with norms for how men become women. Transsexuals all recognize the importance of the group in their lives, and they recognize there would be a time when they would leave the group. This was invariably correlated with anticipating and going full-time. Even Sasha, the director, had severed

ties with the Berdache Society to some degree, although she continued to attend the transsexual meetings in her official capacity. She had, however, discontinued meetings at her home, explicitly to create a more normal environment, where she could preserve her reputation with her neighbors as a natural woman. This occurred when she moved to a new apartment and had the opportunity to create a network of people who knew her only as Sasha the woman, not the transsexual.

From a single event in the Berdache Society meetings, it was possible to assess the transsexuals' progress in transition and to recognize those who were beginning disaffiliation or who had disaffiliated from the group. Invariably, Sasha (who because of her position as director was in some ways unique) began the meetings with: "I'm Sasha and I'm a transsexual," followed by introductions all around the group. Those who were about to, in the process of, or who had, separated from their own, would introduce themselves by their female names only, while the youngsters and transvestites followed the name with the label transsexual or transvestite or an occasional "don't know."

With this simple act, those approaching or in full-time status not only expressed their primary identities as women but rejected the label transsexual as stigmatizing. Being transsexual is therefore an identity phase to be outgrown as one becomes a woman and seeks normalcy. Where the label transsexual was once a godsend, providing a category around which to focus their identity, it now became a dirty word and a strong discreditor of the claim to womanhood.

Ironically, as they become established in the female role and are in a transition from ambiguity into order and are incrementally integrating into society, their penises become more and more gender attributes of liminality. As they feel and look the part, their penises become glaring symbols of the limits of their incorporation into the female role and indicative of the fragility of their incorporation into society. During full-time the desire for surgery intensifies as the penis is increasingly perceived to be an attribute discordant with the female identity. It is the symbol that perpetuates their subidentity as transsexual, as well as a constant reminder of their past. After surgery transsexuals try to forget about their male history, although to some extent they always have a transsexual subidentity because they always need to edit part of their history. However, the transsexual subidentity becomes less important after the surgery as a component of their total identity.

Their success in the full-time role and their ability to pass and to

get jobs as women indicates to their caretakers their readiness for surgery. If they have done all this and still want the surgery, then to the caretakers they are a good surgical risk. The two in combination result in a favorable recommendation for the surgical conversion. Transsexuals are therefore legitimized by their female identities and through their social identity performances in the eyes of those who control the surgery.

The tension created by the incongruity between penis and identity leads transsexuals to request their primary caretakers for an evaluation for surgery. The more they live full-time, the more they want the surgery, and the longer they have lived full-time (a minimum of one year), the more inclined their caretakers are to provide them with favorable evaluations. They are at this point totally prepared for surgery. The agenda they have followed and the transsexual ideology underlying the agenda have served to soften each step of the transition so they are finally ready and there is no turning back.

The surgical conversion punctuates the culmination of their transition. It is their passage out of liminality and is a symbolic and ritual event dramatizing their exit. Surgery consummates a journey that is regularized, patterned, and clearly defined. By the time of surgery transsexuals have become, both in personal and social identity, women, limited in their transformation only in those areas where the body is important.

Notes

1. Voice lessons are undertaken at various times during transition. Many wait until after they have gone full-time for just the difficulty cited. It requires too much effort to switch in and out of male and female voice patterns.
2. Consideration of the employment situation will be discussed in chapter twelve. The strategy endorsed by transsexuals is to quit one's job and then go full-time, living on savings for a while until a new job as a woman can be acquired. The worst strategy, and sometimes unavoidable, was to go full-time on the job. One transsexual had not only taken this latter strategy, but she had also violated transsexuals' beliefs about the proper scheduling of events in transition. Under the influence of her therapist Hope, Lydia had chosen androgyny as the idiom of her transition. She had informed her employers of her transsexualism and was gradually feminizing herself. She was not like the transsexuals who had lived double lives, attempting to hide

the effects of physical feminization but gradually allowing them to be apparent. Hope endorsed Lydia's strategy as one in which the individual would go through a phase of being unrecognizable as either male or female, but embracing both. Transsexuals thought this was a poor strategy in violation of the rules of conduct of the way a transsexual should pursue womanhood. Transsexuals supported the notion that there are only two sexes. For the transsexual to pass as a woman was one foot in the door of normalcy in a dual gender system. Androgyny to transsexuals was an unnecessary and stigmatizing route to womanhood.

3. It must be remembered that this population of transsexuals was of a modal age of over thirty. Their perceptions of little girls' puberty as a cultural phenomena were influenced by the era in which they themselves were growing up. The cultural information about how little girls experience puberty, which was also responsible for the transsexuals' biocultural model of womanhood, may reflect some culture lag. Many Americans are trying to raise children in a nonsexist milieu. The nontraditional socialization of children will undoubtedly affect the manifestation of children's rites of passage into adulthood and influence the meaning of puberty as a biocultural phenomenon.

4. By normal, I refer to a status of nonstigmatization as transsexuals and acceptance as natural women.

EIGHT

What Kind of Woman?

Transsexuals are not the only people concerned about who and what they are. Researchers in the field are also interested in the kind of women transsexuals are. Kind is operationalized in the literature as a broad construct that is based on stereotypes of womanhood found in our society. One recurring theme is prominent in the literature: transsexuals are regarded as hyper-feminine. Hyper-femininity is defined in a variety of ways and includes psychological tests of masculinity-femininity (Kando 1973: 19), endorsement of sex roles based on test behavior (Kando 1973: 24–25; Raymond 1979: 85; Money and Tucker 1975: 206), self-description (Raymond 1979: 78), and career aspiration (Kando 1973:14–15; Driscoll 1971: 66, 68; Raymond 1979: 78).

A number of authors have contributed to this picture of transsexuals as more feminine, in a stereotypical sense, than genetic women. For example, Kando, using a masculinity-femininity index and a test of attitudes towards cultural definitions of masculinity and femininity, found "[t]ranssexuals were . . . more feminine than the two other gender groups [a control population of males and females] and also more conservative in their endorsement of traditional sex role defi-

106

nitions" (1973: 19–24, 31). According to Raymond, "most transsexuals conform more to the feminine role than even the most feminine of natural-born women" (1979: 79). Kando (1973: 81), Driscoll (1971: 66, 68), and Raymond (1979: 78) agree that transsexual career strategies focus on marriage or traditional female occupations. One caretaker, in a personal communication, even stated, "[T]hey all want to be pom pom girls . . . [and] are waiting to serve their expected knight in shining armor." The latter notion is also repeated by Raymond (1979: 78). Transsexuals are described as hyper-feminine and more traditionally female in every respect (self–perception, presentation, behavior, attitudes, career choices, etc.) than genetic women. The question is: are transsexuals as stereotypical as this research suggests? My research indicates otherwise. Transsexuals in this population were as diverse, apart from life-long gender conflict and a shared history of cross-dressing, as the genetic females whom they emulated. What, then, can account for this stereotype prevalent in the literature?

Hyper-femininity, in the broad terms described, may be an artifact of the medical-mental health caretaker system and particular gender identity clinics where transsexuals are intensively involved in programs designed to turn them into women. Raymond notes that the medical and psychiatric communities reinforce sex-role stereotypes (1979: 91). This may, in part, be a product of evaluative procedures for surgery, in which the medical profession and psychiatrists (dominated by males) employ their own stereotypes of women in judging how well transsexuals' appearances, presentation, and sex-role performance fit into their conceptions of womanhood. In this regard, Kessler and McKenna report that one clinician

> said that he was more convinced of the femaleness of a male-to-female transsexual if she was particularly beautiful and was capable of evoking in him those feelings that beautiful women generally do. Another clinician told us that he uses his own sexual interest as a criterion for deciding whether a transsexual is really the gender she/he claims (1978: 118).

One transsexual in my research population, a bisexual feminist who liked to wear jeans and tee shirts, stated, "Shrinks have the idea that to be a transsexual you must be a traditionally feminine woman: skirts, stockings, the whole nine yards." Other transsexuals confirmed this view.

Transsexuals, through the grapevine, literature, and personal experience, know that hyper-femininity is an expectation of caretakers. They also are aware that many male caretakers utilize their own male versions of womanhood, relying on stereotypes of women. Rather than re-educating their male caretakers, many choose to conform to caretaker expectations, realizing this would facilitate the desperately desired surgery.

Transsexuals who are vulnerable and who have no support group to mediate caretaker conceptions of transsexualism may well fall prey to their caretakers' expectations of how they should look, act, and appear. To reiterate Amara's words: "You must conform to a doctor's idea of a woman, not necessarily yours." Transsexuals, without a support group and concomitant transsexual ideological system that addresses the issue of who and what women are, may be prone to accepting male caretakers' conceptions of womanhood and reject the diversity of styles, strategies, roles, and presentational modes reflected in the population of genetic women. Therefore, transsexual hyper-femininity may be a result of a system in which "transsexual candidates are judged on the basis of what a man's view of a 'real woman' is" (Raymond 1979: 92).

Another critique of transsexual hyper-femininity can be leveled at the methods used to determine psychological masculinity and femininity. Are psychometric tests or other instruments of masculinity and femininity measuring what they claim, i.e., identity? Given a group highly motivated to score femininely on index questions, the internal validity of the testing instruments must be questioned. Transsexuals, aware that such tests could be used to evaluate them as candidates for surgery, deliberately select the most traditional and conservative responses to impress caretakers with their femininity.

These indices of identity are fairly obvious since the primary way to construct a test of masculinity and femininity is to use cultural stereotypes of how females are different from males in a variety of domains such as attitudes, aspirations, career goals, and endorsement of stereotypes (see Kessler and McKenna 1978: 9). Kando's masculinity-femininity scale is one such example. The following items, representing some of the scale's five subareas (attitudes, skills and responsibilities, occupational roles, other roles, and gender attributes), are illustrative:

I (would) love to have children.

I am the primary supporter of my family.

In general, I (would) submit to my husband's (wife's) decisions.

Engagement and wedding rings are very important to me. (Kando 1973: 93).

It is not difficult to score femininely on scales such as this one because they utilize such blatant stereotypes.

Four transsexuals in my research population took the Minnesota Multiphasic Personality Inventory given by a local psychologist in order to fulfill requirements for continued hormone therapy. Information about this test, what types of questions were asked, and a strategy for answering, rapidly spread among these transsexuals. All scored femininely on the index, and all claimed it was not difficult to see questions directed at the issue of masculinity and femininity. Therefore, an individual's desire to score femininely when she believed her hormone therapy or surgery was at risk could offset the validity of such tests.

The aforementioned critique raises another question about test validity. Do masculinity and femininity indices necessarily tell us how an individual will live her life in terms of the stereotypes elicited on a test? This is the words-and-deeds dilemma raised by Deutscher (1966). Deutscher questions whether behavior can be predicted from verbal or pencil and paper endorsement (1966: 236–37). Perhaps transsexual femininity can best be seen in everyday interaction, in the living of their roles.

If those selected for a surgical program are only those who score most femininely, then feminine scores will reflect a bias in sampling. Those who do not score femininely will be excluded from a gender program. These individuals may well seek surgery elsewhere, as Meyer and Reter found in 26 percent of a sample of patients who applied to the Johns Hopkins Gender Identity Clinic (Meyer and Reter 1979: 1013). Individuals who are selected out of programs because they do not score highly on femininity indices are eliminated from the data on transsexuals, although they may in fact be transsexuals. Thus, the evidence that transsexuals are more feminine than genetic women denies the variation in the transsexual population because of bias in the process that selects for surgery the hyper-feminine transsexuals or those who are savvy enough to score femininely on identity indices.

In attempting to assess the validity of the hyper-feminine stereotype of transsexuals, I gave fifteen transsexuals the Bem Sex Role Inventory (Bem 1977: 319). This is a scale that measures masculinity, femininity, and androgyny. To check test validity, participant-observation was also used to observe transsexuals in their everyday lives.

The Bem Sex Role Inventory (BSRI) "is designed to measure the extent to which a person's self-definition is masculine, feminine or androgynous" (Bem 1977: 319).[1] In this test, a series of positive traits that are deemed more desirable for one sex than the other are interspersed with neutral characteristics. An individual's masculinity and femininity scores are based on the degree to which he or she defines him or herself in terms of these stereotypical characteristics. Each individual has two scores originally, a masculinity score and a femininity score. From the masculinity and femininity scores an androgyny score is compiled as an index of the coexistence of both masculinity and femininity in an individual's self-concept. The androgyny score itself produces a continuum of scores which range from androgynous, near-feminine, and feminine in one direction, and from androgynous, near-masculine, and masculine in the other direction.

The androgyny score, according to Bem (1977: 322–23),

> reflects the relative amounts of masculinity and femininity that the person includes in his or her self-description, and, as such, it best characterizes the nature of the person's total sex role. Thus, if a person's Femininity Score is much higher than his or her Masculinity Score (that is, if a person describes himself [herself] as being much more feminine than masculine), then we think of that person as having a feminine sex role. Similarly, if a person's Masculinity Score is much higher than his or her Femininity Score, then we think of that person as having a masculine sex role. In contrast, if a person's Masculinity and Femininity scores are approximately equal (that is, if there is really no difference in how masculine or feminine a person thinks he [she] is) then we think of that person as having an androgynous sex role.

The weakness in Bem's system is that it cannot a priori be assumed that endorsement of stereotypical characteristics on the BSRI is necessarily a concomitant of a person's "total sex role." Presumably one's sex role is not only an internal phenomenon of the psyche, but is also lived, behaved, and acted. How well does this test predict behavior?

Following Bem, fifteen transsexuals in my sample who completed the BSRI were given androgyny scores and placed in one of the five possible sex-role categories of that system: feminine, near-feminine, androgynous, near-masculine, or masculine (1977: 322–23). Two other categories have, of necessity, been added: borderline androgyny and near-masculine, and borderline near-masculine and masculine. Table 3 presents the Transsexual Androgyny Scores.

Bem used two sources of comparative data. One data base consisted of approximately 1,500 undergraduate students at Stanford University. These data were broadly analyzed according to three categories. The four sex-role categories other than androgyny were conceptually collapsed so a student was scored according to whether he or she was androgynous, appropriately sex-typed, or cross sex-typed (that is, whether the individual's score was in accordance with gender, so that a female scoring masculine or near-masculine would be cross sex-typed, etc.). Bem reported that "[s]emester after semester, we find that about 50% of the students are 'appropriately' sex-typed, about 35% are androgynous, and about 15% are 'cross' sex-typed" (1977: 323). Her second source of comparative data included two separate populations, a Stanford population of 444 males and 279 females, and a Foothill College population of 117 males and seventy-seven females. Test scores from these two sources were presented in terms of Bem's sex-role categorization system and male and female scores were segregated (1977: 323).

The transsexual scores from the Berdache Society can be interpreted in two ways according to the sex-typing system: by genital gender as males or by identity as females. If transsexuals were considered genetic males, then 40 percent were cross sex-typed (N = 6) in comparison with 15 percent cross sex-typed in Bem's Stanford University undergraduate test population. Only two transsexuals or 13.2 percent (possibly three if the borderline androgyny and near–masculine individual is included) were appropriately sex-typed in comparison to Bem's report of 50 percent appropriately sex-typed in her research population. These scores then do indicate some disparity from a nontranssexual population in the direction expected for transsexuals. However, as will be discussed, these scores did not really reflect how the individual perceived or performed her female role in society.

Although there was some expected variation in an obvious transsexual direction of cross sex-typing, these transsexuals fell well within

TABLE 3

Transsexual Androgyny Scores* (N = 15)

SEX-ROLE CATEGORY	SCORE	NUMBER OF TRANSSEXUALS
Feminine	+1.7	1
Feminine	+1.4	1
Feminine	+1.3	1
Near-Feminine	+.9	2
Near-Feminine	+.8	1
Androgyny	0	1
Androgyny	−.1	2
Androgyny	−.3	1
Androgyny	−.4	2
Borderline Androgyny and Near-Masculine	−.5	1
Near-Masculine	−.7	1
Borderline Near-Masculine and Masculine	−1	1
Total	—	15

Sex Role	Androgyny Score (AS)
Feminine	AS > +1
Near-Feminine	AS > +.5 and < +1
Androgynous	AS > −.5 and < +.5
Near-Masculine	AS > −1 and < −.5
Masculine	AS < −1

*After Bem's interpretation of Androgyny Scores (1977: 323)

the range of androgyny scores reported in the Stanford-Foothill data. Forty percent, or 46 percent (if the borderline near–masculine and androgynous individual is included), of the transsexuals were androgynous. This was higher than the 35 percent noted by Bem as an-

TABLE 4

Comparison of Berdache Society Transsexual BSRI Scores with BSRI of Genetic Women

	STANFORD FEMALES (N = 279)	FOOTHILL FEMALES (N = 77)	TRANS-SEXUALS (N = 15)
Percent Feminine	29	35	20
Percent Near-Feminine	18	15	20
Percent Androgynous	39	41	40
Percent Androgynous Borderline and Near-Masculine Borderline	—	—	6.6
Percent Near-Masculine	8	5	6.6
Percent Near-Masculine and Masculine Borderline	—	—	6.6
Percent Masculine	7	4	0

(Bem 1977: 323)

drogynous, but well within the androgyny range reported for both men and women in the Stanford and Foothill populations (Stanford males 44 percent and females 39 percent; Foothill males 55 percent and females 44 percent) (see Table 4).

If these transsexuals were regarded as females, then 40 percent were appropriately sex-typed compared with 50 percent for the Stanford population. Bem's more detailed classification (Stanford and Foothill) was useful here, for it facilitated comparison with Kando's study which found that transsexuals were more feminine than genetic women (1973: 22). Kando's scale was comparable to Bem's since both utilized prevalent cultural conceptions and stereotypes of women. According to Kando's hyper-feminine model, transsexuals should score in the feminine category to a greater extent than genetic women on masculinity-femininity tests. From the detailed breakdown of Stanford scores, 29 percent of the women at that school and 35 percent of the females at Foothill scored in the feminine sex-role category. In contrast, only 20 percent of the transsexuals (N = 3) scored in the feminine category. The BSRI scores of this population indicated that not all transsexuals

were more feminine than genetic women on a masculinity-femininity index. They, contrary to Kando's findings, illustrated a range similar to that found in the genetic female population. For a comparison of transsexual percentage norms with genetic women from Stanford and Foothill, see Table 4.

Are there other factors that could account for the discrepancy in femininity scores between this population and a comparable population such as Kando's? Both populations were small (Kando had a sample of seventeen), and this alone may be a factor. But there are numerous other studies that also conclude that transsexuals are hyper-feminine, and these include more recent works such as Raymond (1979). My role as an ethnographer, removed from the evaluative position of caretaker, undoubtedly had some effect. Because I had no influence on their psychological evaluations, transsexuals had no particular motivation to impress me with how feminine they were. In addition, the BSRI was not given until a year and a half of participant-observation had ensued and I was well entrenched in transsexual social networks.[2]

In order to assess the validity of the BSRI scores as indicators of transsexual sex roles as a lived phenomenon, four components of sex roles were observed: (1) appearance, focusing on the sartorial system; (2) career goals; (3) endorsement of the feminist movement; and (4) interpretation of womanhood. These four factors provided a method of evaluating transsexual hyper-femininity as lived, acted, and verbally endorsed. They were elicited and expressed in everyday interaction, repeated through time, presented informally and formally, and were *not* an artifact of the test situation.

Appearance

Employing shared stereotypes, a hyper-feminine appearance is one in which the transsexual would be expected to approximate a Madison Avenue version of the perfect woman, wearing makeup, skirts or dresses, stockings, and high heels. However, if the individuals taking the BSRI are analyzed in terms of their appearance (focusing on the sartorial system), there is no correlation between feminine BSRI scores and feminine dress as described above.[3] Neither does an androgynous BSRI score correlate with androgynous dress in which one would expect to see an abundance of unisex types of clothing.

A sampling of transsexuals indicated the variation in clothing expression and a lack of correspondence with BSRI sex-role categories. Elise, who scored borderline near-masculine and masculine, and Amara, who scored near-masculine, might be expected to dress like males or androgynously. Yet Elise and Amara did not choose a more masculine dress than the other transsexuals. Elise, for everyday wear, chose women's jeans and pants, favoring women's tops in lavenders, blues, and pinks, accessorizing with jewelry and earrings. She also liked to wear skirts and dresses for special occasions, and wore her hair in a permed, shoulder-length tousled style. Amara also wore jeans and feminine tops, but was just as likely to appear in a skirt or dress, depending on the occasion. She preferred the more professional look in clothing, favoring suits and conservative dresses. Paula, a postoperative transsexual who joined the group after her surgery and occasionally attended for ceremonial purposes, scored the most femininely on the BSRI. Yet I have never seen her in a dress or skirt. She wore little or no makeup, a short curly hairdo, and pants and blouses. Her choice of style of clothing hardly contrasted to the informal styles chosen by Elise and Amara. Just as Elise and Amara could not be characterized as masculine in appearance and dress, neither could Paula be described as particularly hyper-feminine in appearance.

The other categories did not indicate any correlation between BSRI scores and lived components of sex roles in terms of appearance. Rosemary and Sasha received identical scores in the androgynous sex-role category (they scored $-.1$). Rosemary was an ardent feminist who wore jeans, tee-shirts, and no makeup for most occasions. Sasha, on the other hand, preferred a professional look with feminine frilly touches such as tailored suits and blouses of soft materials with lace and other trim for public appearances. For more informal occasions, Sasha wore pants and blouses but usually added a blazer to these outfits, again giving her appearance a professional flair. Tanya, whose BSRI sex role was near-feminine, was the most hyper-feminine in appearance and was consequently stigmatized by the group for continuing to dress in this way (something she "should have outgrown," as the others have). She chose the Madison Avenue version of womanhood, with her high-fashion makeup and hairdos and exotic, sexy clothes liberally spiced with an abundance of black satin, white lace, and frills, as well as an abundance of accessories. If one only considered Tanya, her high score in the near-feminine category might be construed as

illustrating some correlation between BSRI score and lived sex role, but variation and lack of correlation in the rest of the transsexual population are evidence against such an interpretation.

Career Goals

Kando has characterized transsexuals according to a career-strategies model illustrating broader attributes of sex roles such as attitudes, aspirations, and lifestyle choices (1973: 38–39, 82). His system of categorizing transsexuals includes a typology of female roles: the house-wife, the show business woman, the aspiring housewife, and the career woman type (1973: 38). These types are allocated scores of respectability so that "one could assign a high respectability score to those transsexuals who play predominantly domestic roles and a low one to those who play professional roles" (1973: 81–82). Aside from the obvious sexist bias in this perspective, such a system denies the diversity of womanhood.

Can transsexuals be neatly classified into four types of women based on career options, and is it valuable to view these options in terms of traditional stereotypes? Is it legitimate to view the housewife role as a traditional expression of femininity when, in fact, this housewife may be someone who has worked at a career, endorses feminism, and has a raised consciousness about the value of that role as mother and socializer of future generations? Career choices in terms of occupation may not be indicative of an individual's self-concept as a traditional woman, but may, in fact, be due to an economic system where women are kept in traditional occupations.

Additionally, contemporary women often find themselves in a position of syncretism, subscribing to some of the traditional notions about women's sex roles and at the same time aware and supportive of new options for women. Sometimes women may endorse traditional ideas of female roles such as mother and woman behind the man, and in other cases, give new meaning and options to traditional ideas about women's careers. Just as women are complex and heterogeneous in their career choices and self-concepts, so are transsexuals. For example, those transsexuals scoring femininely or near-femininely did not unequivocally view themselves as future homemakers in a traditional system in which women raise children and men earn money.

In ascertaining career options for fifteen transsexuals who took the Bem Sex Role Inventory as well as an additional two who did not, only one individual stated the desire to be a traditional housewife and work in the home. This individual scored a borderline near-masculine and androgynous on the BSRI. The rest all wanted to have careers and, after surgery, all hoped to find someone to share their lives with in a monogamous relationship, although the partner need not necessarily be a man. None saw a conflict between having careers and having a significant other and/or a husband. For example, Sasha's approach to the issue of working in the home as a housewife was, "I could do a housewife number for about two years before I went crazy and had to go to work." Three specifically wanted to adopt children but knew that this might not be possible since adoption agencies check potential parents' biographies. Their transsexual status would probably be revealed and prevent them from adopting children.

Endorsement of the Feminist Movement

On the related question of feminism, again there was no correlation with scores on the BSRI and presentation of self as a feminist. Although there was diversity in the details of their views of feminism, all endorsed the aims of the feminist movement. As a general theme, transsexuals agreed that women should have the same rights as men and should not be discriminated against. They viewed the feminist movement as vital for women to achieve equality. Several of their comments are illustrative. Eunice (androgynous on the BSRI) stated,

> I don't agree with the extremist end of the movement ("peoplekind" instead of "mankind," that sort of picky garbage), but I agree there should be total equality in life between men and women: in the job market, in relationships, in life politics. For that matter equality should extend to all people, male, and female, black, brown, red, yellow, and white, everybody. Feminism is just one facet of the latter, basic human rights movement.

A BSRI near-feminine, Lydia, revealed that she was generally in favor of the feminist movement although she added, "I think too much animosity has crept into it, thereby negating a lot of the benefits the movement could be having on the general populace."

Some of the more militant statements were made by individuals who cross-cut the BSRI ratings. A near-feminine, Tanya, most traditional in her glamorous and hyper-feminine presentation as a woman, ardently said, "We need the feminist movement. If men think they can get away with what they have done in the past, they are in for some big surprises." Rosemary was equally vocal in response to a question on her view of the feminist movement: "Right on! As women we demand our rights, our dignities, and control of our bodies. And if we are not given them we will rise up and take them."

Contrary to the stereotype of transsexuals as hyper-feminine, reveling in traditional notions of womanhood to a greater extent than genetic women, the transsexuals in this population were not admirers of stereotypical womanhood. They were keenly aware of the feminist movement, wanted careers as well as someone to share their lives with, and represented styles of dressing as diverse as the female population they emulated. In general, transsexuals were all too aware of discrimination in the job market, as they alone had or would experience both sides of the fence in this sector.

Interpretation of Womanhood

Transsexuals, like genetic women, are a diverse and heterogeneous population. Their conceptions of women, when asked "What is a woman?" were combinations of traditional conceptions of female attributes synthesized with new ideas about womanhood. Transsexuals did not view women, or themselves, only in terms of traditional stereotypes employed on the BSRI, such as "childlike, understanding, warm, yielding." They thought of women as complex beings, at times subscribing to some of these traditional stereotypes but often including attributes that are stereotypically associated with the male role. Several of their responses are indicative of the diversity of transsexual conceptions of womanhood.

Amara (near-masculine BSRI): A woman is anything she wants to be. She differs from a male only by anatomy, choice, and sensitivity.

Rosemary (androgynous BSRI): She is a female human being, an incarnation of the goddess, a being of infinite strength and infinite fragility. She is different than, not opposed, but complementary to her brother. She is certainly not subservient to him.

Allyssa (androgynous BSRI): I think being a woman or a man is a way of relating to other people associated with characteristic responses from them. I am very unhappy with the male package and more comfortable with the female package.

Lydia (near-feminine BSRI): A woman is more able and free to express and act her feelings and is comfortable with this. She is soft yet strong, sincere, maternal in feeling and attitude, and aware of who she is. Women are better equipped than men to give love, more sensitive, more responding, and more aware emotionally. A woman can also be conniving, devious, aggressive, selfish. Many of these attributes are the result of social condition, but some I think are inherent to the female, e.g., more romantic in nature and more appreciative of beauty, more tender and more given to sympathy, to name a few. I feel the woman complements the male ego to the extent that both are compatible. She has a deeper understanding of what is human.

Garnet (androgynous BSRI): A female is feminine, loving and caring, sexy, provocative, and beautiful. She is self-sufficient, intelligent, understanding, and nurturing.

Paula (feminine BSRI): Women are as tough and as tender as men are and can be. It's easier for women to be tender because they are raised that way.

These excerpts are typical of the range of responses. Some regarded women in more stereotypical terms than others. The majority opinion was that women are a combination of characteristics typically assigned to males and females. The majority invariably viewed women as warm, loving, and nurturant, but also as independent, self-sufficient, and in charge of their lives. Partly because of their unique experience of having lived as males, most were highly sensitive to feminist issues. They, like genetic women, discovered what it meant to take a cut in pay and to be sexually objectified. They, like many women, felt the tug between traditional notions of womanhood and the new options and images of women in American society.

This particular group may be somewhat more adamant among transsexuals in their rejection of hyper-femininity because they were not involved in a gender program and not subject to males' conceptions of womanhood. They had actively chosen female therapists who had

different conceptions of womanhood. But, more importantly, this group was not hyper-feminine both because of their association with the Berdache Society and because of their social networks in which sanctions and norms developed around the issue of becoming a natural woman, a value on which the rite of transition focused. Real and natural was sanctioned positively, just as hyper-femininity was sanctioned negatively. This population may be seen to respond to the latter in their self-conception and lived components of social identity. Finally, this population was under no pressure to perform on tests or behave hyper-femininely for my benefit as an ethnographer.

Notes

1. For discussion of the many definitions of androgyny, see Raymond (1979: 154–63). While Bem describes androgyny as the simultaneous endorsement of both male and female attributes on the BSRI (1977:323), there is little concurrence on the definition of the term in the literature. Confusion arises as to whether androgyny refers to a psychological state or behavioral expression of sex roles. Neither is it clear whether androgyny includes masculinity and femininity as integrated constructs or whether these are expressed at different times in different situations (Masters, Johnson, and Kolodny 1982: 216).
2. Feinbloom, who also used participant-observation intensively in her investigation of transsexuals, has reached similar conclusions about their alleged hyper-femininity. She states, "[T]here is not one stereotype of the preoperative transsexual male or female and there is not a standard adjustment that all such people make" (1976: 151). She, too, regards transsexuals as a heterogeneous population whose occupations and lifestyles are diverse, citing examples of transsexual fashion models, hairdressers, prostitutes, and feminists. She attributes this diversity to the new options available to women today and believes that transsexual hyper-femininity in the past was a response to a more traditional sex role era (1976: 142, 158–60). As discussed in this chapter, I believe other factors are also responsible for notions of transsexual hyper-femininity, although I certainly think Feinbloom's contention is part of the picture.
3. In this discussion, feminine and masculine are employed in a stereotypical way, to provide a sense of transsexuals' styles of presentation. This discussion does not condone stereotypes, but merely relies on feminine and masculine as convenient descriptors based on shared assumptions.

NINE

Hormonal Management

Passing is the single most important facet of transsexuals' rite of transition. Although passing is a medical requirement that must be fulfilled, it means a great deal more to transsexuals. It is an all-fronts attack on their malehood with implications far beyond its prerequisite status for the surgery. It is a portent of their future lives as females. According to Garfinkel (in collaboration with Stoller 1967: 37), passing is "[t]he work of achieving and making secure . . . [the transsexual's] rights to live as a normal, natural female while having to continually provide for the possibility of detection and run. . . ."

Passing is a multifaceted and significant phase of transsexuals' transition. This chapter focuses on one aspect of passing: hormonal management. The four subsequent chapters provide discussions of other important aspects of the passing experience: "Strategies and Rituals of Passing" (chapter ten), "Full-Time Status and Passing" (chapter eleven), "The Economics of Full-Time" (chapter twelve), and "Transsexual Personal and Sexual Relations" (chapter thirteen).

It is a prerequisite of medical policy that transsexuals participate in a program of hormonal management prior to surgery. Transsexuals

121

look forward to beginning their program of hormone therapy that will continue to some degree for the rest of their lives. It is a significant event in the lives of transsexuals when they begin their hormonal regimen under the supervision of a physician and with the consent of a therapist. While transsexuals can acquire hormones on the black market without medical supervision, a medically monitored program is most meaningful. First, it initiates a time clock of substantiated hormonal management that is used for surgical evaluation in conjunction with full-time experience for evidence of adjustment to the female role. Secondly, a regular program of hormonal management produces systematic somatic changes that are not interrupted or negated as may be the case with black market hormones that are subject to the vagaries of the underground drug markets. In addition, there are sound medical reasons for a monitored program, specifically the health of the individual because hormone overdoses can, at worst, be lethal.

The transsexuals in this study were in various degrees of feminization due to the effects of hormones. Of the total population of transsexuals, including the twelve core members and four others, all but three were on a program of hormonal management, and these three were anxiously awaiting the therapy. The majority of this population was in a process of hormonal reassignment. They had been on their respective programs for varying degrees of time, ranging from three months to seven years.

Transsexuals regard hormonal feminization as a necessary component of passing, although, as several transvestites testified, it is possible to pass without this benefit. Certainly hormonal feminization makes passing easier. The medical rationale for hormone therapy mirrors the transsexuals' rationale: "to facilitate passing and to prepare the patients psychologically, emotionally, and physically for the surgery" (Billowitz 1981).

Transsexual hormone therapy consists of female hormones administered orally and intramuscularly. The primary female hormone is estrogen. Two types of estrogens are available: ethinyl estradiol and conjugated estrogen. The usual method of administration is oral: .1 mg. of ethinyl estradiol is equivalent to 2.5 mg. of conjugated estrogen. Both produce fairly equal breast growth in the individual, although ethinyl estradiol is considered superior by Meyer, Finkelstein et al. (n.d.: 1) in suppressing testosterone production. Transsexuals may also have supplements of conjugated estrogen administered intramuscularly

(Meyer, Walker, and Suplee n.d: 1–5). According to Karrie there are nineteen brands of oral estrogens available (1980: 1).

A secondary source of female hormones is progesterone (Meyer, Finkelstein et al. n.d.: 3). Progestational agents are administered either orally or intramuscularly as a supplement to the estrogen. Six brands of progestational agents are on the market (Karrie 1980:1). The recommended dosages of hormones for precastrated transsexuals, according to Walker, are (a.) 5 mg. of the conjugated estrogen, and after gonadectomy .625 mg. daily, or (b.) .1 mg. of ethinyl estradiol and .05 mg. ethinyl estradiol daily after gonadectomy (*The Janus Information Facility* 1980). The dosage of progestational agents varies (see below).

Research on hormonal management is an ongoing enterprise with a great deal of variation in treatment plans and regimes. Between 1977 and 1978, Meyer, Walker, and Suplee (n.d.: 1–9) evaluated the hormonal management plans of twenty gender identity centers. They found nine different therapeutic strategies. Dosages of conjugated estrogen varied from 1.25–7.5 mg. and, for those using ethinyl estradiol, the range was from .05–.5 taken daily. Two centers used a combination of oral and intramuscular conjugated estrogens daily (total intake 30–40 mg. every two weeks). One combined the estrogen therapy with the use of an oral progestational agent. Two did not add the progestational agent until after the gonadectomy. Five clinics subscribed to a three-week daily intake program of estrogen, but stopped the hormonal regime for the fourth week. This diversity of hormonal management strategies was reflected in the Berdache research population.

Transsexuals and their medical supervisors in this study favored the use of the conjugated estrogen Premarin and the progestational agent Provera. Of the nine hormone regimens reported here, all the preoperative transsexuals (N = 7) were within the dosage of conjugated estrogen suggested by Walker (1980) for the pregonadectomized genetic male (gonadectomy being the functional equivalent to surgery in terms of testosterone production). The three gonadectomized individuals (one postsurgical) were taking higher dosages than the .625 mg. of Premarin recommended by Walker (1980) but were within the range of dosages for the postsurgical transsexual used by five of the twenty centers in the Meyer, Walker, and Suplee analysis. Transsexual number 9 (see Table 5) was taking a higher dosage (3.75 mg. Premarin) than that prescribed by five centers whose range was from 2.3–3 mg.

TABLE 5

Transsexual Hormonal Management Regimes

TRANSSEXUALS (N = 10)	PREMARIN DAILY DOSAGE (MG.)	PROVERA DAILY AND WEEKLY (MG.)	MONTHLY INTRAMUSCULAR INJECTION OF ESTROGENS*
1	10	2.5	1 shot every 3–4 weeks
2	5		1 shot every 2 weeks
3	2.5	2.5	1 shot every week
4 (gonadectomized)	2.5 every other day		1 shot every 2 weeks
5 (gonadectomized)	5	2.5	none
6	2.5	10 every other day	none
7	2.5		none
8	5	20	none
9 (postsurgical, not member of core group of twelve, never affiliated with Berdache Society)	3.75	2.5 2 weeks out of 4	none
10	2.5	2.5	intermittently

*Transsexual unsure as to mg. content.

of conjugated estrogen and slightly under the regime of two centers whose dosage was from 5–7.5 mg. of estrogen for postsurgical transsexuals. Meyer, Walker, and Suplee suggest: "A typical regimen, however, would be 2.5 to 5 mg./day of conjugated estrogen before surgery and slightly less after, usually in combination with a progestational agent" (n.d.: 4). Six of the ten in Table 5, however, have systematically

added the progestational agent Provera to their regimen, and five have intramuscular supplements. Table 5 reflects the diversity of hormone management programs offered by the medical caretakers, and possibly local medical interest in individualizing the hormonal management programs to fit the client's specific needs.

One transsexual was a "cycling" transsexual; that is, she was following the regime set in five clinics that prescribe estrogen only three weeks out of four (Meyer, Walker, and Suplee n.d.: 3–4). There are some practitioners who believe transsexuals should cycle their hormones as females do, in an endeavor to emulate the genetic female's progesterone-dominated half of her monthly cycle. Thus, when Rosemary (number 9 in Table 5) took the progestational agent two weeks out of four she was, in fact, reflecting the woman's cycle. She noticed no adverse side effects from this hormonal program.

Another transsexual, who had acquired hormones on the black market from a transsexual and had taken them regularly for six months prior to placing herself under medical supervision, had cycled herself so that she stopped both her dosage of estrogen and an oral progestational agent five days out of the month. She reported mood fluctuations and irritability.

At one of the Berdache Society meetings, an endocrinologist was invited as a guest speaker. Although she had no transsexual patients, she recommended a regime of cycling. Her proposed program included three weeks of oral estrogens daily, followed by seven to ten days of a progestational agent in conjunction with the estrogen. This was to be followed by a week free of hormones. When asked about side effects like Pre-Menstrual Tension Syndrome (PMS), she acknowledged the possibility of side effects such as fluid retention and mood fluctuations, but suggested these could be treated with the same methods she used to treat PMS in her genetic female patients.

The transsexuals were not impressed with her cycling hormone regime. The majority of this population was antagonistic to the idea, reporting mood swings on those occasions when they briefly stopped taking their hormones for reasons such as scheduling doctor appointments, finances, etc. Elise pointed out an obvious drawback in the program from the transsexual perspective. She noted that for the transsexual, five days or a week without female hormones meant that her male hormones were not suppressed by a daily dosage of female hormones. Although undoubtedly there was some continuation of estro-

gen suppression of testosterone after one stopped taking the hormones, most reported rapid changes in mood when not taking hormones. Elise pointed out that genetic women "still have their female hormones in operation, the relative amounts of each just change. For a transsexual to stop taking female hormones could lead to an increase of testosterone production during the period she stopped taking them, unlike the genetic woman." Whether, in fact, this is true is not as important as the transsexuals' concern over the reduction of the hated male hormone.

The hormonal program of these transsexuals was partially a product of negotiation with their physicians. Here transsexuals actively participated by aiding the medical overseer in constructing a hormonal program with which they were comfortable. They were conscious of their own health and insisted on medical checkups regularly. There was no large-scale, local black market exchange of hormones because of transsexual concern over potential risk to their health. Occasionally, however, such hormones were supplied to an individual who was, for some reason, unable to maintain her hormones for a short period (e.g., finances, could not afford a medical checkup, etc.). Transsexuals as a rule worked in conjunction with local medical practitioners in actively monitoring their dosage and maintaining medical supervision. Only one transsexual endeavored to monitor her own program of hormone management. She established her own schedule after much reading on female hormonal cycles without her physician's knowledge. Her doses were at levels far above and beyond even the maximum dosage regimes represented by two of the twenty centers described in Meyer, Walker, and Suplee of 5–7.5 mg. of conjugated estrogen (n.d.: 8). She reached a high of 40 mg. of Premarin and 50 mg. of Provera before beginning reduction at mid-month. Because I knew she was hesitant to reveal her regime to others in the group for fear of negative sanctions, I presented her with information cited in Meyer's research and other "scare" information on the negative side effects of hormone overdose. In response, she agreed to reduce her dosages to conform to the standard recommendations. Approximately six months after this research was completed, news reached me that she had died of a heart attack. Apparently she had continued this program despite warnings from a number of transsexual friends who had come to know about her extreme hormone regimen, subsequent to my initial warning. It is not unwarranted, given her youthfulness, that the high dosages of hormones were implicated in her death.

Some of the physical changes produced by the hormones are "not readily reversible" such as infertility and breast growth (Berger et al. 1980: 4, 6). In addition, because there are potentially serious health hazards associated with hormonal therapy, "monitoring of relevant blood chemistries and routine physical examinations . . ." is necessary (Berger et al. 1980: 7). Some of the side effects of an overdose of female hormones include "thrombophlebitis, pulmonary emboli and the possibility of myocardial infarction" (Gottlieb 1980: 6). In addition, one must be careful if there is a history of cardiac disease (Karrie 1980: 1). This, in fact, led one transsexual to pursue a gonadectomy under the advice of a physician. A gonadectomy decreases the production of male hormones by 95 percent (the other 5 percent is manufactured by the adrenal glands), thereby allowing the transsexual to reduce the dosage of hormones after gonadectomy and/or postsurgically (see Masters, Johnson, and Kolodny 1982: 72). Careful monitoring, enhanced by transsexuals' interest in their health, facilitated the smooth transition of hormonal reassignment so that, for this particular research population, the issue of health as a possible source of interference in their social transformation was eliminated, except in the one case cited.

Hormonal therapy also results in well-documented reduction in the libidinal drive (Kando 1973: 6; Benjamin 1966: 49). Feinbloom (1976: 27) reports that after six months to a year of continuous hormone therapy, transsexuals become incapable of erection. The difficulty in erection is accompanied by testicular and penile atrophy (Benjamin 1966: 92). Masters, Johnson, and Kolodny note that although erection capacity is diminished by hormones, it can continue for over a year (1982: 67). Two transsexuals in my research population claimed to have the capacity for erection, despite constant use of hormones for two years. Another who had been taking hormones for six years steadily, stated she could still have an erection. These three qualified their information with the fact that their erections were infrequent and required substantial concentration and the use of fantasy.

The somatic effects of hormonal management are evident over the entire body. Breast development reaches an optimum after two years of uninterrupted hormone therapy. The areola increase in size, body hair decreases (facial hair is not affected), and head hair grows faster and thicker (Benjamin 1966; Meyer, Finkelstein et al. n.d.: 4–6). Weight gain is reported by Feinbloom (1976: 27) and noted by several of the Berdache Society affiliates, although Meyer, Finkelstein et al. (n.d.: 4–6) could not substantiate this. The general tendency is for

TABLE 6

**Transsexual Records of Measurement
Changes (N = 3)**

	PRIOR TO HORMONES	1 YEAR HORMONE THERAPY	2 YEARS HORMONE THERAPY
Transsexual 1			
Bust	37″	—	38″
Waist	31″	—	28″
Hips	35″	—	36–1/2″
Thighs	19″	—	20″
Weight	137 lbs.	—	132 lbs.
Height	5′4″		
Transsexual 2			
Neck	15–5/8″	15–1/2″	15″
Bust	38–3/8″	38–1/2″	41″
Waist	32–1/2″	30–1/2″	30–1/2″
Hips	37–1/2″	39–1/2″	39″
Right Arm			
Upper Arm	11″	11–1/2″	10–1/2″
Forearm	10″	9–1/2″	9–1/2″
Left Arm			
Upper Arm	11–1/2″	11–3/8″	10″
Forearm	11″	10–3/8″	11″
Right Leg			
Thigh	21–1/2″	21–1/2″	22″
Calf	14″	13–1/2″	13–3/4″
Left Leg			
Thigh	21″	21–1/4″	22″
Calf	13–7/8″	13–1/4″	14″
Nipple Diameter	1″	1–1/8″	1–1/2″
Weight	172 lbs.	158 lbs.	160 lbs.
Dress Size	20	16	16
Height	6′		

TABLE 6, cont.

	PRIOR TO HORMONES	1 YEAR HORMONE THERAPY	2 YEARS HORMONE THERAPY
Transsexual 3			
Bust	38″	—	38″
Waist	33″	—	29″
Hips	37″	—	38″
Biceps	16″	—	12″
Forearm	13″	—	11″
Thigh	22″	—	22″
Calf	15″	—	14″
Weight	165 lbs.	—	140 lbs.
Dress Size	16–18	—	12–14
Height	5′7″		

breasts and hips to develop in a direction of muscle diminution, reaching a maximum somatic expression that varies individually as a result of genetic potential (Meyer, Finkelstein et al. n.d.: 4–6; Gottlieb 1980: 6).

There was a great deal of individual variation in this population's breast development. Some individuals had visible breast growth as quickly as four months after the administration of hormones, while others took as long as a year before any breast growth was noticeable. One continued breast development several months beyond the two year period that is cited as the maximum time for growth, again illustrating variation in biological potential.

Transsexuals were entranced with their own feminine somatic development as a symbol of their womanhood and future role. They measured, recorded, displayed, and discussed their own breast growth. One reported a 2.5 inch increase in breast development in four months. Another noted that in a year she advanced from a "double A" brassiere cup size to a full "A cup" and was still growing, while a colleague claimed a "B cup" within the same time frame. Yet another stated she reached a "B cup" in three years as well as hip expansion of 2 inches in that time while her weight remained stable. She attributed her breast development to the fact that she began taking hormones

when she was only twenty and also had experienced a late puberty growth spurt as a young man. Three transsexuals provided records of measurement changes reflecting differential response to hormonal management. These are presented as illustrations of the impact of female hormones on the male somatotype.

Transsexuals were highly conscious of the changes in their appearance, and this was always a lively source of conversation, especially during the early stages of hormonal management and passing. One reported that her head hair was less coarse and softer, another noted improved circulation, and two claimed that facial hair was actually diminished, counter to evidence in the literature on the subject.

All cited evidence of the tranquilizing effects of the hormonal therapy. In this regard, Eunice, a preoperative transsexual who had been taking hormones for six years, stated,

> From the beginning I've noticed that estrogen acts as a tranquilizer, not to the point of a soporific, but merely a quieter to my nervous system. I do not become agitated as easily as before. Of course I assume part of the effect is psychosomatic. Also my emotions are much closer to the surface.

While hormones may have a tranquilizing effect by reducing anxiety, transsexuals noticed increased emotionality, "crying at the drop of a hat," and the prevalence of feelings to a far greater degree than before hormonal therapy. It is difficult to sort out the biological from the cultural because women's emotionality is an obvious cultural stereotype. Transsexuals, however, did not regard this negatively but rather took a positive stance on increased access to feelings.

Hormonal therapy was regarded by transsexuals as an important part of their transition and a necessary prelude to passing in the public sector. Although transsexuals would occasionally attempt to pass prior to hormonal therapy, the majority felt it was too risky. Increased success in passing was seen as a dovetailing of practice, instruction, and the feminizing results of hormone therapy.

TEN

Strategies and Rituals of Passing

It was commonly agreed that in order for transsexuals to create a coherent picture as social women they should spend as much time as possible cross-dressing. The Berdache Society provided a sympathetic ambience for early passing endeavors. Here transsexuals had a group of experts on the subject who had been watching and observing women all their lives, and who knew how to translate their knowledge of female presentation into techniques of passing. The Berdache Society from time to time had special presentations on makeup, hair, wigs, dressing, where to shop for larger sizes, how to pad breasts and hips until the effects of hormones were visible, and the like. Transsexuals in the Berdache Society meetings and through social networks were a responsive and helpful audience. For a while in meetings, a feminine evaluation form (see Figure 3) was given out by Sasha to help individuals improve their presentation. It fell into disuse because many felt it too impersonal and perhaps hurtful because it was out of the context of personal interaction. This form covered the major areas that transsexuals considered important in passing: self-image, overall appearance, hairstyle, makeup, apparel, mannerisms, etc. Four areas of

gender attribution are generally used by transsexuals themselves to evaluate passability: physical body, demeanor (areas of nonverbal response), verbal expression, and biography (see also Kessler and McKenna 1978: 127). Of primary importance is the physical body. The private and public body is altered through hormone therapy, electrolysis (permanent removal of facial and body hair), letting the hair grow and styling it in a feminine hairstyle, shaving body hair, thinning arm hair with electrolysis and bleaching it, piercing the ears, growing the fingernails and manicuring them, and possibly having cosmetic surgery such as a tracheal shave and breast augmentation surgery. These techniques leave one physical attribute at issue: the genitalia. Before full-time passing, the genitalia were not as critical as during full-time status but were still problematic and had to be hidden. This was achieved by a device known in drag queen argot as a "gaff." It is similar to a string bikini bottom and it holds the penis and testes between the legs, pressed tightly against the body. Another device which is used is pantyhose with a girdle on top that keeps the genitalia tucked tightly between the legs and unobtrusive. Careful selection of pants and slacks is necessary to maintain the invisibility of genitalia.

Demeanor includes presentation in terms of overall appearance, along with nonverbal communication such as mannerisms. Appearance is dictated by the rule of naturalness. Thus, in the majority of cases, transsexuals prefer underplayed and conservative styles, after outgrowing a period of exaggerated and hyper-feminine dress.

As soon as possible, transsexuals begin to let their hair grow. This is inhibited to some degree during dual-role passing because transsexuals may be still working as males. Until separation occurs, they might have to wear wigs, but according to transsexual passing theory, wigs should be natural and unaffected.

The results of the hormone therapy that ultimately propel transsexuals into separation and transition can be hidden when in their male roles, but revealed and emphasized when they dress as females. These can also be augmented by breast and hip padding and brassieres, if development is not sufficient. This aspect of overall appearance contributes to the presentation of a female social identity. Appearance, however, can be discredited if the nonverbal aspects of the performance are shoddy. Transsexuals become experts in nonverbal presentation, having developed a knowledge of female kinesics from watching and through experience.

FIGURE 3

Feminine Evaluation Form

The purpose of this evaluation is to give the person being evaluated the opportunity to find out how she appears to others and to compare the comments with her own opinion of herself in an effort to find out the things she may need to work on to improve her femininity and personal appearance. (ca. Jan–March 1980)

BE HONEST AND COMPASSIONATE!

Name_____

Self-Image (Does she project confidence or fear in public?)

Overall Appearance (Neatness, etc.)

Hairstyle, Wig, Own Hair (Look natural? Good color? Good style?)

Apparel (Color match? In style? Fit? etc.)

Ability To Pass in Public

Mannerisms (Posture? Speech patterns? Walk? etc.)

Needs To Work On (which of the above?)

Best Feminine Asset (Hair? Figure? Makeup?)

Shows Most Improvement With

Other Comments (Any advice?)

DO NOT SIGN YOUR NAME

Transsexuals consciously and deliberately alter the way they walk, taking smaller steps and keeping the arms close to the body. They sit with their knees together, imitating the style encouraged by a generation of traditional parents. The development of breasts fosters protective movements around that area of the body in the manner of genetic females. They explicitly work on graceful, flowing movements in walking, standing, and sitting (cf. Fast 1977: 18–19).

A number of transsexuals participated in a course, taught by an actress, on body movement and voice geared to transsexuals' specific needs. She provided exercises in dance movement for transsexuals who were acutely aware of the subtle differences between the way men and women move in contemporary dances. From this instructor the participants learned to move their hips more freely and less stiffly. Knowledge they gleaned from this course was rapidly spread throughout the wider transsexual network. Information on nonverbal behavior was consciously organized into a complex lore of kinesic syntactic rules for presentation. It included the obvious, such as walking, along with the more subtle gestures such as the difference in ways men and women smoke cigarettes.

Another significant domain in passing is the verbal sector. Again, a number benefited from the transsexual workshop in which the actress gave them pointers on articulation, pitch, rhythm, word choice, etc. Several had speech therapists who were successfully altering their pitch into a higher, more typically female pattern. Voice and speech patterns are important for transsexuals' overall presentation, especially when they go full-time and talk with potential employers on the telephone. However, voice and speech patterns do not progress as rapidly as appearance in the passing arena, and much initial public passing is traumatic for transsexuals because of this. Perfection in speech takes some time and practice for most.

Apart from recognizing that pitch and tone in most cases need to be raised, transsexuals are aware of paralinguistic and sociolinguistic gender disparities in speech. They know that females generally raise pitch at the end of a sentence and use tag questions, such as "isn't it?" (see Harrison 1974: 104; Lakoff 1980: 51–52). They are also sensitive to female lexical usage. They consciously use weaker expletives, choosing to be generally more polite than males, and they opt for women's adjectives such as lovely, cute, darling, and the like, which, if used by males, would impugn their integrity (cf. Lakoff 1980: 50).

These transsexuals are not participating in a feminist speech revolution; they simply want to pass. They practice female voice and speech patterns until they become habitual and are no longer a conscious effort.

A final significant aspect of passing is biographical editing: creating personal histories as females that can be used in the negotiation of the finer details of the role performance. This process begins when transsexuals first choose female names for their female personae, names that seldom change in the course of the transition into womanhood. Later, as full-time approaches, they have legal name changes, sometimes keeping the same last name, sometimes using a middle name as a last name, or picking an altogether different surname. Early in the passing strategy, no legal or official changes are made. Despite this, a female name is an important statement of imminent womanhood.

A coherent female biography becomes increasingly important to full-time transsexuals, as they are likely to meet people with whom they may have to exchange life history information. Prior to full-time, this history is less critical than during full-time, when they actively reach out and extend their social networks to include people who know them only as women. During dual-role occupancy, transsexuals are not eager to get to know others while in the female role lest their male personae should become known. But even in this phase there are situations demanding an explanation of traditionally male abilities such as competence in mechanics or military experience. A consolidated biography that can explain nontraditional female careers, for example, can prove to be a useful tool.

Whether part-time or full-time, the audience is important because of its potential to become a "knowing audience" (cf. Goffman 1963: 66). In the management of identities, all audiences are potentially knowing and hence capable of discrediting transsexuals' role performances. By creating a female biography, transsexuals are facilitating the development of their personal and social identities as women, and this recreated history becomes an explanation for being. Through biographical editing, transsexuals establish continuity in their lives around the "theme" of women—past, present, and future (cf. Kaufman 1981: 54). A consistent biography is therefore an important component of transsexual "face" (cf. Goffman 1967: 5). By slipping up on their biographies, their performances can be discredited.

Much of learning to pass is in the "doing of gender" through interaction with an unknowing audience. However, if a passing performance is marginal, this audience can make a tentative gender assignment. At this point the unknowing audience can become knowing by searching for gender signals and cues to confirm or disconfirm the tentative attribution. In such cases transsexuals realized the equal prominence of all the domains of gender in passing: the physical body, demeanor, verbal expression, and biography in contributing to a credible social identity performance.

In addition to these four areas, transsexuals acknowledge the importance of confidence in negotiating with an unknowing audience, also confirmed by Kessler and McKenna (1978: 135) and Feinbloom (1976: 238). Confidence in one's presentation takes time and practice. Transsexuals concur that confidence is part of presenting themselves as natural women and increases their ability to pass. In turn, success in passing enhances their self-confidence in a positive feedback loop.

Transsexuals feel that it is difficult enough to pass in the early phases with an unknowing audience. The cost of interacting with a knowing or sensitized audience is too high. They unequivocally disagree with Money and Walker's (1977: 1300) statement: "As the syndrome of transsexualism becomes more well-known and less stigmatized, it will be increasingly feasible for transsexuals not to have to hide their change of status." From the transsexuals' perspective, a knowing audience has the power to imprison them in the category transsexual.

An opportunity arose for transsexuals to consolidate ideas about their status as a result of group affiliation and the formation of the Center for Identity Anomalies, with its advocacy and education goals. In September 1981, a crisis crystallized their beliefs on stigma reduction and helped form the educational goals of the Center, as well as bringing out clearly their views of the audience's role in passing. A local television program wanted the Center to do a special on transsexuals. The spokesperson for the program felt it would be a good opportunity to inform the public about transsexualism and dissipate any myths and stereotypes they might have about the phenomenon. Sasha opened the floor for discussion, and at times the arguments became heated because a few members, primarily transvestites, could not understand why the majority of transsexuals were opposed. The gist of the discussion was that public media events, where transsexuals actually appeared either in photographs or in person were, in fact, sensitizing

the community to their presence, thereby making it more difficult for them to pass. Allyssa maintained that, "It is very easy for a transsexual to become notorious. It is almost impossible for a transsexual to achieve respect if the fact of their transition becomes general public knowledge."

Because many transsexuals were taller and larger than the average genetic woman, they felt these attributes alone could discredit their social identitites as women. In short, where transsexuals previously passed as women, a sensitized audience could make it more difficult for them to pass undetected. If an audience was aware that transsexuals tend to have deeper voices than genetic women do, statistically speaking, then social identity could be questioned. If, indeed, an audience was sensitized to the fact that so many transsexuals shave the hair on their arms because they feel that their arm hair growth reflects a male pattern, that could also cause social identity discreditation. While one discrepant gender cue would not necessarily discredit the entire performance, a sensitized audience might not accept gender as an eternal verity, making the job of passing more difficult for transsexuals. Therefore, the majority of transsexuals opposed the idea of educating the community at large and believed focus should be on areas of interaction where efforts could do the most good, namely the medical and mental health professions as well as the legal sector. It is important to transsexuals that gender remain unproblematic for the majority of people.

Not only did this population shy away from media presentations, although there were always some for whom fame was its own reward, but they felt those who went "professional" were indirectly threatening others' ability to pass by sensitizing the audience (cf Goffman 1963: 86). Most transsexuals agree that the less the public knew about them the better. They do not want a destigmatized transsexual status, but rather acceptance as "normal" women. Professional transsexuals would sensitize audiences to the fact that gender can be socially constructed while passing transsexuals simply reinforce the social order. For transsexuals, the real heroines are transsexuals who slip into society as women, although they have a great deal of respect for transsexual pioneers such as Christine Jorgensen and Renee Richards, who will never be accepted as women by society.

There is evidence that transsexuals accurately perceive the dangers of non-naive audiences. I had presented a series of seminars on sex and gender under the auspices of a mental health agency during my

research. One transsexual slipped into the class unnoticed, ostensibly as a student. She passed well, and I received no questions or other indication that anyone thought of her as anything but a "natural" woman. However, when Sasha agreed to come and talk to this small audience about transsexualism, the other transsexual thought it in her best interests to drop out of the seminar at that point. Following Sasha's presentation, participants in the workshop made a point of taking me aside and questioning me about the departed transsexual's identity. Although she had passed, class members were now sensitized to her "male" voice and other gender attributes that could be construed as masculine.

Another incident was also revealing. A friend was visiting who had suffered a pituitary disease that resulted in the development of extremely large hands, feet, and head. She was a genetic female and had no gender conflict. In the midst of our discussion another friend dropped by. She came in and proceeded to the kitchen with me, and in a whispered voice, apologized for interrupting me because she thought I was interviewing a transsexual informant. This friend had met several transsexuals who, recognizing a sympathetic other, had revealed their transsexualism to her. As a consequence, she questioned this woman's gender on the basis of her large hands and had ascribed to her the transsexual status.

Sensitization of the audience interferes with the transsexuals' careful separation of audience, segregating those to whom they reveal themselves and separating themselves from those who knew them as males. For transsexuals a sensitized audience is an additional danger to their social role performance, an uncontrolled factor in their efforts at stigma management.

Passing is also the foundation for the transsexual age mate system, in which age mates reckon social age, based on their ability to pass and on their approaching full-time status. The ultimate evolution of the age mate system comes when individuals no longer feel they are passing, but are women and merely expressing their inner essence. They are then no longer colleagues in transsexualism, but women friends in collusion. Age mates become increasingly important in the process of separation and transition. In the early stages of passing, transsexuals rely on their age mates and others attending the Berdache Society meetings for help and instruction in passing. Both in meetings and throughout the transsexual social network, passing theory is ex-

changed. It is a body of lore that provides a set of rules on how one is likely to ensure a successful performance.

One theory includes the belief that late night food marts and fast food houses are places that one is sure to "get read" (not pass). When asked why this is so, the answer is that the people of the night in a heterogeneous urban milieu have seen everything the city has to offer. They are sensitized to female impersonators and are, as a consequence, clever at reading the gender cues that are likely to give transsexuals away. These situations are, therefore, excellent barometers of passing expertise. Passing at late night spots is considered a real indication of absorption in the female role and not likely to occur until transsexuals are well on their way to full-time or have gone full-time.

Other lore includes the idea that the more transsexuals are out in public together, the greater the chance of getting read, particularly if these are individuals who are neophytes in passing. Passing is best done as a one-woman experience with the aid of a cohort, preferably a g.g. (genetic girl). As mentioned, genetic women are regarded as having the *mana* of a lifetime of experience as women and consequently are highly valued as cohorts in the passing process. Having a g.g. who was either a roommate or a friend who spent a lot of time with the transsexual is regarded as a special source of passing insight on two counts. First, she can act as a direct tutor, sharing that history of special "for women only" information. Secondly, there is almost an aura of contagious magic about her. It is as if her femininity or femaleness rubs off on her transsexual friend by her physical proximity, sharing and doing things together. She also acts as a real life role model in many respects.

Genetic women are given a special status in transsexuals' initial passing experiences or "rites of the first time." Rites of the first time dramatize and impress upon transsexuals the dynamics of the system they will enter as women. All passing, until habitual, has this function. Through rites of the first time and other self-conscious passing endeavors, transsexuals learn to act out their future role and interact in their future role relations. According to Van Gennep, rites of the first time are the most prominent rites of passage because they symbolize the status transformation. The first act of passing in public is symbolic of entering the new role as women. The second act is the "beginning of habituation" (see Van Gennep 1960: 175; Chapple and Coon 1942: 485).[1]

Rites of the first time are shared with other transsexuals, lauded, and elevated to a position of importance as premonitions of future gratification in the new role. As time passes and habituation increases, passing is eventually taken for granted. A waitress calling a transsexual "Ma'am" or "Miss" is a significant event retold and spread throughout the transsexual grapevine. Others, anticipating this rite of the first time share the experience vicariously. Many of those well into approaching full-time and in full-time role occupancy are bored by such minor accomplishments, as they face more challenging tasks.

The most desirable condition for the first passing adventure is at night with a "genetic girlfriend" in a heterosexual bar. I had occasion to share this rite of the first time with Elise, whose excitement and tension were visible both before and during the event. I acted as her cover since she was unsure about her voice at the time. I could not detect a ripple of discreditation in the audience around us. In fact, two males were obviously engaging in nonverbal expressions of interest in and approval of the tall, slender, striking, golden-haired woman who was my companion. She did not notice this as she was too concerned about getting read. It was an intriguing experience, for she was so wary of interaction in a new world she had not experienced before. She was keenly aware and "on" in her performance. I suspect that if rites of the first time were not so exciting and absorbing, culture shock might have set in.

Broad daylight public passing in a shopping center is considered a more difficult rite of the first time. It usually follows nighttime passing and habituation to bars, restaurants, and movies. The daylight rite of the first time is a qualitatively different experience from the nighttime one. Here transsexuals do not have the protective cover of darkness. In the daytime they have to worry about the details which the cover of darkness filters, such as a five o'clock shadow or other potentially discrediting attributes.

Other rites of the first time include symbolic statements of the transsexual's ensconcement in womanhood and blossoming naturalness, such as shedding hip and breast padding, going braless (and having one's knowing friends acknowledge this), switching from pancake makeup to a lighter foundation because electrolysis has progressed to the point that such a heavy cover was no longer necessary, etc.

Another rite of the first time was most poignant. I had styled the natural hair of one transsexual in a female manner as a rite of the first

time and her friend, an age mate, subsequently invited us both to her house and asked me if I would do the same for her. Styling was significant because both had worn wigs in passing. While this is not possible for all transsexuals since some are balding, it is still considered an ideal to strive for. Medium length hair can be managed for dual role occupancy: styled in a traditional male style at work and, with the use of hair technology, given a female facade for passing. Wigs are considered suspect for transsexuals who are full-time and do not have the excuse of balding because they are symbolically associated with female impersonation, drag queens, and transvestism. Styling is a powerful and symbolic rite of the first time as an omen of new naturalness. Habituation comes with expertise in learning to handle various hair technology and equipment. The power of that symbolic event was expressed in tears of gratitude by both transsexuals. Discarding the wig was a highly charged and very emotional event for all concerned.

Note

1. These were transsexuals' first attempts at interacting with the new system, i.e., a world in which they were regarded as females. Repeated passing endeavors prepared them by habituating them to new role expressions. Habituation was, of course, the key to a natural self-confident and unselfconscious presentation that could not occur until, through self- awareness, transsexuals became keenly aware of their new role boundaries. The crux of these self-conscious performances that occurred in rites of the first time and other early passing attempts was the initiation of habituation to the new status.

ELEVEN

Full-Time Status and Passing

Transsexuals share an ideology about the best way to enter full-time. Although not every transsexual follows this strategy, it is considered the ideal method for approaching full-time status. This strategy incorporates maximum separation from the past so that transsexuals' emerging identities as women have the greatest opportunity for pristine development unhampered by others who "knew them when." Ideally, this is accomplished by leaving the work force as men. Through the course of having spent more and more time as women and having initiated physical feminization of their bodies, they reach a critical psychic level of discomfort with their role as men. These variables, along with the fact that colleagues at work may have noticed the changes caused by hormones, make full-time a necessary step.

Quitting work is regarded as the "right" way to go about full-time because transsexuals realize to "change over" on the job is likely to cause undue stigma and difficulty in what is already a difficult process. In changing over on the job, co-workers may label transsexuals and, consequently, they may not have the opportunity to escape the label and be accepted only as women. Co-workers are also likely to continue

to relate to them as men in women's clothing, as transvestites, or perhaps as homosexuals—an equally unappealing category to transsexuals. Thus there are a number of reasons to leave work and seek new employment where they are known as women. Yet some transsexuals, because of institutional affiliation of the educational and career-training sort or simply because they really like their jobs and/or the income, change over on the job.

Both strategies were practiced by the transsexuals with whom I worked. Of the seven who went full-time during the course of research, four changed over while in their current jobs or in their institution of training; three did not. Of the other five transsexuals, full-time when I met them, one had changed over on the job while the remaining four had not adopted this strategy.

The experience of those who changed over in the same employment setting contributed to the idealization of the proper ethno-strategy for full-time. All but one (the androgynous individual) had bad experiences. The other four suffered a great deal of stigmatization from their co-workers. This milieu was intolerable, and within a year they found other jobs or situations where they could begin anew. One escaped by graduation from her institute of training in fashion. Their experiences were retold as horror stories among their transsexual compatriots, exemplifying the problems of not following the right path to womanhood. Those following the right path, who quit their professions as men and later pursued employment as women, had their stories retold as examples of success.

Transsexuals did not regard finding work as women easy. It was known that this could take some time, but then finding positions as women was considered an intrinsic part of full-time and thus unavoidable. To prepare for this period of adjustment that could take many months, transsexuals saved as much money as they could while working as males to tide them over. In addition to financial difficulties, transsexuals had certain problems to overcome in job placement, such as nontraditional training and expertise, inability to use all of their male occupational histories, references, and the like. Thus, it could take a great deal of time and energy for them to consolidate and edit their work biographies to make themselves employable.

Quitting their employment as men, living on savings, and gaining experience as full-time women were regarded as necessities to their transition despite the heavy financial burden. Certainly the social con-

comitants of changing over on the job were considered far too costly in terms of psychic stress.

Going full-time is a dramatic event, ushering in symbolic birth and death. In characterizing full-time, transsexuals (in the early stages of full-time prior to role habituation) frequently used the terminology "to wake up" or "to awaken" as a woman. To awaken as a woman is a qualitatively different experience from spending the weekend as a woman. To awaken as a woman is a symbolic act with reference to beginning a new phase of life wherein one would nevermore sleep and wake up as a man. The symbolic aspects of awakening are analogous to birth as a woman. This experience is the being of womanhood, not just living on its fringes.

By waking up as women, transsexuals are establishing the fixity of their place in the world as women. Prior to full-time, although they are working towards full-time, dual role passing is not firmly separated from the behaviors of drag queens and transvestites. By going full-time, transsexuals are participating in a ritual act, dramatizing their status as women, distinct from transvestites and drag queens. To wake up for the first time as women is a ritual of the first time with portents of what they will be and what they are no longer.

This rebirth or awakening is a drama of separation from their former worlds as men. It is not just simply one manifestation of the numerous symbolic murders of the men they were, but rather it is the core of the full-time experience. It is expressed in the majority of transsexuals' antagonism to androgyny, as the following account illustrates.

Hope, a local therapist, concocted an androgynous strategy for transsexuals' transition into womanhood and encouraged several clients (only one was part of this research population) to take this alternative. Androgyny entailed gradual feminization in which transsexuals at one point in this process would appear gender-ambiguous. Hope liked the idea of androgyny because she felt this gradual feminization would prevent transsexuals from "going from one stereotypical box [male] to another [female]." This perspective did not consider transsexuals' hyper-feminine phase (in which they likened themselves to young females going through biological and social puberty) as a meaningful and important part of their transformation.

Lydia was the only Berdache Society affiliate who chose the androgynous strategy. She gradually feminized herself on the job. She had long hair as a man that she wore in a pony tail or with a bandana over her brow. She continued to wear similar clothes, opting for slacks

and tee-shirts, but adding gender cues such as clear nail polish and a little mascara. Several people at work started noticing the change in her appearance, including her breast development. She then announced her situation to her supervisor and told a few other co-workers. The upshot of this was that her supervisor had no objections either to her transsexualism or the gradual feminization that she continued to pursue.

Lydia's transition and the issue of androgyny caused quite a stir among transsexuals. One evening Hope sponsored a discussion of the subject with several of her proandrogyny clients, whom she brought to a Berdache Society meeting. There was a lively discussion, with the majority of the present research population strongly objecting to it. Lydia's success in the endeavor was attributed to her uniqueness. She was regarded as the kind of person who could succeed at anything she tried, even if it happened to be androgyny. She was considered a very special type of person, liked and respected by all for her positive attitude, her warmth, and her caring nature.

The majority felt androgyny was a terrible way to approach womanhood. They considered it improper, unsound, and the antithesis of what transition was about. In full-time, transsexuals have the opportunity to become destigmatized as transsexuals and begin their full incorporation into society as natural women. To feminize themselves gradually leads to an unnecessary period of stigmatization. In addition, to appear androgynously is to relate and interact with people as freaks or anomalies. An important facet of transsexual identity development as women is attributed to full-time status when they interact with people who respond to them only as women. That, in fact, is one of the advantages of separation from their former employment as men.

In going full-time transsexuals continue biographical editing, creating documented histories of themselves as female. This includes creating the paper trails of personal and social identity verification as women so necessary for a number of reasons. If they are going to work as women, they need to alter bank, social security, and educational records, for example. Since they were full-time role occupants they also needed to have conformity in checks, bank accounts, credit cards, and a variety of other documents to match their social personae as women. In short, documentation is one facet of biographical editing that entails producing a history of womanhood. Information on what changes to make and how to make them is readily available from other transsexuals. Changes of legal documents and financial records occurs

just prior to separation from employment as men or immediately after
quitting and going full-time. As transsexuals approach full-time or
change over, they pursue document changes with a fervor. Sometimes
they effect multiple changes in one day such as bank accounts, driver's
licenses, social security cards, and credit accounts. An impressive array
of these items can be changed as the result of one initial legal change—
the name.

The legal change of name is critical in the rite of transition. It is
an important rite of the first time in the building of the female bi-
ography. Although Feinbloom considers the legal name change as a
"crucial rite of passage," it is actually one of many rites of the first
time in a rite of passage. Transsexuals, in effect, reverse the ordering
of birth and adolescence, going through adolescence first as preparation
for the birthing process. Changing names legally is one expression of
resurrection as legitimate women. It also helps the transsexuals in
creating life histories in their own image, that of females reinterpreted
and recreated through documentation. This fosters the creation of
integrated biographies where history, documentation, and social iden-
tity are isomorphic (see also Feinbloom 1976: 263; Kaufman 1981: 56;
Kando 1973: 98–99). The legal name change can be viewed as the
ritual creation of tangible "identity pegs" (Goffman 1963: 38–39),
something on which the female identity can hang.

The core group of twelve transsexuals all had legal name changes.
The legal name change was accomplished by first going to the county
clerk's office and filling out an application explaining the reason for
the name change. Changing gender was the reason given by trans-
sexuals. Transsexuals were advised to appear in the female role when
requesting the change of name to enhance the credibility of the request.
The same afternoon an appearance before a judge in court was re-
quired. At that time, the judge could make comments (e.g., the name
change could not be used for fraudulent purposes) and place conditions
on the name change (e.g., all creditors had to be notified). Following
this, the judge signed a court order for the name change. The order
had to be published in a local newspaper in the county of petition for
three sequential days. A local magazine not widely read, which pub-
lished legal notices of all kinds, was usually used by those transsexuals
living in the largest county. The cost for the name change was twelve
dollars and the publishing fee approximately nine dollars.

The legal name change provides the option of changing all other

documents legally. It is however, more than a key to other documents. In asking one transsexual what it meant to her to have a name change, she stated, "It's a new beginning. It makes you feel like a person. I'm really this person. It was a milestone for me. I had lived in the female role for three days; I'll never forget the day. It gives you an identity as a human being."

As elsewhere, in the area of this research, the name change could not be used to change the designated sex on certain documents. These changes were contingent upon a surgeon's written statement that genital reconversion surgery had been performed. However, there is variation from state to state and room for slippage in the system. The change of sexual designation, while not theoretically permitted for the driver's license, is somewhat negotiable. One transsexual in another state had a legal name change before relocating to the area of this research. Her driver's license story illustrated slippage in the system. She stated,

> The driver's license was quite a fluke. I went in to get a police I.D., which has a photo but doesn't mention sex. They wouldn't give me an I.D. since I already had a driver's license. In explaining it to the people in charge they simply decided to change the sex on the driver's license. It blew me away.

College transcripts can be changed with little problem. Transsexuals send copies of the name change and usually confer with someone in charge as to the situation. The colleges, from all reports, are most cooperative. If sex is stated in the transcripts, this is changed to female. Bank accounts, credit cards, and the social security cards are also changed rapidly after the legal name change. Coherent documentation as females is thus created. These documents are important for transsexuals when they go full-time and seek employment as women.

Legal documentation is symbolic of their move from dual-role occupancy to single-role occupancy. Male pictures on their driver's licenses and other forms of identification are replaced with female pictures, female names, and possibly new sex designations. Their male roles and male pasts, given credibility through a trail of documents, are obliterated. They are given a death blow, and pen and ink traces of former male existences are methodically destroyed.

Systematic destruction of their former male persons is also expressed by transsexuals' riddance of their male clothing. Transsexuals, prior

to entering the rite of transition, share with transvestites a history of systematic purges of their *female* clothing. They acknowledge these purges as part of the quest to be normal, to rid themselves of the desire to wear women's clothing. These are symbolic and ritual attempts of the most personal kind: to become right with the world and to try to live their lives without the conflict symbolized by female apparel. When transsexuals eliminate their *male* wardrobes, it is a rite of the first time not shared by transvestites or dual-role transsexuals. It is a symbolic statement that they are not transvestites. Through this act their male vestiges are removed from their immediate and not so immediate lives. Closets that previously had two separate sections for clothing now held only female clothing. By taking their male clothing literally out of the closet and dispensing with it, they are symbolically coming out of the closet as women.

The wardrobe purge is a move out of the liminality and betweenness of dual-role occupancy. The consolidation of identity is reiterated by the consolidation of openly displayed female artifacts including makeup, hair accessories, jewelry boxes, and other gender-labeled cultural baggage that formerly cast suspicion on their identities.

Lexically, too, full-time emerges as a symbolic death and rebirth. It is common for transsexuals to refer to their male role as dying during this phase with statements such as "Robert or George died," when they describe going full-time to knowing others. Sometimes such statements introduce the topic of their assumption of full-time status.

During full-time their male role is also referred to as that "other person." Many ban their male names from their own lexicon and that of their close friends. When they discuss their male past, euphemisms such as "during my past life" are used. It is as if the male life happened to someone else. In a sense it is true, for through these symbolic expressions of exit from the male world, female identity is reinforced.

Transsexuals recognize implicitly that full-time brings something unique to their womanness. They openly state, "You can never know what it really feels like to be a woman until you go full-time." Full-time is a distinctive period when the final touches are put on the female role performance as well as a period of immersion in which habituation to the role facilitates the all important quality of naturalness. All in all, transsexuals regardes full-time as a very special, almost magical phase where the inner essence of womanhood blossoms, and everything that had been so consciously studied becomes second nature.

During full-time a transsexual learns to perceive the world through the eyes of a woman and to interact as a woman. The inner development of the primary female identity and the transsexual subidentity is reinforced by interaction in their new role. Feedback from their social environment encourages their self-concept as females. Through interaction with a new system, where they are related to more and more as women, they discover some aspects of a female world view they had not encountered before.

An incident occurred that made this aspect of their transition all too clear. Rose, a full-time transsexual, was leaving a Berdache Society meeting one night. Another transsexual, Alma, it was later disclosed, had noticed a naked man walking near the sidewalk of the narrow, tree-lined residential street where the Berdache Society meetings were held at the time. Alma had disregarded his presence, thinking "There sure are a lot of weirdos out there" and had driven on home. Rose, who left some time later, noticed the shadow of a man down the street but she paid him no heed. As she got in the car, she was accosted by this man who threatened her with an ice-pick-like weapon and attempted to stab her. Fortunately, she was able to deflect the weapon and slam the car door, just as a car came down the street shining headlights that scared him off. Rose believed she was fortunate because she offered more resistance than he was expecting.

This incident focused transsexuals' interest on the subject of "thinking like a woman." Rose and the other transsexuals were concerned that her initial response, as well as Alma's, was based on a typical male attitude of invulnerability. They all agreed in a discussion at the next Berdache meeting that a genetic woman would not have been in Rose's position, for a g.g. walking down the street alone, late at night, in a high crime area, would have been cautious and aware of movements on the street. In short, a genetic woman would have been more conscious of her surroundings that particular night and more attuned to the potential for attack.

This incident launched a conversation about how transsexuals have to learn to perceive the world in the same way as women. It was not a sexist discussion about women as fragile creatures, but one that reflected the reality of a crime-ridden environment where women are victimized by rape and assault to a much greater degree than men. Local women were aware of potentially dangerous situations and, through experience, understood that they were sexually objectified and that this was a facet of crime against women. Rose's encounter raised

transsexual consciousness about thinking as if they had a lifetime of women's history.

Living full-time, despite its drawbacks, gives transsexuals a sense of the world view of women that they only encounter sporadically by living two roles. Full-time status is equated with the realization every day that there is the potential for sexual objectification and criminal victimization. Paradoxically, sexual objectification by males when in public and in mixed contacts is further confirmation of their social identity as women. Yet transsexuals want to be taken seriously as persons, not just sex objects. When living as men, this was not particularly an issue for them.

Certainly male admiration is very rewarding to transsexuals, and incidents of male appreciation are retold and treated as indicative of transsexual success in passing. Transsexuals derive a great deal of social role performance validation from such encounters. This reinforcement, appreciated during passing endeavors and full-time status, can be a double-edged sword because full-time also raises the question of sexual objectification in the form of sexual harassment.

For example, Greta (a full-time transsexual) was in a store and noticed a man obviously eyeing her. He followed her around the store and when she stopped to examine some merchandise, he came up behind her and patted her on the backside. She turned around and gave him a nasty stare and stormed off. That did not seem to discourage him for he followed her again and did the same thing. This time she responded by saying, "If you don't leave me alone, I'll call the store manager." Numerous incidents such as these heightened transsexuals' sense of what it means to be sexually objectified, something they had not encountered as men. Sexual harassment was thus added to their psychic repertoire of what it means to be women.

Full-time status facilitates the development of a full-fledged female primary identity as well as having repercussions for transsexual status and affiliation with the Berdache Society. Transsexuals begin the process of disaffiliation from the group as they approach and become embedded in their roles as women. Affiliation with age mates who are at the same stage in social and identity development continues and perhaps increases as they adjust to their new place in society as women.

Although full-time transsexuals phase themselves out of the Berdache Society, there is still a sense of loyalty to the group for all it had given them. Ceremonial returns to the group provide reinforcement for accomplishments out there in women's everyday world. And

they, in turn, become success models for other, "younger" transsexuals. While socially younger affiliates of the Berdache Society are still transsexuals, full-time transsexuals are becoming women. They prefer the company of age mates in a similar stage of growth. The full-timers explained that the meetings bored them. Instruction in the art of passing and other transsexual tips focused on those at an earlier stage; more advanced full-timers had weaned themselves from the meetings in which transsexuals, not real women, interacted.

One full-time transsexual even felt that the meetings were detrimental. She believed that being around younger transsexuals, who were still rough around the edges in passing techniques, caused her to relapse, to act and behave in ways that had masculine connotations. She preferred to stay away from the meetings for this reason. When she was around normals, she claimed to have no problems in maintaining her feminine role.

As transsexuals sever their ties with the Berdache Society, they deny their transsexual identities. They no longer regard themselves as transsexuals (although transsexualism as a subidentity is still prominent and could be invoked by issues of biography, genitalia, etc.). Their core identity is female, and passing consequently becomes a slur conceptually.[1] They have eliminated symbols of their male histories, and in doing so, the term passing is avoided. It implies they are passing themselves off as something they are not; it is a deception. As they become women, passing is no longer applicable for they are no longer imposters but presenting themselves as they really are.

In the course of full-time, transsexuals advance to the point that it is rare that they are questioned by an unknowing audience. However, a knowing audience is another matter. Since most knowing audiences are also stigmatized, it matters little that their role performance might be questioned by these groups. As a result, passing before a knowing audience can now be the height of reinforcement for transsexuals and a barometer of their excellence in incorporation in the female role.

One of Britt's greatest successes in passing occurred during a ceremonial return to the Berdache Society after a long absence. She attended with a transvestite friend of hers, Leah. One of the new transsexual members commented to Leah how attractive his wife was and how wonderful it was that she was so supportive of Leah's transvestism. Britt related this incident with a great deal of pride even though she had lived full-time for over two and a half years and was about four months postoperative at the time.

Another example of passing among one's own kind came from Sasha. She was in a gay bar one night, continuing her friendships from her former days in the gay community, and noticed a beautiful woman sitting at the bar. In her words, she "checked her out" for telltale gender cues that only transsexuals are really aware of: the Adam's apple, hands, neck, hair on the arms, etc. She had Sasha "fooled" until a gay friend informed her otherwise. Sasha had nothing but awe for this transsexual who could pass before an expert gender reader, another transsexual.

The homosexual community (both male and female) is another group of insiders who, through their experience with drag queens, are a sensitized and knowing audience. The gay subculture also serves as a barometer of successful role performance although it is not actively sought out by most. It is, however, acknowledged that "if you don't get read in the gay community, you won't get read anywhere."

The gay community provides intermittent opportunities for younger transsexuals to practice cross-dressing in a fairly tolerant atmosphere, as well as an opportunity for transsexuals to get together in larger groups in public. Thus, concern over getting read because of appearing in public in a group larger than two, does not apply to excursions to the gay public outlets. The rationale is that chances are good that one will get read in the gay community anyway and if that happened, it does not matter, for after all the gay community is not a group transsexuals want to be incorporated into.

Still another audience is considered the ultimate test of passing. During full-time, if transsexuals escape getting read by children, this is regarded as a major accomplishment. Transsexuals cannot explain the apparently uncanny ability of children to question their gender performance. Children then are the ultimate passing test. Tales are rampant among transsexuals of children who have read them. Passing before children is applauded by all and considered an event of some importance in transsexuals' passing endeavors.

Note

1. I continue to use the term transsexual throughout. This is primarily a matter of semantic convenience but is emically a slur. Transsexuals, through immersion in full-time status as females, regard themselves as women, not transsexuals.

TWELVE

The Economics of Full-Time

The *Standards of Care* do not specifically require that transsexuals work as women, but many medical-mental health caretakers do require it. Working as women is also a normative expectation of transsexuals in this research population. Landing a job as a woman is an event of great significance in transsexual lives that is shared by others and is considered the ultimate test of "making it as a woman." It provides an external source of social role validation and consequently has implications for identity transformation as well as survival. It fosters the development of new networks of people in transsexual lives since it is one of the most important fronts for the formation of normal affiliations.

While two different audiences—knowing and unknowing—have been discussed in terms of finding employment as full-time women, the strategy of acquiring work with unknowing audiences deserves some further attention. All those in my sample who were full-time, with one exception, eventually secured jobs with unknowing audiences, even those who initially changed over in their former positions. (The

exception was the androgynous individual, Lydia, who is a special case and not discussed in this chapter.)

Transsexuals look for work relatively soon after going full-time; the longest reported case of job hunting was about a year. Tanya, who had not been able to find work full-time, supported herself through various social service programs. She was most unusual among the group in this respect. Beset by troubles in passing and by emotional problems, she looked for work intensively for a year. Although transsexuals understand that finding jobs is difficult and are remarkably supportive of each other's efforts, they do not condone living on city, county, state, or federal welfare sources. Tanya's inability to find employment was one more indication of her in-group marginal status.

The normative expectation among the group was that transsexuals must find work as women. Any kind of work would do, for there was little status differentiation allocated to jobs or careers when surgery was at stake. Working as women was the only expectation. If transsexuals really wanted to be women, then they had to work as women. The rationale was that before they could really consider living completely as women (i.e., have surgery), they had to be able to adjust to living on women's wages. If transsexuals could not adjust to the cut in pay, then they were not women, for after all, women live on lower wages than men and manage to survive.

The responses of former employers were remarkably supportive. The very worst response a transsexual received was from a former blue-collar employer who told her he did not agree with what she was doing and that he would say only that she was employed as a woman at his establishment. Other reactions were exceptionally favorable. Transsexuals called and spoke to former employers or wrote them letters with documentation and explanations of transsexualism and followed up with phone calls. One transsexual's experience with a former employer was typical of the favorable responses.

This particular transsexual had not informed her most recent former employer of her status change. However, when using an employment agency, she listed this previous position as part of her work history. She took a calculated risk that the placement agency would not call her former employer. Because she had changed both her surname and first name, her previous place of employment received several calls for her under her new name. Her former employer had no idea whom the placement agency was talking about. However, one determined

employment counselor at the agency began comparing the transsexual's work record as listed with the placement agency with the previous employer's knowledge of his employees. Between the two of them they successfully matched the transsexual with her former male persona. The employer's suspicions were aroused and he questioned several employees. One of them had been informed of the transsexual's change in status and the employer's suspicions were confirmed. When he received another call from the employment agency asking about the transsexual under her female name, he replied that "certainly she worked here" and gave her an excellent recommendation. Later the transsexual, hearing that the employer knew about her, called him and explained the whole story to him. He told her he would be happy to act as a reference for future employers and wished her luck. Knowing employers could then become cohorts in transsexuals' biographies as working women. This facilitates their entrance into new positions where they can be totally accepted as women without male histories.

Getting jobs as women is not always easy for transsexuals. They worry about getting read, particularly if they are applying for work early in full-time. Other problems generally have to do with the high rate of unemployment, gaps in their work histories that potential employers might interpret negatively, and positions that transsexuals are qualified for but for which they cannot apply. For example, any job in which a physical examination is required is avoided, for obvious reasons. In addition, biographical editing occurs in filling out medical history questionnaires. They are likely to be asked about menstrual periods, and here they either have to lie, giving appropriate cycle information, or use medical excuses such as a hysterectomy. This is not problematic since transsexuals are generally well read on the subject of female biology. By reading and questioning their genetic women friends about the subject, they become experts on women's cycles and "female" problems. This is one area in which they have to be competent in order to create biographical consistency.

Employment as women is rewarding for transsexuals. The work environment can provide a milieu of role integrity. Transsexuals often comment on how satisfying it is to be treated as women at work. They enjoy the female friendship networks that develop at work and have the opportunity to add to their repertoire of information on biographical editing. Work situations, then, often contribute to the creation of coherency in biography. Transsexuals share with each other infor-

mation on biographical editing acquired in their new status and expanding social networks. It is agreed that the best history of a personal past is one closest to the truth. Sasha, for example, explained her knowledge of the military with the "fact" that she was married to a military man.

Transsexuals, in discussions with women co-workers, are liable to be asked personal questions about their past on subjects such as children, divorce, marriage, etc. The absence of children, for example, can be explained by an early hysterectomy. Whatever the story line, it has to be consistent.

To be accepted as one of the women at work, to share personal information about one's past, and to discuss relationships are all sectors of female backstage behavior that transsexuals cherish and have missed in their male past. Their initiation into this backstage occurs as a consequence of closeness with genetic women. The work environment provides the opportunity for more of these friendships. The more women they gain as confidantes, the more they learn about some of the more secret and invisible sectors of the female role.

Some employment situations particularly facilitate the extension of transsexual female social networks and generate income at the same time. Two transsexuals supplemented their incomes through house-to-house sales of women's products. These were female specific environments and were regarded as highly valuable experiences in those terms alone. The all-female sales meetings were also conducive to entrance into women's backstage. The small financial reward in such endeavors was offset by access to these private sectors of women's worlds, an aspect of work recounted time and again by transsexuals as essential for their maturation.

While the female networking portion of working as women may be rewarding, the pay is not. This is because women are subject to financial discrimination in the work force and also because transsexuals have to eliminate parts of their work history and consequently seek occupations that pay less. Maria, for example, took the opportunity to go into business for herself, part-time as an artist and part-time as a housecleaner. Her former position as a highly specialized electrical engineer provided her with approximately $18,000 a year; now she earned $7,500. It was difficult for her to support herself as an artist, and the income from housecleaning was not high. Because of her specialized skill in engineering and the tightly knit social networks

involved in that particular field, she was afraid that should her former employer become aware of her transsexualism, it would spread rapidly throughout the information networks. She chose not to take that chance and subsequently eschewed her former profession. In addition, as far as she knew, there was not a single female employed in her particular field locally. She had no training in any profession that could lead to a career-oriented position. So she chose job autonomy, as did another transsexual, self-employed in media communication. She, too, had training in a highly specialized profession, ironworking, and self-employment was chosen for similar reasons.

There is some transsexual prejudice against working in blue-collar jobs. It is generally thought that association with all male co-workers in these sectors is detrimental to presentation of self as women because it encourages male nonverbal and verbal role expression. The case of one transsexual who had changed over on the job and was working full-time as a woman in a male-dominated blue-collar position (a plumber) is indicative. Transsexuals felt this environment encouraged her to act masculine and inhibited her performance as a female. Her role presentation was acknowledged by her peers as more credible when she exchanged her blue-collar job for a white-collar position in a female-dominated work environment. This particular individual was able to fall back on her college training to acquire her new position.

Another transsexual found herself seeking employment in a profession dominated by women. She tried to acquire work in a management field for which she was qualified, but was not hired after numerous applications. She had high-level personnel skills, management training, and experience and had applied for jobs in her profession, a male-dominated field. She was finally able to acquire employment in a position that was not specifically sex dichotomous, but she suffered a drop in pay from $16,500 as a male to $10,000 a year. She also found out that the man whom she had replaced in her new job made several thousand more a year than she did. She was not able to enter higher-level positions in the work force. As a result of personality conflict with her employer, she began to prepare herself for clerical work, a traditionally female field. Her experience in applying for jobs had reconciled her to the fact that as a woman she would have to enter a job position at a low level and perhaps work up to a more prestigious position. She was also at a disadvantage because she was an older woman and suffered additionally from age discrimination.

Amara's employment experience also involved discrimination against women. She had a high-salaried white-collar job and when she went full-time was able to use much of her former work history. She sought employment in the same field, again male dominated. As a male, she had received job offers from other companies who had previously tried to pirate her from her former employer. As a woman, she sought the same profession with other companies (those she had no prior contact with in her male role), but she was not hired. In her former job she made $24,200 and had an expense account. Although she had hopes of maintaining the same income level, transsexual friends warned her that this was unrealistic for a woman. After numerous unsuccessful job applications, she lowered her income expectations. At the time of this research, the only work she could find was a $15,000 a year retail position that she regarded as temporary.

Transsexuals working as women do not generally make as much money as they would had they remained men. In some cases, this is the result of leaving high paid, male-dominated blue-collar professions. Positions as women in female-dominated fields require no less skill than comparable male occupations, yet reflect discrimination in the area of equal pay for equal work (see Feldman 1974: 56; Howe 1977: 236–40). Unfortunately, for the majority of transsexuals, becoming a woman leads to a reduction in income. This encourages their understanding of current feminist issues, from the vantage point of firsthand experience.

While transsexuals are expected to work as women and to live with extraordinary cuts in pay, their expenses remain the same or even increase. They have to continue hormone therapy, electrolysis, doctors' visits, medical monitoring, and therapy. Most therapists want to continue regular sessions for at least part of their full-time period. Transsexual monthly expenditures on hormones, therapy, and electrolysis in relation to monthly income can be found in Table 7.

An additional cost is the female wardrobe for employment purposes, since a partial wardrobe can no longer suffice. If transsexuals decide to have other surgical feminization during full-time, it can be costly. Britt had to plan carefully to finance a castration that cost her $1,400 and $1,300 breast implants, both of which were standard prices in the geographical area of this research.

During full-time and working as women, transsexuals planned the financing of the vaginal construction. This operation, obtained locally,

TABLE 7

Monthly Expenditures on Hormones, Therapy, and Electrology (in dollars)
(Figures obtained between Dec. 1980 and Feb. 1981)

TRANSSEXUAL NUMBER	SHOTS AND PILLS	THERAPIST/ PSYCHIATRIST	ELECTROLOGY	MONTHLY TOTAL	MONTHLY INCOME (GROSS)	TOTAL SPENT ON ELECTROLOGY IN PAST (ESTIMATED MARCH 1981)
1	64	140	140	344	1,150	500
2	37	60	140	237	540	1,150
3	30	120	120	270	625	6,000
4	35	120	140	295	1,250	875
5	87	— *	60	147	1,000	180
6	45	140	88	273	500	60
7	25	170	60	255	833	1,300
8	5	175	140	320	2,166	1,680
9	50	20**	120	190	350	30

*This was the only transsexual in transition not undergoing therapy. She would have to seek a therapist at some point. She was, however, successfully passing as a woman. She was able to acquire hormones from a medical practitioner who, at one point, did not require a psychological evaluation. He later, however, tightened his requirements to include the evaluation.
**This transsexual used a community mental health clinic where her fee was charged on a sliding scale reflecting her low monthly income.

cost between $5,500 and $10,000, depending on the surgeon. Unfortunately, transsexuals' financial capability as women least equipped them to pay for the high cost of surgery. It was difficult, with all the other expenses, to save money for surgery. Since insurance companies did not generally cover transsexual surgery, funds were sought from a variety of sources: banks, parents, friends, extra part-time jobs, and even prostitution.

Prostitution, both before and after surgery, has been reported by professionals in the field of gender dysphoria (Star 1981: 180; Raymond 1979: 198; Kando 1973; Hoenig et al. 1974). The general tone taken by these authors is one of disparagement. For postsurgical transsexuals, Benjamin feels prostitution enhances self-acceptance as women (1966: 51), while Stoller (in Kando 1973: 17) refers to prostitution as an example of postsurgical maladjustment. Presurgically, prostitution is

obviously an opportunity to generate income to pay for the surgery and/or to keep up with the other expenses of transsexualism in the face of typically low women's wages. Postsurgically, the same low-income situation may explain why transsexuals resort to prostitution, to recover from the financial devastation of surgery.

In my sample, three preoperative transsexuals engaged in prostitution. They did so under the auspices of business agencies which split their pay on a 60-40 percent basis, with transsexuals keeping 60 percent. The cover agencies screened clients and provided transsexuals with some protection from entrapment. Apparently there was and is a market for transsexual prostitutes among clients. Transsexuals earning incomes in this manner were specifically trying to save money for the surgery and to offset some of their other medical costs. None had a previous history of prostitution.

In view of the professional opinion of transsexuals who engage in prostitution and the legal repercussions, it is not surprising that transsexuals are hesitant to report it to caretakers. Why transsexuals engage in prostitution can be explained quite simply without resorting to the psychological explanations of maladjustment common in the professional literature. While psychological explanations might be part of the answer, money and lack of opportunity is the one explanation which underlies a variety of other motives. The need for money is also a structural concomitant of transsexuals' costly, but required, relationship to the medical-mental health sectors. It is somewhat ironic that the very people who are partially responsible for transsexuals' high cost of living are also those who cast aspersions on their prostitution which is, in many cases, the result of the need to defray high medical-mental health costs.

THIRTEEN

Transsexual Personal and Sexual Relations

As full-time transsexuals integrate themselves into society as women, they have more opportunity to develop social networks and confront the inevitable issue of sexual relations. As a concomitant of perfected female role performances, they begin to experience sexual objectification in their daily encounters. Many of these are of the faceless variety, at a distance. However, during full-time role occupancy transsexuals are presented with increasing opportunities for face-to-face encounters of a potentially sexual and personal kind.

Part-time status is a period of loneliness. In that period, when transsexuals lead double lives, it is too dangerous to date or become intimate. Only one transsexual formed a relationship while in the part-time phase of transition. During this period, most of the transsexuals in the research population had friendships only with one another and with genetic women in addition to some relationships with their families. Full-time status is still a lonely period in terms of intimate contacts or sexual liaisons, for such contacts are potentially dangerous. It is during full-time status that transsexuals become integrated in their female roles to the point where they pass exceedingly well, hold jobs,

and are, in effect, almost complete women except for the genitalia. The final transformation is pending. The surgery becomes critical to transsexuals, for their genitalia are an increasingly discreditable attribute in the face of their personal and social identity transformation. Their genitalia limit their participation in public swimming, athletic clubs, and the like, where revealing attire necessitates their exclusion. But more importantly, their genitalia are an obstacle to their private lives as women desiring intimate relationships.

To form relationships requires meeting people, sharing time together, dating, and going out. The desire to find someone to love and care for, or perhaps to have several partners with whom they can be intimate, is a desire to be complete and whole with female genitalia. The transsexuals' morality system sanctions disclosure of transsexualism when in a serious relationship, presurgically or postsurgically. They do not, however, feel compelled to inform people with whom they are casually involved. As a result, dating and intimacy are difficult for full-time transsexuals. Some simply opt out, waiting until after the surgery to consider the prospects of dating, intimacy, and sex. Others are desperately lonely and long for affective relationships. These relationships do not necessarily have to be heterosexual.

There were ten affiliates of the Berdache Society who were full-time preoperatives and two others who, in the course of research, had surgery. Of these twelve, three chose to avoid intimate or sexual relationships altogether until after the sex change. The others were intimate either in serious relationships or brief sexual encounters that did not lead to more enduring liaisons, in conventional or nonconventional modes of sexual expression.

Relationships

Only two transsexuals formed relationships with significant others; these others were women. One transsexual had a year-long relationship with a lesbian woman. The lesbian, self-labeled, with stated bisexual tendencies, was an active participant in lesbian subcultural networks and public outlets. Another transsexual also chose to have a relationship that could be considered a lesbian one, in the sense that both were women. But in this case, the partner was not a lesbian subculturally for she did not label herself as such nor did she utilize the

lesbian community outlets. She fell in love with the transsexual's male persona, yet stayed with the transsexual throughout the transformation. Both of these transsexuals found caring others to share their lives with who were women and accepted them as preoperative transsexuals.

The first transsexual lesbian couple formed their relationship after the transsexual was living full-time as a woman. This relationship was satisfying in that the lesbian, Roxanne, provided the transsexual an affective as well as a sexual outlet. Intimacy enhanced the transsexual's self-confidence and was a valuable learning experience. The relationship ended after some rocky times and was resumed more casually, but still intimately, after about ten months.

Sexually both the transsexual and Roxanne considered their relationship a lesbian one. Although the transsexual used her penis to penetrate her partner coitally, she perceived this act through fantasy as one in which she was, in fact, penetrated. In this regard, it must be remembered that penetration is not just a characteristic confined to penile-vaginal intercourse. Penetration of various sorts is a potential accompaniment of stimulation of the female genitalia through vaginal stimulation, or using dildoes or by oral or manual means, or other "sex toys." While, among genetic women, penetration may or may not be the focus of each sex act, it is certainly an option for each sex act. Thus, transsexuals' fantasies of vaginal stimulation and penetration are not necessarily limited to the heterosexual sort, but may include lesbian penetration fantasies as well. Transsexuals' fantasies that they have vaginas capable of penetration and stimulation are common. But the penis, in an active sexual encounter, is also an antagonistic symbol, one at odds with the fantasy of a vagina. Therefore, sexual experiences for transsexuals with knowing partners can at once enhance their self-concepts as women and yet be potent reminders that their becoming is less than complete. Fantasizing a vagina in such situations is clearly a method of identity enhancement.

A transsexual-lesbian relationship can promote transsexuals' contacts and friendships with others in the lesbian community. This is not to say that the lesbian community is an outlet for transsexual sexual liaisons, since many lesbians do not tolerate transsexuals. They regard them in the same way they regard gay transvestites: men who are impersonating women. Consequently, lesbian and bisexually oriented transsexuals who are concerned about lesbian hostility are justified to some extent. Transsexual-lesbian relationships should therefore be

considered as individual phenomena, not subculturally condoned op-
portunities for sexual intimacy. Transsexuals' male organs are as much
a potential source of their stigmatization in the lesbian community as
they are in heterosexual society.

The transsexual involved with the woman who was not a self-iden-
tified lesbian had a stable, strong, and intimate relationship. This
couple settled into what could be a life-long enterprise. Transsexuals
in the group recognized this relationship as a most fortunate one for
the transsexual, who had found a mate to share her life with, who
supported her in her quest for surgery, and who was an important part
of the transsexual's contentment. This relationship was formed as the
transsexual prepared for full-time. That her genetic woman partner
had become attached to the transsexual during dual-role occupancy
was a very unusual occurrence.

This relationship was considered an ideal one because of the mutual
love and support between the two, who became roommates. It was
regarded by transsexuals as a situation most conducive to the trans-
sexual's quest for surgery. Love is highly valued among transsexuals
in this population. Individuals such as the women partners described
are viewed as remarkable people who are few and far between. Trans-
sexuals recognize that for the majority of people a penis would be
disruptive to the sexual encounter in which female genitalia are an
assumed correlate of female social identity. Thus of the twelve trans-
sexuals, it was not surprising that only two formed relationships that
were enduring.

Sexual Encounters

Transsexual sexual options are limited. However, heterosexual men
are another potential source of sexual intimacy for transsexuals. Several
transsexuals tried dating or going out in the heterosexual sector. Dating
was nonetheless hazardous, for at some point in the dating relationship
sexual intercourse became an issue. Transsexuals were then faced with
two choices: telling their partners they were transsexual or making up
excuses to protect their identity and avoid unpleasant, embarrassing,
or possibly dangerous situations. Because of more relaxed attitudes
about sex, this issue could become crucial almost immediately. Trans-
sexuals contributed to this situation because they wanted to experience

their sexuality as women, even though vaginal coitus was not an option. Thus, they were torn and frustrated. They wanted very much to kiss, fondle, and otherwise experiment with their sexuality as women, but that invariably brought up the problem of intercourse.

One transsexual developed an ingenious strategy to cope with this dilemma which enabled her to have limited sex as a woman with an unknowing male without revealing her penis. The most important facet of her plan was to prevent detection of her penis despite sexual expression. To ensure this she wore a girdle, tucked her penis between her legs and placed a feminine hygiene pad over the penis and testicles. Over this she wore pantyhose. When in a sexual clinch, she told her partner that she had female problems, specifically that her vagina was a "bloody mess" so she could not have intercourse and "it was all just too embarrassing." This, however, did not prevent her from experiencing other aspects of her sexuality or from satisfying a partner. She had successfully used this technique and had spent the night with a number of men who were unaware of her genital status. Her strategy was, of course, disclosed to other transsexuals.

Her own erections were not problematic because after a year of hormone therapy, erections, although still possible, were not spontaneous. Two other transsexuals found this strategy useful as a method for gaining intimacy without discreditation or disclosure. Having warm bodies to touch and explore is a valued experience in the lives of transsexuals whose options for affective and sexual encounters are sparse. Such experiences are also reinforcing to their self-concepts as women, for role reinforcement is a symbol of the legitimacy of their performance. This strategy was still considered dangerous, however, and most avoided dating heterosexual men except for limited contact in public places.

Another intimacy strategy included exploring the options available among other stigmatized groups. Sex within the subcultural margins of society is certainly one option for transsexuals, given their status. As previously mentioned, lesbian relationships are not emically viewed as marginal, but merely options for women. Thus, sex with gay men, other transsexuals, transvestites, or sado-masochists (including those into bondage and discipline) are all possibilities. Sex with gay men is, however, generally avoided because gay men regard transsexuals as men. Occasionally, as in the case of two of the transsexuals, a rare encounter with gay men occurred because sex with gay men was

regarded as better than no sex at all. One can only presume the feeling was mutual. These encounters were described as unsatisfactory by those who participated in them and generally only happened when transsexuals considered themselves really desperate for sexual intimacy.

For transsexuals, sexual liaisons in the cultural margins are considered intermediary or stop-gap endeavors, temporary excursions to fill their needs for intimacy and sexuality, legitimate options until the surgery. Relationships, as opposed to brief sexual encounters with the stigmatized, are not condoned by transsexuals. A line is drawn between forming relationships with compatriots in stigma and having sex with them. The party line is normalcy, but this can be negotiated somewhat since sexual outlets are regarded as a necessary part of transsexuals' lives. As long as these are encounters and not a permanent way of life, they are not incompatible with the ultimate quest for a sex life with women or heterosexual men which transsexuals regard as mainstream.

Sex and intimacy within the stigmatized sectors of society do provide one outstanding advantage for transsexuals: they can avoid explaining themselves. Transvestite partners, for example, understand transsexuals' desire to have sex while in the female role. With the stigmatized, transsexuals can also experience as broad a range of sexual expression, including anal intercourse, as they can with any knowing partner. Anal intercourse is not usually part of sex with unknowing partners, since the potential for discovery of male genitalia is too great. But in the sexual underworld, the transsexuals are not so restricted and can enjoy anal penetration. Anal stimulation is one aspect of transsexuals' masturbatory activity and a possibility with any knowing partner who is willing. For transsexuals, anal penetration is a source of symbolic association with the vagina as well. As an act, it feeds into their self-conception as women and in that sense, it is a functional equivalent of vaginal sex until they can experience the real thing. One transsexual referred to her anus as a "surrogate vagina."

Sex in the sociocultural margins, while not overtly sanctioned by transsexuals, is also not openly proclaimed, although the grapevine ensures that most are informed of one another's activities. Transsexuals acknowledge amongst each other that marginal sex holds rewards, but do not openly approve of it. Most transsexuals thought the relationship of Ophelia and Pearl, two preoperative transsexuals who were a dyad, was just too fringy. Thus, when Ophelia and Pearl married in a gay

church, the majority did not attend. Sasha, a transvestite, and I were the only guests.

Although they wore traditional garb in colors associated with the bride and groom, the ceremony was a spouse-to-spouse one, used in a gay community church for gay wedding ceremonies. There was some teasing about who was the bride because both considered themselves women. Sasha and I gave the brides away. Although Ophelia was dressed in the groom-style outfit, she received the more elaborate ring, while Pearl received a plain silver band. They successfully mixed the traditionally sex-dimorphic cultural images of brides and grooms, such that neither was completely in the domain of one or the other. They viewed their marriage as a lesbian one.

When I asked the Berdache Society network why they did not attend, I was told there was a deliberate boycott of the wedding. One transsexual said it was a "mockery." There was general concern that the press might get wind of it. They felt this was not the image they wanted the Berdache Society or the Center for Identity Anomalies to present as characteristic of transsexualism, if an image was to be presented at all.

Another transsexual reported a sexual encounter she had had with a bisexual man and a bisexual woman. It provided her with a unique opportunity for intimacy, given her status. In this situation she experienced a broad range of sexual activity although she did not permit manipulation of her penis. She particularly enjoyed sexually arousing the male in concert with the bisexual woman, although she was more sexually attracted to the woman. She found a shower with the woman the most stimulating of the myriad experiences because of the complete body contact and overt sensuality. The male was involved with some masochistic fantasies, and she and the woman used some bondage-and-discipline techniques and spanking as well.

Sado-masochism (S and M) and bondage and discipline (B and D) were expressed in individual private sexual acts as variations in the range of transsexual sexuality or as part of a sado-masochistic subculture. Although a gay sado-masochistic ("leather") subculture was present locally, it was not utilized by transsexuals to my knowledge. However, a sado-masochistic subculture, unaffiliated with the gay leather scene, delineated in terms of professional services, extensive networks, and semi-public outlets did include transsexual participants. This sado-masochistic subculture intersected the transsexual group

through a transvestite who used to be active in the S and M subculture as well as in the Berdache Society, although he later relocated. This subcultural sector was manifested publicly in several outlets including "Beats Me Boutique" operated by a dominatrix (a professional sadist) and her husband, assisted by their slave. These three were part of a larger network of people who enjoyed sado-masochistic sex of all varieties.

Transsexuals in the group represented two types of sado-masochistic activity (including bondage and discipline, unless stated otherwise). One type participated through the subcultural domain organized under the tutelage of the dominatrix, Mistress X. The second variety of S and M occurred in privacy, apart from subcultural affiliation and outlets.

Of those whom I have information from on this subject (N = 12), five had been involved in the subculture of sado-masochism and participated in "scenes." Needless to say, the subcultural affiliation was difficult to separate from the private practice. A dichotomy could be drawn between those who were experimenting with it as part of their fantasy expression, either alone or with a partner, and those who were part of a larger network of individuals who used public outlets like Beats Me Boutique. The latter were usually fronts for professional activities involving fees or exchange of goods and services. In addition, the S and M subculture was catered to by a number of sado-masochistic and bondage-and-discipline publications. These provided sources of contacts for scenes and information on professional types of encounters such as those provided by Beats Me Boutique. Within the sado-masochistic subculture was a special category of sexual expression that focused on genetic men who dressed as women.

One transsexual, no longer involved with bondage and discipline fantasies and activities, gave me a stack of old magazines and books on the subject. Most focused on males who were forcibly dressed as women and subsequently sexually abused by dominant women and men. These books and magazines included a variety of titles such as *The Domination of Peter, The Suffering of Marissa, The Training of Vivian,* and *Ropes, Garters and Gags.* Cross-dressing as a clear-cut domain of sado-masochistic subcultural interests was represented specifically by such titles as *The Transvestite in Bondage, Transformed into a Girl,* and *Sadists in Skirts.*

Submission emerged as a major theme in transsexuals' sado-ma-

sochistic fantasies. Nine of the twelve transsexuals reported S and M fantasies. The submissive role was predominant, with the exception of one whose fantasies consistently involved her as a dominant mistress. In all their fantasies they envisioned themselves as women. One transsexual, for example, imagined she was a beautiful slave girl from a distant planet. Another described a fantasy in which

> leather covers the entire body. Ballet boots to the hip, leather corset with crotch strap to hold vaginal and anal dildoes in place, leather bra with bare nipples which have permanent rings in them as do nose and vaginal lips. Discipline helmet with severe gag, single glove for arms.

Bondage, including rope suspension, was added.

Another transsexual had imagined being tied to a bed, with an anal plug inserted and other restraints. She also fantasized wearing a harness from neck to crotch that impeded her movements. In all these fantasies transsexuals were the passive recipients in mental dreams of bondage and discipline.

A total of eight transsexuals had actual experience with bondage and discipline, seven in a submissive role and one in a dominant role. One utilized bondage techniques in masturbation, inserting anal dildoes and restraining her genitalia. This allowed her to express her masochistic role in the masturbation fantasy. Two had acted out scenes with partners. In these instances the partners enacted rape fantasies with the transsexual restrained physically while a dildo was inserted anally. These encounters were unaffiliated with S and M subculture.

Five sought contacts through the sado-masochistic subculture. One arranged several meetings with male cross-dressers who wanted to share a scene. She revealed:

> Some were dominant, others both dominant and passive. The usual method of bondage was to rope the individual to the furniture or simply tie the rope on the body. I was usually the subject, but sometimes I helped with the bondage of another. I have been kissed, felt, masturbated, and received a blow job while bound.

One transsexual was involved in bondage with a partner who was a professional dominatrix. Their scenes had not involved the really brutal aspects of dominance and submission and seemed more con-

fined to bondage and restraint, although some of the milder forms of sadism were used on occasion such as spanking, nipple pinching, and slapping. For the most part, the transsexual was usually the passive partner. Most professional dominatrixes maintain distance and only rarely may the masochist touch them sexually, although this may vary.

Two full-time, preoperative transsexuals became slaves to mistresses. One of them was an occasional weekend slave, and the other was a slave to Mistress X for several months. The latter was also living full-time as a slave with Mistress X and her husband. Some of their activities included Mistress X forcing her to wear a tampon anally, changing her name to "Labia," and making her wear a slave collar at all times. After several months the transsexual got tired of the situation and sought a relationship with a lesbian lover.

The one individual who preferred a dominatrix role found a few willing partners for her fantasy. She traced her dominatrix fantasy to an incident in grade school when she observed a little girl who had managed to become "queen" of the jungle gym. She recalled this little girl ordering all the other children about and preventing them from reaching the top of the gym. She thought to herself at the time that she wanted to be like this little queen. It was clearly an important memory, for she described it in detail. She believed this was her earliest memory of dominatrix desires. This transsexual acquired a dominatrix outfit, complete with garters, fishnet stockings, cape, and black wig, with a small and elaborate dagger at her waist.

Transsexuals' apparent focus on the submissive role in their fantasies seems, at first, contrary to their feminist leanings and egalitarian views of the sexes. Although some have difficulty reconciling a feminist political orientation with pleasure derived from rape fantasies or fantasies of male sexual power over women, these are by no means inevitably linked (Barbach 1980: 119 in Masters, Johnson, and Kolodny 1982: 252). According to Nancy Friday, such fantasies do actually illustrate women's control because they are in charge of what their imagined assailants do (1973: 109 in Masters, Johnson, and Kolodny 1982: 256). Thus, feminist values and the content of fantasies are not necessarily correlated.

How do transsexuals' masochistic fantasies compare with genetic women's fantasies? Recent evidence suggests that masochistic fantasies of rape are one of women's two core fantasies and that they are more common for women than men (Offir 1982: 258). Women prefer the

fantasy of being forced while men prefer fantasizing that they are doing the forcing (Hunt 1974; Sue 1979 in Offir 1982: 187). Fantasies of forced sexual encounters of the same category as the transsexuals' imaginings are the second most frequent fantasy of heterosexual women and are first among lesbians (Masters, Johnson, and Kolodny 1982: 252, 257; Offir 1982: 258).

Transsexual fantasies, therefore, are not unlike women's prevalent fantasies in content. It is more difficult to assess and compare the actual incidence of sado-masochistic activities among transsexuals with the population at large. Although there are no reliable statistics available on the number of people in the general population who act out their fantasies, it is estimated that between 5 percent and 10 percent of the population participates in S and M sex occasionally (Masters, Johnson, and Kolodny 1982: 253, 349). By comparison, 66 percent (N = 8) of the research population took part in sado-masochistic types of sex. While a psychologist or psychoanalyst could have a heyday explaining this pattern of eroticism, a sociocultural explanation can offer insight into not only transsexuals' masochistic activity but also their fantasy lives.

Because transsexuals have so few sexual options, they drift into the sexual margins of society. S and M is one of the few outlets available. However, there are other sexual margins to choose from. Why do they select this particular one? Can the three who engaged in S and M sex apart from the subculture be accounted for? Why is the submissive, masochistic, passive role chosen in behavior and fantasy? Quite possibly the sado-masochistic expressions are "an extreme way of acting out a cultural script that says that sex is about dominance and submission" (Offir 1982: 258). In their masochistic fantasies and activities transsexuals were enacting prevalent cultural messages about sex and women. That they act them out in this way can be related to the fact that they have the opportunity to do so while their other options are severely limited. Transsexuals' stigmatized status can make it easier for them to pursue and act out fantasies generated by our culture because of generalized marginal drift, a tendency for the stigmatized to participate in the margins of society regardless of particular subcultural affiliation due to ease of access.

It cannot be denied that there are prominent cultural images that women are passive and submissive in sex, that they derive sexual gratification from suffering, and that they enjoy being raped. Whatever

the origin of these cultural myths, they are visible and easily available to people enculturated in American society. English (1980:49) believes that the cultural expectation that men have the dominant role sexually is reflected in prevalent fantasies of female bondage and rape. Transsexuals' masochistic fantasies can be explained in the same way. An important facet of transsexuals' fantasies is that in them they are women who are being restrained and forced. They are clearly identifying with a cultural stereotype about the role of women in sex.

Transsexuals in transition are far more restricted than genetic women in their opportunities to experiment with their sexuality. Their entrancement with the passive sexual role in S and M fantasies and activity reflects the weakest aspect of their transformation as women: direct sexual experience. They lack mainstream sexual experience, and until they can get it, they have to rely on cultural stereotypes. As they discover more and more about women's sexual attitudes and behavior through increasing networks of women friends and experience some noncoital conventional sex play with heterosexual men and/or through lesbian encounters, interest in S and M activities seems to decline. The more they become women and develop their lives as women, the less their involvement with S and M. As transsexuals approach surgery, they tend to remove themselves from the sexual margins completely unless it is a source of income. The pattern that I believe occurs—and this needs more research—is that the S and M fantasies are initially a locus of sexual arousal and probably necessary for sexual gratification. As transsexuals near surgery, the fantasies are no longer necessary for arousal, but because they reflect prominent cultural themes they continue as components of transsexuals' fantasy lives as they do in genetic women. Thus, the focus on S and M may be a phase of their own misinterpretation of women's sexuality in response to cultural stereotypes and in the face of limited sexual options.

Before concluding, I would like to return to the transsexual whose interest resided in sadistic fantasies and activity. This transsexual, who preferred the role of dominatrix, was also reacting to a cultural image of womanhood portrayed in our society, that of the Amazonian female in garters, stockings, corset, and whip. This image is a prominent fantasy of males in our society, according to Friday's report (1980). Although it is not as prominent an image of women as the submissive victim, it is available and represents a symbolic counterpart to the

masochist stereotype. So this transsexual was also reacting to a portrayal of women in our society, albeit one not endorsed as widely.

Transsexuals therefore have limited sexual experience. They long for intimacy and sex as complete women. To be complete women includes a sexual component, although transsexuals do not pursue the surgery only to have sex. Sexual desire is not regarded as a good thing to reveal to therapists or surgeons as a reason for surgery. The transsexuals know therapists wish to hear that they want surgery so they can become "integrated." While this is, indeed, part of the motivation, a significant factor is the somatic domain as it relates to their ability to have intimate liaisons and relationships. What occurs is that transition is a rite of transformation where they have become women in every sector but one, and this contrast makes them all the more anxious for the final element of womanhood that they have been denied: the option to have a normal sexual and intimate life. This is an important part of becoming a complete human being, as it is for any other people, but the transsexuals downplay it so as not to jeopardize their therapists' opinion of them as good candidates for surgery. Surgery sets the stage for the final phase of transformation and birth as complete women.

FOURTEEN

The Rite of Incorporation

Transsexuals who have lived as women for at least a year and have demonstrated that they can pass as women, have met the minimal medical requirements in order to qualify for surgery. Their next step is to acquire a psychological evaluation from their primary therapist, if they have not already done so. This accomplished, a second psychological evaluation is also necessary. Of the two transsexuals who had the surgery in the course of this research, one had been under the care of a psychiatrist for three years and this therapist provided her with the primary evaluation. She sought her second evaluation from a psychologist. He based his evaluation on approximately three personal interviews and an interpretation of the transsexual's performance on the Minnesota Multiphasic Personality Inventory. The other transsexual, whose primary evaluation was made by an MA in clinical psychology, sought her second from a psychiatrist, who based his report on three personal interviews.

For the majority of the research population under the care of therapists in the mental health professions, second evaluations are often sought from psychiatrists. This psychiatric evaluation costs a great deal

more per hour than the one given by their primary therapists. In this research area, an MA's charge is approximately $35, which was part of the reason transsexuals selected them for the long-term primary evaluation to begin with. In comparison, local psychiatrists would charge from $55 to $65 per hour. The second evaluation is considered a necessary evil by transsexuals. They are looking for rubber stamps who will evaluate them quickly, not for psychiatrists who may want to see them for another three months or longer, at great financial cost. They consider this superfluous as their primary evaluation has already been extensive. The secondary evaluators, therefore, are not considered in terms of the therapeutic endeavor by transsexuals, but rather as a medical hurdle.

Transsexuals on the verge of surgery cannot afford prolonged treatment by psychiatrists at the current rate. Fortunately, local psychiatrists generally did not require that transsexuals see them for more than three or four hourly sessions for the second evaluation. These psychiatrists relied heavily on the opinion of the primary therapists in making their judgment of their clients' eligibility for surgery.[1] Several local psychiatrists had reputations as "good" second evaluators among transsexuals. A good second evaluator did not require more than a few sessions and hence was not too much of an additional financial drain.

Two surgeons performed transsexual surgery locally. Both were in private practice, and transsexual surgery was one part of their practice. Neither was associated with gender clinics. Transsexuals preferred one surgeon, Dr. Smith (a pseudonym) over the other, Dr. Williams (also a pseudonym), primarily because Smith's fees were considerably lower. Dr. Smith was also preferred because transsexual surgery was a much larger part of his practice.

The total cost of a surgical conversion by Dr. Smith was between $5,500 and $6,000 including hospitalization, while the charges for Dr. Williams' surgery were approximately $10,000. The cost of surgery was an important factor to transsexuals and, although Dr. Williams was, in general, regarded as equally skilled, Dr. Smith was generally favored because of the $4,000 savings. Of the two transsexuals who had surgery in the fall of 1981, one chose Smith and one Williams.

Transsexuals are well educated regarding the intricacies of the surgical conversion operation. In this case, they discussed and reviewed the techniques of the two surgeons who differed primarily in procedural details and in after-care regimes. The surgeons themselves contributed

to transsexuals' education by providing information on the entire process of the surgery, from before-and-after pictures of their work to photographs taken during the operation illustrating the stages of the surgery. In this area, as well as others, transsexuals are also self-educated. They read anything and everything they can find on the subject. They also avail themselves of local postsurgical transsexuals. Although postoperative transsexuals do not generally associate with the Berdache Society, they are known through the transsexual grapevine and are willing to help educate their presurgical sisters. They provide information about the whole process from describing their presurgical preparation and their recovery after surgery, to presenting visible testimonial of the results.

A number of descriptions of the surgery are available in the literature, from the excellent lay description by Feinbloom (1976: 27–28) to the more technical account of Jones (1969: 313–24). There are several major surgical procedures in use for constructing a vagina in the genetic male (Laub 1981). These diverge in both specific technique and in the tissue used for the lining of the vagina. The two local surgeons used the penile inversion procedure, where the penile tissue is inverted to form the lining of the vagina, although this is not the only possibility. Laub (1981), for example, employs tissue from the upper rectum as a "living pedicle graft which provides certain advantages, such as natural lubrication." Other surgeons use segments of the intestine as vaginal lining (Laub 1981). Ongoing research among surgeons has resulted in the creation of aesthetic, functional vaginas with minimal postsurgical complications.

Smith and Williams, as previously stated, utilized the tissue from the penis, inverted in a cavity constructed in the abdomen in a position corresponding to that of the natural vagina. The tissue from the testicular area is then fashioned into labial folds. The sensitive genital tissue is also the source of a clitorislike bud positioned, appropriately, somewhat superior to the vaginal opening. The vagina is generally between five and one-half to six inches in depth.

There is a great deal of transsexual folklore around the realistic and authentic appearance of the constructed vagina. A favorite type of anecdote focuses on fooling gynecologists. In one such account, a transsexual visited a gynecologist for a vaginal examination. The gynecologist, in the course of the examination, chastized the transsexual who had revealed that she had not had a Pap smear. The gynecologist insisted on a Pap smear, and the transsexual finally told her that she

was a transsexual and consequently had no cervix. This lore reinforces transsexual ideology of their total transformation as women: that through surgery they become women, indistiguishable from the population of genetic women. The skill of the two local surgeons was such that an average person would not, in fact, question the authenticity of the surgically constructed vagina.

The operation is a major trauma to the body. Allyssa was hospitalized for nine days following Dr. Smith's surgery and Britt for seven days subsequent to Dr. Williams' operation. Lois, a postoperative transsexual (unaffiliated with the Berdache Society) described the experience as: "feeling like someone has ripped open your guts and then has poured in cement." Allyssa reported the postsurgical sensation of a "phantom erection." This she attributed to the stretching of the penile tissue in the vagina which was packed with gauze.

The vagina must be dilated in some manner after the surgery to keep the cavity open. Dr. Smith and Dr. Williams differed in the details of the after-care regime. Allyssa's vagina was packed with gauze that remained until the day before she was released, while Dr. Williams utilized a soft inflatable type of dilating device that could be deflated for insertion and inflated once in place. Britt wore this continuously for four weeks after the surgery, removing it for fifteen to twenty minutes two to three times a day. Allyssa was given a similar inflatable soft dilating device that she, too, was required to wear for four weeks postsurgically. In her case, the postsurgical regime prescribed dilation with the device three to four times a day for twenty to thirty minutes.

For both transsexuals, the after-care program included a gradual decline in dilating time. For example, Britt decreased the amount of time she wore the soft dilator so that at the end of two months she graduated to wearing it continuously only at night, with insertions several times a day of a firm device (a vibrator or dildo was often selected) for the next three months. After four weeks, Allyssa adopted a firm dilating device and during the following three-to-four-week period gradually tapered off dilation to once a day. Both continued to decrease the number of times and length of time of dilator insertion, so by the time they were approximately six months postoperative, they maintained the vaginal opening by dilation two or three times a week (see Thompson 1969: 325). If they did not have active sex lives, some vaginal dilation would be required to maintain the vaginal cavity after that period.

Transsexuals can begin sexual relations approximately six weeks after

the surgery, although this varies individually. Drs. Smith and Williams both approved of sexual relations at this time as beneficial not only emotionally but also as a mechanism for dilating the vagina.

The dilators are uncomfortable and inserting them initially can be painful. A lubricating cream is used for dilation with a firm device. The transsexual vagina created by the penile inversion technique has no mechanisms for self-lubrication and consequently lubricating creams and jellies are necessary for intercourse, too.

Reports of transsexual postsurgical orgasms are encouraging. Benjamin, for example, found orgasm fairly common among postsurgical transsexuals (1966: 108). Of the two postoperative transsexuals, one reported she was not only orgasmic, but capable of multiple orgasms. The other was in the process of learning to be orgasmic. Both were typical in the postsurgical response of deriving pleasurable sexual sensations from vaginal stimulation.

It can be some time after the surgery before returning to work. Depending on the occupation, recuperation periods as long as six weeks might be necessary, although part-time desk-type positions can be resumed sooner. Both Allyssa and Britt were capable of some part-time work between two and a half and three weeks after surgery.

The issue of returning to work as soon as possible is an important one to transsexuals who are often left financially destitute after the surgery. This was true in Allyssa and Britt's situations. One had borrowed money from a friend, and the other had depleted all her resources by scavenging from savings and a trust fund. Both had to take time off from full-time positions, and this necessitated explanations. Allyssa used the excuse of a hysterectomy, while Britt informed her supervisor of the truth. He was understanding and supportive and kept her secret from other co-workers.[2] Since that time, Britt has continued to work for the same company, while Allyssa found a higher paying, career-oriented position. None of their co-workers suspected.

Both were happily adjusting after the surgery. Neither felt a need to continue therapy. Studies of postsurgical adjustment point to the sense of well-being engendered by the conversion operation. Transsexuals generally feel better about themselves after the surgery than before it (Pomeroy 1967: 447). Allyssa pointed out one reason. Prior to surgery, any financial setback was "life threatening" since it could jeopardize the conversion operation. Presurgically, Allyssa felt financial crises had the power to entrap her in transition. After she had had

the surgery and paid for it, she felt more comfortable in coping with financial setbacks, for after all, she quipped: "They can't repossess it."

Meaning and Ritual in the Rite of Incorporation

The surgical procedure and the resulting genitalia are symbols of transsexuals' incorporation into society, the culmination of a long and arduous passage. They finally achieve the status of full-fledged women by fulfilling the cultural prerequisites of gender: people who claim the label female must a priori have vaginas. For transsexuals, the vagina presents them with possibilities denied them as women with penises. Several pre- and postoperative transsexuals described what the surgery meant to them. Their comments, presented below, all pointed to the perceived options inherent in the status of genital women.

I want the surgery because it will permit me to express my sexuality in the manner appropriate to a woman.

I want to look more like a woman. My life won't change much at all. All surgery will do for me is make me more happy that I can undress completely in a health spa, etc.

It will allow me to have sex as a female and totally be a female.

A long-term monogamous relationship is important to me. I don't think I can really settle down as a normal person until after the surgery. With the final exception of intimate relationships, it won't change much.

Surgery will make me whole like any other woman.

I want my life to be complete. I am functioning about 95 percent of the time in the female role. The other 5 percent involves things that involve my sex organ, like not being able to join a health spa or having normal sex with a man.

I want surgery so my body conforms to my spirit. It is discomforting to see yourself in a mirror with male genitalia and know it isn't right. Surgery will complete my external image.

Being able to have relationships or even brief sexual encounters is one component of transsexuals' bid for membership in normal society.

Whether they choose to explore that option is not as important as having the option as women rather than people who are regarded as deviant males, transvestites, or homosexuals. For transsexuals without the vagina, gender is problematic not only in terms of sexual intimacy but in other sectors as well. For example, presurgically, even something as innocuous as travel can be an issue. Transsexuals can acquire passports but their sex is designated as male. Rather than face potential harassment during foreign travel where passports are closely scrutinized, transsexuals avoid international forays, although it is often not an issue since they are saving their money for surgery.

Travel in the United States is also an unpleasant prospect for preoperative transsexuals. Some states still carry laws against males dressing in women's attire. A simple stop for a traffic violation can be extremely embarrassing or, worse yet, can lead to detention or imprisonment. The evidence is on transsexuals' driver's licenses; the sex is male. Allyssa felt her surgery would diminish the "tension, pressure, and paranoia" that occurs with interstate travel.

These, then, are just a few examples of the problems preoperative transsexuals faced. The list could go on to include a variety of situations common to all transsexuals and some unique to particular individuals. Perhaps the inability to experience sex and intimacy as women compared with the other limitations cited is only a fraction of transsexuals' total life experience as females, but this fraction is substantial to those denied access. Surgery provides closure to the liminality of their transition. The greater their adjustment to their roles as women, the more glaring does their genitalia become as a symbol of discontinuity. Surgery is the mechanism for transsexuals' integration into society. As one transsexual stated: "With the surgery I can be a member of the female club." It is their opportunity for humanness and normalcy. Surgery is the final phase of their rebirth as women. Transition has been a period of ritual births and deaths, but the rite of incorporation is itself a metaphorical summation of these into a primary ritual of rebirth.

The rite of transition concludes with the rite of incorporation, in which transsexuals are vested with symbolic keys to the full range of women's options. The gradual process of preparation for full incorporation has thrust them into life crises produced by their social and personal identity as women that is contradicted by the ever-present symbol of masculinity. These crises are ritually ameliorated by the

medical profession (cf. Chapple 1970: 302). The rite of incorporation resolves the genital disconformity and alleviates the somatic source of stigma. They can now confront a new system of social relations.

The surgery is much more than just a "technical affirmation" (see Feinbloom 1976: 232). It is a ritual rebirth: the birth of a woman. This symbolic birth follows transition. It will be recalled that the term transition refers to transsexuals' real life test. It is also a medical term for the period of cervical expansion in the pregnant woman prior to the final phase of expulsion: birth of the infant. Semantically, the analogy with birth is inescapable. Transsexuals are like infants, only in their case infancy follows their social puberty and maturity.

After the surgery, doctors provide written verification of the fact that transsexuals have been surgically reassigned. This statement is a metaphor for "It's a girl!" On the basis of this affidavit, transsexuals can request either a new birth certificate or a modified one in which their sex is redeclared female. The surgical conversion expresses symbolically the ascription of sex at birth, a legal as well as social assignment. Through the remarkable surgical procedure, transsexuals are symbolically reborn as well as actually reborn. The vagina is a testimonial to their lives as women, as are their new or modified birth certificates.

The surgery is a ritual of rebirth in which all transsexuals must participate to acquire the full range of role options associated with their new legal and social status. Through the rite of incorporation, neophyte women acquire biographical accreditation as well as the somatic means for full incorporation. Their social return coincides with their physical return from the hospital. Their recuperation marks their re-creation, transformation, and emergence from liminality. They have become women, socially, legally, hormonally, and genitally.

Incorporation Postsurgically

I have collected information from five postsurgical transsexuals. Two of these individuals were never associated with the Berdache Society, and one was only an occasional visitor. None has reported any drastic changes in her life. All but one were exploring sexual relationships and intimacy. These were not limited to heterosexual relationships: three of the individuals were bisexual and one lesbian.

Certainly some experienced growing pains similar to those of genetic women who are torn between a tradition that links sex and love and the new-found freedom to experience sexuality as an end in itself. One transsexual was trying to understand where the one night stand fit into her life. Another was enjoying the pleasures of a new-found romance, and still another was firmly attached to a partner.

Having a vagina necessitates medical care of the new genitalia and that requires inside information not readily available to males. Here several transsexuals expanded their knowledge of female folklore considerably. They sought this information from genetic women, not transsexuals, who had previously provided so much of the information necessary for the rite of transition. Women and their cultural baggage, beliefs, and values were esteemed by transsexuals, but now the relationship was as an insider, as woman to woman. One transsexual called and asked me about treating a yeast infection, and I passed on female folk medical lore on yogurt and vinegar treatments. This kind of information would not have been spread to a great degree through the transsexual grapevine. It was limited to those on the verge of surgery and postoperatives. At this time transsexuals' affiliation with their sisters is not actively continued. While special friends remain, transsexuals do not socialize with one another as much as previously.

Transsexuals' incorporation into society continues to be dependent upon stigma management. When they reveal to their partners a transsexual past, as is considered the proper thing to do with serious relationships, they take a chance of rejection. Their incorporation is premised upon their successful interaction and acceptance. They are granted the full options of genetic women only if they do not reveal their "disreputable pasts." They can be stigmatized if this information becomes common knowledge at their place of employment, for example. The rite of incorporation, should it become known, is also potentially discrediting. Incorporation, therefore, rests on the continued management of a "spoiled identity" (cf. Goffman 1963). Yet without the rite of incorporation they would not have the opportunity to drift into society as bona fide women. The rite of incorporation means they can experience the full range of role options, duties, rights, and responsibilities of persons with vaginas.

While all people participate in stigma management to some degree (Goffman 1963: 138), transsexuals must maintain their fronts through

biographical editing. The vagina is a technique of managing the stigma of their male past, for it redocuments their history as ascribed females. Transsexuals have the potential for complete incorporation as a result of the rite of incorporation, but it is up to them not to reveal their transsexual status. They, like many others with an identity blemish, can be prevented from entering certain sectors of society, for example, employment where identities are scrutinized closely, such as political careers, government positions with the State Department or the CIA, and possibly some businesses where security checks are routine. They are not alone in not passing muster for these careers and may find themselves in the same situation as people with psychiatric records, police records, histories of drug abuse, or other biographies that may be marginally accepted, but are not approved of by mainstream employers.

Transsexuals have been incorporated tenuously, but they have the *option* for full incorporation by virtue of their genitalia. They have the same opportunities as all people who must manage their identities to some extent. Surgery is their source of incorporation. It is their access to normalcy. They can finally be treated as if they had always been women, although to some degree this is contingent upon their successful identity management. The value of the rite, in the words of Allyssa, lies in the "incorporation it permits."

A Concluding Thought

Gluckman (1962: 27) has said that "modern societies reduce to a theoretical minimum the distinctions between male and female." Certainly it is true that rigid distinctions in sex roles are becoming blurred. But what of transsexuals?

Through their rite of passage they illustrate an important cultural conception of gender. A gender is more than and apart from the sum of its roles or biological constituents. Although sex roles may overlap, there are still differences between male and female gender identities. These seemingly negligible distinctions loom large in the lives of genetic men who pursue womanhood. Transsexuals' transformation is a far more complex process than simply changing sex roles. It is a becoming.

Notes

1. This information is based on the two postsurgical transsexuals and a number of preoperative transsexuals who acquired their second evaluation in anticipation of surgery. Five transsexuals expected to have the surgery within the next year and did so subsequent to this research.
2. Since Britt's supervisor revealed he was gay, she felt some safety in telling him as a fellow compatriot in stigma.

APPENDIX

Review of the Literature

The literature in the field of gender dysphoria may be broadly classified into two major categories. The first is medical in approach, including psychiatric and psychological research. This research will be referred to as clinical because of its focus on transsexualism as a syndrome subject to treatment and observation. The second approach is sociocultural. In this literature, transsexualism is regarded as an epiphenomenon related to and existing within the larger sociocultural system. Although these two approaches vary in scope, research questions, and methodology, there is also some overlap between the two in both orientation and methods. Therefore, this classificiation is necessarily idealized.[1]

Clinical Approaches

ETIOLOGY

Etiology and surgical outcomes are the two most conspicuous research foci in an otherwise diverse clinical literature. The question of trans-

sexual etiology is related to the broader issue of gender identity for-
mation in "normal" males and females. The study of transsexual
etiology, therefore, has implications not only for cross-sex identity,
but for understanding the majority of people whose gender identity is
in conformity with gender roles.[2] Scientific concern over the formation
of gender identity in transsexuals, and in the normal population for
that matter, has centered on the relative influence, or interaction of
biological and/or socialization variables (and to a lesser extent, the
influence of other external factors such as cultural messages about
gender) on the formation of a cross-sex identity.

Those researchers who stress the importance of socialization vari-
ables, such as family dynamics, are the intellectual heirs of the
age-old nature *vs.* nurture controversy. The contemporary nurturist
position, however, does not exclude biological factors entirely from
the explanation of the formation of the atypical gender identity. Bi-
ological variables in transsexualism are thought to have some as yet
unknown influence.

Among the well-known researchers who consider socialization var-
iables as the most prominent factors in the development of cross-sex
identity, with biology playing an inferior role, are: Money and Ehrhardt
(*Man and Woman, Boy and Girl,* 1971); Money and Tucker (*Sexual
Signatures,* 1975); Stoller (*Sex and Gender,* 1968); and Green (*Sexual
Identity Conflict in Children and Adults,* 1974a). Of the socialization
factors contributing to transsexualism, Stoller (1968: 263–74) and
Green (1974a: 216–40; 1974b: 47, 51) concur that dominant, over-
protective mothers in association with absent fathers (in a physical or
emotional sense) are salient factors in the etiology of the syndrome.
Green (1974b: 216–41) is notable for adding the dynamic of channeling
and the labeling of the young transsexual boy as a sissy, thus including
not only the family, but peers and sociocultural processes in his causal
scheme.

The other perspective evident in the clinical literature considers
biogenic variables pre-eminent (e.g., genetic, prenatal hormonal, and/
or fetal metabolic factors). Researchers taking this perspective elevate
biological variables (i.e., nature) to a more important position than a
merely supporting role. Those suggesting that there may be a biogenic
basis to gender identity anomalies include: Benjamin (*The Transsexual
Phenomenon,* 1966); Starka, Sipova, and Hynie ("Plasma Testosterone

in Male Transsexuals," 1975); D. Blumer ("Transsexualism, Sexual Dysfunction and Temperal Lobe Disorder," 1969); and Eicher et al. ("Transsexuality and H-Y Antigen," 1981).

SURGICAL OUTCOMES

Besides the etiology, the clinical literature is concerned with the question of treatment. Battle lines are currently drawn around the issue of whether surgery is an adequate solution to gender identity conflict, and follow-up studies are essential to assessment of the efficacy of surgery as a solution.

Among those who endorse the surgical procedure and provide evidence that the results are satisfactory in terms of transsexuals' postoperative emotional and social adjustment are Benjamin (1966), Pauly (1968; 1981), and Satterfield (*Rocky Mountain News*, March 15, 1982).

Although a majority of these researchers report favorable outcomes of surgery and support surgical resolution as a legitimate technique accompanying a therapeutic management program of gender role reversal, Meyer and Reter (1979) have challenged this position, basing their determination on fifteen operated and thirty-five unoperated transsexuals. They conclude: "Sex reassignment surgery confers no objective advantage in terms of social rehabilitation [for transsexuals]" (1979; 1915). This controversial report has been criticized on a number of grounds by Pauly (1981), Fleming, Steinman, and Bocknek (1980), and Gottlieb (1980).

Although the most prevalent position at this time is that once a transsexual's identity is fully crystallized it cannot be reversed, a number of professionals have recorded cases of curing transsexualism through psychotherapeutic intervention. Among these are: Barlow, Abel, and Blanchard (1979); Barlow, Reynolds, and Agras (1973); Davenport and Harrison (1979); Dellaert and Kunke (1969); Kirkpatrick and Friedman (1976); Forester and Swiller (1972); Green, Newman, and Stoller (1971); and Steinman et al. (in Pauley 1981:50; Steinman et al. 1981:1). These reversions are, however, limited to a small number of cases and must be regarded in that light. Given the evidence to date, surgery seems to lead to the most successful resolution of the problem of gender identity conflict.

Sociocultural Approaches

In contrast to the clinical approach, the sociocultural approach is concerned with the relationship of the transsexual, and of transsexualism, to the culture at large. And unlike the former, sociocultural researchers are less interested in transsexualism as a syndrome and are more attentive to the sociocultural parameters of gender anomalies. In general terms, this literature seeks to understand transsexualism within the context of the extant sociocultural system, considers how the sociocultural system affects the expression of transsexualism, and asks what transsexualism can reveal about cultural conceptions of gender. The sociocultural literature is roughly divided along disciplinary lines between sociology, expecially the school of ethnomethodology, and anthropology.[3]

ETHNOMETHODOLOGICAL STUDIES

Ethnomethodology, as a sociological school of thought, stems from the work of Harold Garfinkel (1967). In his *Studies in Ethnomethodology*, Garfinkel establishes the parameters of this school of thought (1967: 75):

> The study of common sense knowledge and common sense activities consists of treating as problematic phenomena the actual methods whereby members of society, doing sociology, lay or professional, make the social structure of everyday activities observable.

The ethnomethodologist does not make assumptions about the construction of social meaning by "imputing biography and prospect to the appearance," but by disrupting what members of society take for granted and interpreting how order is reconstructed out of the disruptions (Garfinkel 1967: 77). Garfinkel, in association with Stoller (1967: 116–85), was the first ethnomethodologist to investigate transsexualism. Agnes, the male-to-female transsexual in the investigation, was considered an ideal case of a natural-field disruption. Agnes, by virtue of her transsexualism, revealed the rules by which gender is constructed in our society. These rules rest on premises that are regarded by society as natural: that there are only two sexes, that these are inviolable, and that they are determined by genitalia. The transsexual violates these premises, yet reconstructs an explanation of herself that rationalizes these basic beliefs about gender (pp. 127–85).

Kando's *Sex Change* (1973), Feinbloom's *Transvestites and Transsexuals* (1976), and Kessler and McKenna's *Gender: An Ethnomethodological Approach* (1978) are all works which incorporate the ethnomethodological perspective in an analysis of transsexualism. These authors reiterate Garfinkel's original quest to understand the sources of the social construction of gender. In addition to the shared perspective of ethnomethodology, they utilize Goffman's (1963) concept of symbolic interaction to various degrees. Although the theoretical and methodological frameworks are similar, each of the three studies has a different focus, providing an interesting and diverse explication of ethnomethodological interpretations of the phenomenon of transsexualism.

ANTHROPOLOGICAL STUDIES

Anthropological approaches, like ethnomethodological ones, are characterized by a view of atypical gender and role as firmly rooted in the cultural context. Anthropological studies integrate evidence from the cross-cultural record and analyze gender anomalies of dress and role as an institution.

The most widespread gender anomalous institution is the berdache. The berdache is usually a genetic male (although evidence of the female berdache is found in the literature) who dresses partially or completely as a female, adopts the female role to various degress and in some cases assumes facets of culturally approved, female sexual behavior (Churchill 1971: 81; D'Andrade 1970: 34; Ford and Beach 1951: 130). The berdache has been variously referred to as an example of cross-cultural homosexuality (Ford and Beach 1951: 130), transvestism (Rosenberg and Sutton-Smith 1972: 71), and transsexualism (Green 1966: 179, 83). The literature on the berdache is included in this review of transsexualism, despite lack of definitional consensus, because transsexualism shares with the institution of the berdache the behavioral correlates of cross-dressing and performance of the female role.

While Westermarck (1956: 101–38) seems to have been one of the first to study systematically the berdache, as early as 1906, a number of other anthropologists have contributed to its documentation. Omer Stewart recorded its occurrence for Kroeber's *Cultural Element Distributions* (1937–1943) and for "Homosexuality Among American In-

dians and Other Native Peoples of the World" (1960a: 9–15, 1960b: 13–19). Devereaux cited the case of the *alyha* among the Mohave Indians as a berdache role (1937: 498–527). Hoebel also noted it was present among Plains Indians groups (1940: 458–59) as did Lowie (1935: 48). Evans-Pritchard observed berdachism among the Azande (1970: 1428–34) and Hill among the Navajo (1935: 273–79) and Pima (1938: 338–40), and Bogoros described the "softman" of the Chukchee (1907: 449–51).

Apart from describing the berdache, anthropologists are interested in understanding how the institution relates to sex-role dichotomization. Hoebel explained the berdache among the Plains Indians as an option for males who could not fulfill the demands of the aggressive male warrior role (1949: 458–59). Goldberg (1961), in a study of twenty-one societies, found no support for Hoebel's contention that there may be a relationship between warfare-bravery and the cross-dressing berdache role (in Munroe, Whiting, and Hally 1969: 87). Downie and Hally (1961), in a similar investigation, reported that cross-dressing roles were more often found in societies that had little sex-role disparity, as did Munroe, Whiting, and Hally's (1969) retest and confirmation of the former's finding (Munroe, Whiting, and Hally 1968: 87–90).

Levy (1973), in his work with the Tahitians, proposed a relationship between Tahitian low sex-role disparity and the *Mahu* (berdache). The Tahitian version of the male cross-dresser, according to Levy, carries vital information about the differences in male and female sex roles in a society where there is very little divergence between the two. The *Mahu* role allows the differences between the sexes to become apparent, where otherwise such differences are blurred.

Wikan (1977), in her work among the Omani, discussed what a specific berdache role in a particular culture reveals about the cultural concomitants of gender roles. The Omani berdache (*xanith*) throws into relief Omani conceptions of female virtue and laissez-faire attitudes about crime and deviance, and functions as a legitimate sexual outlet for males in a society where women by nature of their virtue and as the property of the males, are sexually taboo until they are married (1977: 310, 314–15).

Continuing this line of research, Thayer (1980: 287–92) has reinterpreted the role of the berdache among Northern Plains Indians, taking a socioreligious approach. Thayer viewed the berdache as a

symbolic mediating figure, like others whose power was derived from the Plains visionary complex (e.g., shamanistic callings) and who were in an interstitial position between the secular-human world and that of the sacred and divine. As neither male nor female, yet both male and female, the berdache also "has powers to mediate or cross sexual boundaries and roles" (1980: 292). A consequence of this interstitial position and role was that he transcended normative cultural categories. And by virtue of the power of transcendence, the berdache "did not threaten, abuse, or collapse pre-existing categories" but maintained, enriched, and enhanced existing social and sexual classification (1980: 292).

Although anthropologists have been interested in cross-sex role behavior, few have explored the related question of cross-sex identity. However, Whiting (1969), in his work with Burton (1961), studied cross-sex identity using the "absent-father and cross-sex identity" hypothesis. Burton and Whiting's hypothesis shares several of the features of the dominant-mother/absent-father etiological models of transsexualism advanced by Stoller (1968: 264) and Green (1974a: 216–40, 1974b: 47, 51). Burton and Whiting (1961: 89) maintain that, in cases where an infant boy sleeps exclusively with the mother and where a long postpartum sex taboo exists, the child will have exclusive attention of the mother. In polygynous societies, the father, denied sexual access to the mother, will cohabit with another wife and by implication be absent from the young boy (Whiting 1969: 416–55). As the child's primary association is the maternal one, he assumes that the mother is the keeper of certain desired resources and he envies her status, not the father's. The child, who has equated female status with desired resources, will then covertly practice her role and the optative identity from which he is barred (Burton and Whiting 1961: 89). But as these are societies where the male role is still superior, the boy must be taken from the subordinate world of women with which he identifies. The solution is the male initiation ceremony designed to alter the young man's cross-sex identity (Burton and Whiting 1961: 89).

In an ingenious study, Parker, Smith, and Ginat (1975: 687–706) tested the Burton and Whiting hypothesis in a polygynous Mormon community in the United States. According to the Burton and Whiting hypothesis, the necessary variables were present for a certain group of Mormon boys in the community to develop a cross-sex identity. In comparing this group of boys with a control group in the same com-

munity, a variety of tests of masculine-feminine identity were employed. The researchers found no difference in masculine identification between the two groups of boys. Cross-sex identity was not demonstrated, nor was father absence, as suggested by Burton and Whiting, found to be a critical variable (Parker, Smith, and Ginat 1975: 700–703).

Sagarin's (1975: 329–34) reanalysis of the Imperato-McGinley et al. report (1974) of eighteen pseudohermaphroditic males, known in the study site of Santo Domingo as *guevedoce*, provides an appropriate conclusion to this review of the anthropological literature.

The *guevedoce* has been discussed from the clinical perspective of Imperato-McGinley et al. as an example of the primacy of hormonal factors over socialization factors in determining gender identity and psychosexual orientation. The *guevedoce*, due to a recessive gene expressed through in-breeding, were at birth genitally ambiguous. They were reared as girls until puberty when radical virilization occurred, their gender identity changed, their behavior became masculine, and they chose females as their sexual objects. Imperato-McGinley et al., according to Sagarin, attribute this change to the impact of testosterone in utero and at puberty.

In contrast, Sagarin proposed an emic interpretation of the pseudohermaphrodites' seemingly remarkable gender reversal. He noted they were not raised as girls but as members of a special indigenous category of children with female characteristics who will become males at puberty (Sagarin 1975: 331). By understanding the *guevedoce* as a folk classification, Sagarin has offered an explanation from a sociocultural perspective which challenged the Imperato-McGinley view that testosterone accounted for the reversal of gender identity, role behavior, and female sexual object choice. Thus, according to Sagarin, the *guevedoce* was not someone who had a cross-sex identity problem that needed reversing, but rather was someone who was expected to become a male at twelve.

Notes

1. For an in-depth review of this literature, see Anne Bolin, "In Search of Eve: Transsexual Rites of Passage" (Ph.D. Diss., University of Colorado, Boulder, 1983), pp. 318–79.

2. "Gender role: everything that a person says and does, to indicate to others or to the self the degree to which one is male or female or ambivalent . . . gender role is the public expression of gender identity, and gender identity is the private experience of gender role" (Money and Ehrhardt 1972: 2, 84). Gender role is also referred to as sex role (Kessler and McKenna 1978: 11).

3. Although the sociocultural approach can in most cases be classified as either ethnomethodological or anthropological, one endeavor defies classification within this dual scheme. Janice Raymond's *The Transsexual Empire* (1979) spans both approaches. This work is a radical feminist treatment of transsexualism and the medical empire associated with the phenomenon. Raymond regards rigid sex-role stereotypes as a first cause of transsexualism, with the medical profession and their male-to-female transsexual cohorts as the second cause of transsexualism. Her interpretation relies on a sociopsychoanalytic version of a male conspiracy theory. Reminiscent of Bettelheim's (1962) theory of male vagina and womb envy, Raymond proposes that males (the medical community and transsexuals) are trying to co-opt women's power of creativity inherent in female biology through a male birthing process, i.e., transsexual surgery (1979: 107–8).

Bibliography

American Psychiatric Association. 1980. *Diagnostic and Statistical Manual of Mental Disorders*, 3rd ed. Washington, D.C.: American Psychiatric Association.

Anderson, R. 1976. *The Cultural Context*. Minneapolis, Minn.: Burgess.

Andreski, Stanislav. 1972. *Social Science as Sorcery*. New York: St. Martins.

Angelino, Henry, and Charles L. A. Shedd. 1955. A Note on the Berdache. *American Anthropologist* 57(1): 121–26.

Balzer, Marjorie Mandelstam. 1981. Rituals of Gender Identity: Markers of Siberian Khanty Ethnicity, Status and Belief. *American Anthropologist* 83(4): 850–67.

Barlow, D. H., G. G. Abel, and E. B. Blanchard. 1979. Gender Identity Change in Transsexuals: Follow-up and Replications. *Archives of General Psychiatry* 36(9): 1001–7.

Barlow, D. H., E. J. Reynolds, and S. Agras, 1973. Gender Identity Change in a Transsexual. *Archives of General Psychiatry* 28:569–79.

Barry, Kathleen. 1979. *Female Sexual Slavery*. Englewood Cliffs, N.J.: Prentice-Hall.

Bateson, Mary Catherine. 1980. Continuities in Insight and Innovation: Toward a Biography of Margaret Mead. *American Anthropologist* 82(2): 270–77.

Beach, Frank A. 1973. Human Sexuality and Evolution. In W. Montagu and W.A. Sadler, eds., *Reproductive Behavior*. New York: Plenum Press, 333–65.

Bem, Sandra L. 1977. Psychological Androgyny. In A. G. Sargent, ed., *Beyond Sex Roles*. St. Paul, Minn.: West 319–24.

Benjamin, Harry. 1966. *The Transsexual Phenomenon*. New York: The Julian Press.

———. 1967. The Transsexual Phenomenon. *Transactions of the New York Academy of Sciences Series* 2, 29(4): 428–30.

———. 1969. Introduction. In R. Green and J. Money, eds., *Transsexualism and Sex Reassignment*. Baltimore: The Johns Hopkins University Press, 1–10.

Berger, Jack C., et al. 1980. *Standards of Care: The Hormonal and Surgical Sex Reassignment of Gender Dysphoric Persons*. Galveston, Tex: The Harry Benjamin International Gender Dysphoria Association, Inc.

Bettelheim, Bruno. 1962. *Symbolic Wounds*. New York: Collier.

Billowitz, Arron, et al. 1981. A Diagnostic Approach to Patients with Gender Identity Disorders. Paper presented at the 7th International Gender Dysphoria Symposium. The Harry Benjamin International Gender Dysphoria Association. Lake Tahoe, Nev., 4–8 Mar.

Blumer, Dietrich. 1969. Transsexualism, Sexual Dysfunction, and Temporal Lobe Disorder. In R. Green and J. Money, eds., *Transsexualism and Sexual Reassignment*. Baltimore: The Johns Hopkins University Press, 213–19.

Blumer, Herbert. 1969. *Symbolic Interactionism: Perspective and Method*. Englewood Cliffs, N. J.: Prentice-Hall.

Bogoros, Waldemor. 1907. *The Chuckchee Religion*. Vol. 11, *Memoirs of the American Museum of Natural History*. Leiden, Netherlands: E. S. Brill.

Bolin, Anne E. 1974. God Save the Queen: An Investigation of a Homosexual Subculture. Master's Thesis, University of Colorado, Boulder. (Available through University Microfilms International, Ann Arbor, Mich.)

———. 1981. Transsexuals: Caretaker and Client Interrelations. Paper presented at the Society for Ethnohistory, Colorado Springs, Col., 29 Oct.–1 Nov.

———. 1982. Advocacy with a Stigmatized Minority. *Practicing Anthropology* 4(2): 12–13.

———. 1983. In Search of Eve: Transsexual Rites of Passage. Ph.D. diss., University of Colorado, Boulder. (Available through University Microfilms International, Ann Arbor, Mich.)

Bossard, J. H. S., and E. D. Boll, 1948. Rite of Passage—a Contemporary Study. *Social Forces* 26: 247–55.

————. 1950. *Ritual in Family Living*. Philadelphia: University of Pennsylvania Press.

Brain, Robert. 1978. Transsexualism in Oman? *Man* 13(2): 322–23.

Braroe, Niels W. 1965. Reciprocal Exploitation in an Indian-White Community. *Southwest Journal of Anthropology* 21(2): 166–78.

Brown, Roger W. 1963. *Social Psychology*. New York: The Free Press.

Burnett, Jacquetta H. 1975. Ceremony, Rites, and Economy in a Student System of an American High School. In J.P. Spradley and M. A. Rynkiewich, eds., *The Nacirema*. Boston: Little, Brown.

Burton, R. V., and J. W. M. Whiting. 1961. The Absent Father and Cross-Sex Identity. Reprinted from *Merrill-Palmer Quarterly of Behavior and Development* 7(2): 86–95. The Bobbs-Merrill Reprint Series in the Social Sciences, A277. New York: Bobbs-Merrill.

Butts, June Dobbs. 1981. Growing Up Black, Gay and Gender Dysphoric: An Analysis of Ten Transsexuals. Paper presented at the 7th International Gender Dysphoria Symposium. The Harry Benjamin International Gender Dysphoria Association. Lake Tahoe, Nev., 4–8 Mar.

Campbell, D. T., and J. C. Stanley. 1963. *Experimental and Quasi-Experimental Designs for Research*. Chicago: Rand McNally.

Caplin, N., and S. D. Nelson. 1973. On Being Useful: The Nature and Consequences of Psychological Research on Social Problems. In I. L. Horowitz, ed., *The Use and Abuse of Social Science*. New Brunswick, N.J.: Transaction Books, 136–61.

Casey, William C. 1981. Transsexual Lesbians. Paper presented at 7th International Gender Dysphoria Symposium. The Harry Benjamin International Gender Dysphoria Association. Lake Tahoe, Nev., 4–8 Mar.

Chapple, Elliott. 1970. *Culture and Biological Man: Explorations in Behavioral Anthropology*. New York: Holt.

————— and C. S. Coon. 1942. *Principles of Anthropology*. New York: Holt.

Churchill, Wainwright. 1971. *Homosexual Behavior among Males*. Englewood Cliffs, N.J.: Prentice-Hall.

Cohen, Mabel Blake. 1966. Personal Identity and Sexual Identity. *Psychiatry* 29(1): 1–14.

Coon, Carlton S. 1971. *The Hunting Peoples*. Boston: Little, Brown.

D'Andrade, Roy. 1970. Sex References in Cultural Institutions. In L. Hudson, ed., *The Ecology of Human Intelligence*. Harmondsworth, Eng.: Penguin.

Davenport, C. W., and S. I. Harrison. 1977. Gender Identity: Change in a Female Adolescent Transsexual. *Archives of Sexual Behavior* 6(4): 327–40.

Dellaert, R., and T. Kunke, 1969. Investigation of a Case of Male Transsexualism. *Psychotherapy and Psychosomatics* 17(2): 89–107.

Deutscher, Irwin. 1966. Words and Deeds: Social Science and Social Policy. Reprinted from *Social Problems* 13(3): 235–54. The Bobbs-Merrill Reprint Series in the Social Sciences, S–569. New York: Bobbs-Merrill.

Devereaux, George. 1937. Institutionalized Homosexuality of the Mohave Indians. *Human Biology* 9(4): 498–527.

Dixon, Jean, et al. 1981. Psychosocial Characteristics of Applicants Evaluated for Surgical Gender Reassignment. Paper presented at the 7th International Gender Dysphoria Symposium. The Harry Benjamin International Gender Dysphoria Association. Lake Tahoe, Nev., 4–8 Mar.

Douglas, Jack P. 1971. *American Social Order: Social Rules in a Pluralistic Society.* New York: Free Press.

Douglas, Mary. 1973. *Natural Symbols.* New York: Vintage Books.

Downie, D. C., and David J. Hally. 1961. A Cross-Cultural Study of Male Transvestism and Sex-role Differentiation. Unpublished manuscript. Dartmouth College.

Driscoll, James P. 1971. Transsexuals. *Transaction* 8(5–6): 28–37, 66, 68.

Edgerton, Robert B. 1964. Pokot Intersexuality: An East African Example of the Resolution of Sexual Incongruity. *American Anthropologist* 66(6): 1288–99.

Ehrhardt, A. A., and H. F. L. Meyer-Bahlburg. 1971. Effects of Prenatal Sex Hormones on Gender Related Behavior. *Science* 211 (4488): 1312–18.

Eicher, Wolf, et al. 1981. Transsexuality and H-Y Antigen. Paper presented at the 7th International Gender Dysphoria Symposium. The Harry Benjamin International Gender Dysphoria Association. Lake Tahoe, Nev., 4–8 Mar.

English, Deirdre. 1980. The Politics of Pornography. *Mother Jones* 5(3): 20–23, 44, 48–50.

Evans-Pritchard, E. E. 1970. Sexual Inversion among the Azande. *American Anthropologist* 72(6): 1428–34.

Fast, Julius. 1977. *The Body Language of Sex, Power and Aggression.* New York: M. Evans.

Feinbloom, Deborah H. 1976. *Transvestites and Transsexuals: Mixed Views.* New York: Delcorte Press/Seymour Lawrence Books.

Feldman, Sylvia. 1974. *The Rights of Women.* New Jersey: Hoyden.

Fiske, Shirley. 1975. Pigskin Review: An American Initiation. In J. P. Spradley and M. A. Rynkiewich, eds., *The Nacirema.* Boston: Little, Brown, 55–68.

Fleming, M., C. Steinman, and G. Bocknek. 1980. Methodological Problems in Assessing Sex-Reassignment Surgery: A Reply to Meyer and Reter. *Archives of Sexual Behavior* 9(5): 451–56.

Ford, C. S., and F. A. Beach. 1951. *Patterns of Sexual Behavior.* New York: Harper and Row.

Forester, G. M., and H. Swiller. 1972. Transsexualism: Review of Syndrome and Presentation of Possible Successful Therapeutic Approach. *International Journal of Group Psychotherapy* 22(3): 343–51.

Forty-One Sex Change Patients Have No Regrets. *Rocky Mountain News*, 15 Mar. 1982: 13.

Garfinkel, Harold. 1967. *Studies in Ethnomethodology*. Englewood Cliffs, N.J.: Prentice-Hall.

Garfinkel, H., and R. J. Stoller. 1967. Passing and the Managed Achievement of Sex Status in an "Intersexed" Person. In H. Garfinkel, ed., *Studies in Ethnomethodology*. Englewood Cliffs, N. J.: Prentice-Hall, 116–85.

Geertz, Clifford. 1972. Deep Play: Notes on the Balinese Cockfight. In Clifford Geertz, ed., *Myth, Symbol and Culture*. New York: Norton, 1–33.

Glantz, S. A. 1980. Biostatistics: How to Detect, Correct, and Prevent Errors in the Medical Literature. *Circulation* 61(1): 1–6.

Gluckman, Max. 1962. Les rites de passage. In Max Gluckman, ed., *Essays on the Ritual of Social Relations*. Manchester, Eng.: Manchester University Press.

Goffman, Erving. 1961. *Encounters*. New York: Bobbs-Merrill.

———. 1963. *Stigma: Notes on the Management of a Spoiled Identity*. Englewood Cliffs, N.J.: Prentice-Hall.

———. 1967. *Interaction Ritual*. Garden City, N.Y.: Doubleday.

———. 1969. *Strategic Interaction*. New York: Ballantine Books.

———. 1970. *Gender Advertisements*. New York: Harper and Row.

Goldberg, R. 1962. War and its Relationship with Sexual Tensions and Identification Conflict. Unpublished Senior Honors Thesis, Radcliffe College.

Goody, Jack. 1961. Religion and Ritual: The Definitional Problem. *The British Journal of Sociology* 12: 142–64.

Gottlieb, Anthony. 1980. Transsexualism and Sexual Identity. Paper presented at the Vail Psychiatric Conference. Vail, Col., 2 Feb.

Green, Richard. 1966. Transsexualism: Mythological, Historical and Cross-Cultural Aspects. In H. Benjamin, ed., *The Transsexual Phenomenon*. New York: The Julian Press, 173–86.

———. 1969. Childhood Cross-Gender Identification. In R. Green and J. Money, eds., *Transsexualism and Sex Reassignment*. Baltimore: The Johns Hopkins University Press, 23–36.

———. 1974a. *Sexual Identity Conflict in Children and Adults*. New York: Basic Books.

———. 1974b. Children's Quest for Sexual Identity. *Psychology Today* 7(9): 45–51.

Green, R., and J. Money., eds. 1969. *Transsexualism and Sex Reassignment*. Baltimore: The Johns Hopkins University Press.

Green, R., L. E. Newman, and R. J. Stoller. 1972. Treatment of Transsexuals. *Journal of Contemporary Psychotherapy* 6(1): 63–69.

Harrison, Randall P. 1974. *Beyond Words*. Englewood Cliffs, N.J.: Prentice-Hall.

Hastings, Donald W. 1969. Inauguration of a Research Project on Transsexualism in a University Medical Center. In R. Green and J. Money, eds., *Transsexualism and Sex Reassignment*. Baltimore: Johns Hopkins University Press, 243–51.

Haviland, William A. 1978. *Cultural Anthropology*. New York: Holt.

Hill, Willard W. 1935. The Status of the Hermaphrodite and Transvestite in Navajo Culture. *American Anthropologist* 37: 273–79.

———. 1938. Note on the Pima Berdache. *American Anthropologist* 40: 338–40.

Hoebel, E. A. 1949. *Man in the Primitive World*. New York: McGraw-Hill.

Hoenig, J., J. C. Kenna, and A. Yond, 1974. Surgical Treatment of Transsexuals. *Acta Psychiatrica Scandinavica* 47: 106–36.

Honigmann, John J. 1978. The Personal Approach in Culture and Personality Research. In G. D. Spindler, ed., *The Making of Psychological Anthropology*. Berkeley: University of California Press, 302–29.

Howe, Louise Kapp. 1977. *Pink Collar Workers*. New York: Avon.

Humphreys, Laud. 1970. *Tearoom Trade: Impersonal Sex in Public Places*. Chicago: Aldine.

Imperato-McGinley, J., L. Guerrero, T. Gautier, and R. E. Peterson. 1974. Steroid 5a-Reductase Deficiency in Man: An Inherited Form of Male Hermaphroditism. *Science* 186: 1213–15.

The Janus Information Facility. 1980. *Guidelines for Transsexuals*. (Available from Paul A. Walker, Director, The Janus Information Facility, 1952 Union Street, San Francisco, Calif. 94123.)

———. 1980. *Current Recommended Hormonal Therapy for Transsexuals*. (Available from Paul A. Walker, Director, The Janus Information Facility, 1952 Union Street, San Francisco, Calif. 94123.)

Jones, Howard W. 1909. Operative Treatment of the Male Transsexual. In R. Green and J. Money, eds., *Transsexualism and Sex Reassignment*. Baltimore: Johns Hopkins University Press, 313–22.

Kando, Thomas. 1973. *Sex Change*. Springfield, Illinois: Charles C. Thomas.

Karrie. 1980. Is Female Hormone Therapy For You? Reprinted from *The Gateway*, Feb.

Kaufman, Sharon. 1981. Cultural Components of Identity in Old Age: A Case Study. *Ethos* 9(1): 51–87.

Kemnitzer, David S. 1977. Sexuality as a Social Form: Performance and Anxiety in America. In J. L. Dolgin et al., eds., *Symbolic Anthropology*. New York: Columbia University Press, 292–309.

Kessler, S. J., and W. McKenna. 1978. *Gender: An Ethnomethodological Approach*. New York: John Wiley.

Kimball, Solon T. 1960. Introduction. In Arnold Van Gennep, *The Rites of Passage*, trans. by M.B. Vizedom and G. L. Caffee. London: Routledge and Kegan Paul. (Orig. ed. 1909.)

Kirkpatrick, M., and C. Friedman. 1976. Treatment of Requests for Sex Change. Surgery with Psychotherapy. *American Journal of Psychiatry* 133(10): 1194–96.

Kottak, Conrad Phillip. 1982. *Anthropology*. New York: Random House.

Lakoff, Robin. 1980. Talking Like a Lady. In E. Angeloni, ed., *Readings in Anthropology 80/81*. Guilford, Conn.: Dushkin Publishing Group, 49–53.

Langness, Lewis L. 1965. *The Life History in Anthropological Science*. New York: Holt.

Laub, Donald R. 1981. The Natural Vagina. Paper presented at the 7th International Gender Dysphoria Symposium. The Harry Benjamin International Gender Dysphoria Association. Lake Tahoe, Nev., 4–8 Mar.

Leach, Edmund R. 1968. Ritual. In D. Sills, ed., *International Encyclopedia of the Social Sciences*. Vol. 13. New York: Macmillan.

Levy, Robert I. 1973. *Tahitians: Mind and Experience in the Society Islands*. Chicago: University of Chicago Press.

Lowie, Robert H. 1935. *The Crow Indians*. New York: Farrar and Rinehart.

Lyman, S. M., and W. A. Douglass. 1973. Ethnicity: Strategies of Collective and Individual Impression Management. *Social Research* 40(2): 344–65.

McCall, George J. 1966. *Identities and Interaction*. New York: The Free Press.

Maccoby, E. E., and C. N. Jacklin. 1974. *The Psychology of Sex Differences*. Stanford: Stanford University Press.

MacCormack, C., and M. Strathern, eds. 1980. *Nature, Culture, and Gender*. Cambridge: Cambridge University Press.

MacRae, Duncan. 1976. *The Social Function of Social Science*. New Haven: Yale University Press.

Malamuth, N. M., and J. J. Check. 1980. Sex and Violence: Pornography Hurts. *Science News* 118: 170–72.

Male Fantasies. 1980. *Time* 115(7): 50.

Martin, M. K., and B. Voorhies. 1975. *Female of the Species*. New York: Columbia University Press.

Masters, W. H., V. E. Johnson, and R. C. Kolodny. 1982. *Human Sexuality*. Boston: Little, Brown.

Mead, George H. 1934. *Mind, Self and Society*. Chicago: University of Chicago Press.

Meyer, J. K., and D. J. Reter. 1979. Sex Reassignment. *Archives of General Psychiatry* 36: 1010–15.

Meyer, W. J., J. W. Finkelstein, C. A. Stuart, et al. (n.d.) *Physical and Hormonal Evaluation of Transsexual Patients during Hormonal Therapy*. Galveston, Tex.: The University of Texas Medical Branch at Galveston.

Meyer, W. J., P. A. Walker, and Z. R. Suplee. (n.d.) *Survey of Transsexual Hormonal Treatment in Twenty Gender-Treatment Centers*. The Janus Information Facility, Department of Pediatrics and Psychiatry and Behavioral Sciences, The University of Texas Medical Branch at Galveston.

Middleton, John. 1973. Some Categories of Dual Classification among the Lugbara of Uganda. In R. Needham, ed., *Right and Left: Essays on Dual Symbolic Classification*. Chicago: University of Chicago Press, 369–90.

Miller, E. S., and C.A. Weitz. 1979. *Introduction to Anthropology*. Englewood Cliffs, N.J.: Prentice-Hall.

Money, J., and A. A. Ehrhardt. 1972. *Man and Woman, Boy and Girl*. Baltimore: The Johns Hopkins University Press.

Money, J., and C. Primrose. 1969. Sexual Dimorphism and Dissociation in the Psychology of Male Transsexuals. In R. Green and J. Money, eds., *Transsexualism and Sex Reassignment*. Baltimore: The Johns Hopkins University Press.

Money, J., and F. Schwartz. 1969. Public Opinion and Social Issues in Transsexualism: A Case Study in Medical Sociology. In R. Green and J. Money, eds., *Transsexualism and Sex Reassignment*. Baltimore: The Johns Hopkins University Press, 253–69.

Money, J., and P. Tucker. 1975. *Sexual Signatures: On Being a Man or a Woman*. Boston: Little, Brown.

Money, J., and P. A. Walker. 1977. Counseling the Transsexual. In J. Money and H. Musaph, eds., *Handbook of Sexology*. New York: Elsevier/North Holland Biomedical Press, 1289–1301.

Montague, S. P., and W. Arens, eds. 1981. *The American Dimension: Cultural Myths and Social Realities*. Sherman Oaks, Calif.: Alfred Publishing.

Munroe, R., J. M. Whiting, and D. J. Hally. 1969. Institutionalized Male Transvestism and Sex Distinctions. *American Anthropologist* 71(1): 87–90.

Myers, David G. 1979. How Groups Intensify Opinions. *Human Nature* 2(3): 34–39.

Nadel, Siegfried F. 1974. *Nupe Religion*. London: Routledge and Kegan Paul.

Naftolin, Frederick. 1981. Understanding the Bases of Sex Differences. [Introduction to a series of articles.] *Science* 211(4480): 1261–1311.

Needham, Rodney, ed., 1973. *Right and Left: Essays on Dual Symbolic Classification*. Chicago: University of Chicago Press.

Newton, Esther. 1972. *Mother Camp: Female Impersonation in America*. Englewood Cliffs, N.J.: Prentice-Hall.

———. 1977. Role Models. In J. L. Dolgin et al., eds., *Symbolic Anthropology*. New York: Columbia University Press, 336–48.

Offir, Carol Wade. 1982. *Human Sexuality*. New York: Harcourt.

Ohno, Susumu. 1979. *Major Sex-Determining Genes*. Berlin: Springer-Verlag.

Ortner, S. B., and H. Whitehead. 1981. *Sexual Meanings*. Cambridge: Cambridge University Press.

Parker, S., J. Smith, and J. Ginat. 1975. Father Absence and Cross-Sex Identity. *American Ethnologist* 2(2): 687–706.

Pauly, Ira B. 1968. The Current Status of the Sex Change Operation. *Journal of Nervous and Mental Diseases* 147: 460–71.

———. 1969. Adult Manifestations of Male Transsexualism. In R. Green and J. Money, eds., *Transsexualism and Sex Reassignment*. Baltimore: The Johns Hopkins University Press, 37–58.

———. 1981. Outcome of Sex Reassignment Surgery for Transsexuals. *Australian and New Zealand Journal of Psychiatry* 15: 45–51.

Person, E. S., and L. Ovesey. 1974. The Psychodynamics of Male Transsexualism. In R. C. Friedman et al., eds., *Sex Differences in Behavior*. New York: Wiley, 315–31.

Pfafflin, Friedmen. 1981. H-Y Antigen in Transsexualism. Paper presented at the 7th International Gender Dysphoria Symposium. The Harry Benjamin International Gender Dysphoria Association. Lake Tahoe, Nev., 4–8 Mar.

Pomeroy, Wardell B. 1975. The Diagnosis and Treatment of Transvestites and Transsexuals. *The Journal of Sex and Marital Therapy* 1(3): 215–24.

Posinsky, S. H. 1962. Ritual, Neurotic and Social. *American Imago* 19: 375–90.

Randell, John. 1969. Preoperative and Postoperative Status of Male and Female Transsexuals. In R. Green and J. Money, eds. *Transsexualism and Sex Reassignment*. Baltimore: Johns Hopkins University Press, 355–81.

Raymond, Janice G. 1979. *The Transsexual Empire: The Making of a She-Male*. Boston: Beacon Press.

Read, Kenneth E. 1980. *Other Voices: The Style of a Male Homosexual Tavern*. Novato, Calif.: Chandler and Sharp.

Redfield, Robert. 1953. *The Primitive World and its Transformations*. New York: Cornell University Press.

Reik, Theodor. 1940. *Masochism in Modern Man*. New York: Farrar, Straus.

Rosen, Alexander C. 1969. The Inter-Sex: Gender Identity, Genetics, and Mental Health. In S. C. Plog and R. B. Edgerton, eds., *Changing Perspectives in Mental Illness*. New York: Holt, 659–71.

Rosenberg, G., and B. Sutton-Smith. 1972. *Sex and Identity*. New York: Holt.

Sagarin, Edward. 1975. Sex Rearing and Sexual Orientation: The Reconciliation of Apparently Contradictory Data. *The Journal of Sex Research* 11(4): 329–34.

Sanday, Peggy Reeves. 1981. *Female Power and Male Dominance*. Cambridge: Cambridge University Press.

Sarason, Seymour B. 1981. An Asocial Psychology and a Misdirected Clinical Psychology. *American Psychologist* 36(8): 827–36.

Schneider, David M. 1980. *American Kinship*. Chicago: The University of Chicago Press.

Schwartz, G., and D. Merten. 1975. Social Identity and Expressive Symbols. In J. P. Spradley and M. A. Rynkiewich, eds., *The Nacirema*. Boston: Little, Brown, 195–211.

Schwartz, M. S., and C. G. Schwartz. 1955. Problems in Participant-Observation. Reprinted from *The American Journal of Sociology* LX (4): 343–53. The Bobbs-Merrill Reprint Series in the Social Sciences, S–503. New York: Bobbs-Merrill, 343–53.

Shepherd, Gill. 1978. Transsexualism in Oman? *Man* 13(1): 133–34.

Simmel, Georg. 1950. *The Sociology of Georg Simmel*. K. H. Wolff, ed. and trans. New York: Free Press.

Smith, D. 1981. Unfinished Business with Uninformed Consent Procedures. *American Psychologist* 36(1): 22–66.

Smith, M. Brewster. 1954. Anthropology and Psychology. In H. Becker et al., eds., *For a Science of Social Man*. New York: Macmillan, 32–36.

Sontag, Susan. 1970. Notes on Camp. In *Against Interpretation and Other Essays*. New York: Dell, 277–93.

Spradley, J. P., and M. A. Rynkiewich, eds. 1975. *The Nacirema: Readings on American Culture*. Boston: Little, Brown.

Star, R. 1981. Cutting the Ties that Bind. In J.R. Barbour, ed., *Human Sexuality 80/81*. Guilford, Conn.: Dushkin Publishing Group, 178–85.

Starka, L., I. Sipova, and J. Hynie. 1975. Plasma Testosterone in Male Transsexuals. *The Journal of Sex Research* 11(2): 134–38.

Steinman, D. L. and J. P. Wincze. 1981. The Behavioral Treatment of Individuals Presenting Gender Identity Disorders: A Serendipitous Finding. Paper presented at the 7th International Gender Dysphoria Symposium. The Harry Benjamin International Gender Dysphoria Association. Lake Tahoe, Nev., 4–8 Mar.

Stewart, Omer C. 1960a. Homosexuality among American Indians and Other Native Peoples of the World. *Mattachine Review* 6(1): 9–15.

———. 1960b. Homosexuality among American Indians and Other Native Peoples of the World. *Mattachine Review* 6(2): 13–19.

Stoller, Robert J. 1968. *Sex and Gender: On the Development of Masculinity and Femininity*. New York: Science House.

———. 1974. Foreword. In R. Green, ed., *Sexual Identity Conflict in Children and Adults*. New York: Basic Books, ix–xvi.

———. 1975. *The Transsexual Experiment*. London: Hogarth Press.

Thayer, James S. 1980. The Berdache of the Northern Plains: A Socioreligious Perspective. *Journal of Anthropological Research* 36(3): 287–93.

Thompson, Patricia Hadley. 1969. Apparatus to Maintain Adequate Vaginal Size Post-Operatively in the Male Transsexual Patient. In R. Green and J. Money, eds., *Transsexualism and Sex Reassignment*. Baltimore: The Johns Hopkins University Press, 323–30.

Turner, Victor. 1962. Three Symbols of Passage in Ndembu Circumcision Ritual. In M. Gluckman, ed., *Essays on the Ritual of Social Relations*. Manchester, Eng.: University of Manchester Press, 124–73.

———. 1967. Betwixt and Between: The Liminal Period in Rites de Passage. In Victor Turner, ed., *The Forest of Symbols*. Ithaca, N.Y.: Cornell University Press, 93–110.

———. 1968. *The Drums of Affliction*. Oxford: Clarendon Press.

———. 1969. *The Ritual Process*. Chicago: Aldine.

———. 1974. *Dramas, Fields and Metaphors: Symbolic Action in Human Society*. Ithaca, N.Y.: Cornell University Press.

———. 1977. Process, System and Symbol: A New Anthropological Synthesis. *Daedalus* 106(3): 61–80.

Van Gennep, Arnold. 1960. *The Rites of Passage*. Trans. by M. B. Vizedom and G. L. Caffee. London: Routledge and Kegan Paul. (Orig. ed. 1909)

Vernon, Glenn M. 1965. *Human Interaction*. New York: Ronald Press.

Walinder, Jan. 1967. *Transsexualism: A Study of Forty-Three Cases*. Goteborg, Sweden: Scandinavian University Books.

———. 1981. Cross-Cultural Approaches to Transsexualism: A Comparison between Sweden and Australia. Paper presented at the 7th International Gender Dysphoria Symposium. The Harry Benjamin International Gender Dysphoria Association. Lake Tahoe, Nev., 4–8 Mar.

Walinder, J., B. Lundstrom, and I. Thuwe. 1978. Prognostic Factors in the Assessment of Male Transsexuals for Sex Reassignment. *British Journal of Psychiatry* 132: 16–20.

Wallace, Anthony F. C. 1970. *Culture and Personality*. New York: Random House.

Warren, Carol A. B. 1974. *Identity and Community in the Gay World*. New York: Wiley.

Weintraub, Pamela. 1981. The Brain: His and Hers. *Discover* 2(4): 15–20.

Westermarck, Edward. 1956. Homosexual Love. In B. W. Corey, ed., *Homosexuality: A Cross-Cultural Approach*. New York: The Julian Press, 101–38.

Whiting, John W. M. 1969. The Effect of Climate on Certain Cultural Practices. In A. P. Vayda, ed., *Environment and Cultural Behavior*. New York: Natural History Press, 416–55.

Wikan, Unni. 1977. Man Becomes Woman: Transsexualism in Oman as a Key to Gender Roles. *Man* 12(2): 304–19.

Winick, Charles. 1970. *Dictionary of Anthropology*. Totowa, N.J.: Littlefield, Adams.

Wojdowski, P., and I. B. Tebor. 1976. Social and Emotional Tensions during Transsexual Passing. *The Journal of Sex Research* 12(3): 193–205.

Index

207